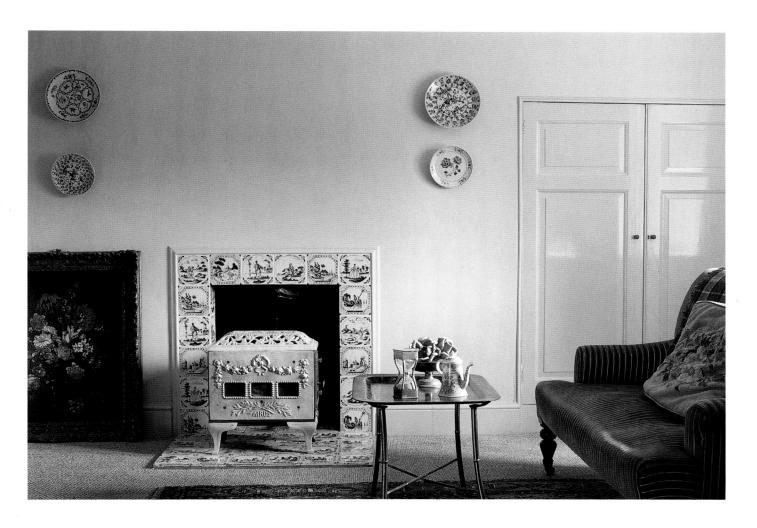

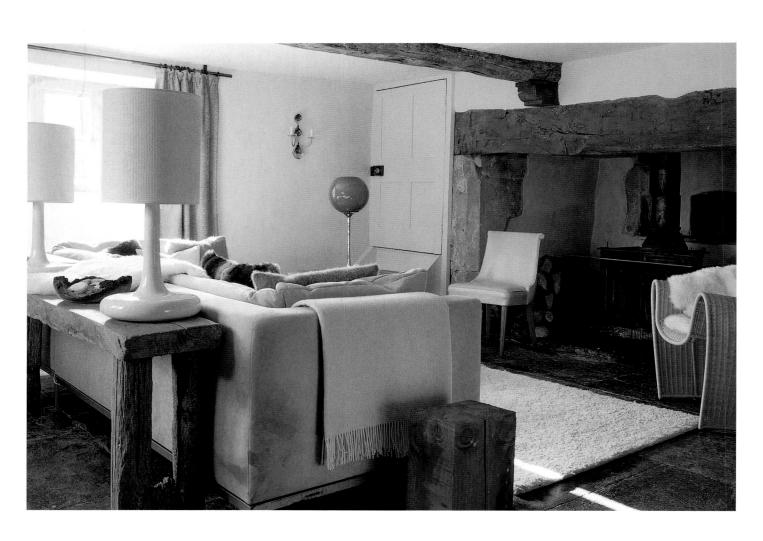

kevin m°cloud

choosing colours

An expert choice of the best colours to use in your home

quadrille

Colour accuracy and the limitations of this book

This volume has been printed in Hexachrome[®], an advanced printing process that uses six component colours rather than the conventional four. While Hexachrome[®] offers over 3,000 controllable colours, there are still some limitations and variations within the printing process. As a result it is impossible to guarantee the fidelity of the colours reproduced.

The paint matches given in the four-page pull-out section have been matched to all the printed swatches in this book using paint manufacturers' colour cards. However, neither the author nor the publisher can take responsibility for any discrepancies in colour between a swatch colour in this book and its corresponding specified manufacturers' colour.

It is important to note that different batches of paint from any manufacturer will vary minutely in colour. When buying paint, always check the batch numbers on the tin and buy from the same batch whenever possible. If it is not possible to buy from the same batch, mix the tins to achieve a uniform colour.

To get an accurate up-to-the-minute paint match for any colour swatch in this book and to buy the best of British branded paint, visit www.choosingpaint.com

Editorial Director Anne Furniss Creative Director Helen Lewis Project Editor Lisa Pendreigh

Design Assistants Jim Smith and Katy Davis **Picture Researcher** Nadine Bazar and Claire Limpus

Production Director Vincent Smith

Production Controllers Beverley Richardson

First published in 2003 by Quadrille Publishing Ltd Alhambra House 27–31 Charing Cross Road London WC2H 0LS

Text and palettes © Kevin M°Cloud 2003 Design and layout © Quadrille Publishing Ltd 2003

All rights reserved. No part of this book may be reproduced, stored in a retrieval system or transmitted in any form or by any means, electronic, electrostatic, magnetic tape, mechanical, photocopying, recording or otherwise, without prior permission in writing from the publisher.

The rights of Kevin McCloud to be identified as the author of this work have been asserted by him in accordance with the Copyright, Design and Patents Act 1988.

Cataloguing-in-Publication Data: a catalogue record for this book is available from the British Library.

ISBN 1 903845 77 7

Printed and bound in China

contents

why I wrote this book 6 how this book works 7 how colour works 8

THE PALETTES

PURE COLOURS 12

01 yellow

02 yellow-orange

03 orange

04 orange-red

05 red

06 red-violet

07 violet

08 violet-blue

09 blue

10 cyan

11 turquoise

12 green

13 green-yellow

14 grey

15 brown

16 neutrals

PERIOD COLOURS 46

17 early period colours

18 early twentieth-century colours

19 1920s colours

20 colours from 1940s New York

21 colours from 1950s schemes

22 colours from more 1950s schemes

23 colours from 1960s schemes

24 another 1960s scheme

25 1960s furniture colours

NATURAL PALETTES 78

26 haze

27 a Norse legend

28 seascape

29 field and forest

30 quarry colours

31 earth pigments

32 the lost colours of the Kalahari

33 colours obscured by age

34 baked clay

35 deep water

36 the colours of pebbles

37 the colours of shells

38 water and air: Oriental elements

SIMPLE PALETTES 108

39 in the red corner, in the blue corner

40 silk, cinnabar and oxblood

41 gilt-edged, blue-blooded

42 fifties vogue

43 the red and green story, part i:

racing green

44 the red and green story, part ii:

English chintz

45 the red and green story, part iii:

Italian punch

46 the red and green story, part iv: French pinks

47 natural dyes

Tratural dyes

48 archaeological colours

49 earthy primaries

COMPLEX PALETTES 132

50 northern light

51 chocolate ice-cream sundae

52 the innocence of powder blue

53 brown and blue in a hot climate

54 colours for a new white box

55 vegetarian primaries

56 the importance of brown and cream

57 a dash of brown to tie it all together

58 a little journey across the colour globe

59 seen through a fine gauze

60 blue adventure

VIBRANT PALETTES 164

61 an aniline trip on class A colours

62 now, in glorious full colour

63 weaving the rainbow

64 full-on seaside dazzle

notes to the palettes 176

bibliography 186

paint stockists and suppliers 188

useful colour terms 190

picture credits 191

acknowledgements 192

paint matches see pull-out leaflet

WHY I WROTE THIS BOOK

I wanted to do just one thing with this book: provide a well-researched reference work, which would be a useful working tool for the designer, decorator, homeowner, student, architect, craftsman, artist and anybody who gets fired up by the emotional power of colour.

Having compiled this collection of colour palettes, I'm now aware how impossible it is to be universal. To include every historical or regional palette or every colour model or every example of a 'balanced' colour scheme, if such things even exist, would demand an encyclopaedic set of books, which nobody would then read. In fact those books that try to order colour into harmonious symmetries of complementaries and split the colour wheel into arrangements by fraction are very worthy, but also very dull.

Instead I've tried to convey collections of colours that best exemplify their time or place and which are powerful. A powerful palette to my mind is a palette that's not just a set of interesting or strong colours: it's something that has its own identity above those colours and which can trigger strong associations, sometimes in our subconscious, of a time or place or emotion. A single colour can of course trigger such associations by itself, like a Miles Davis solo can. The palette, on the other hand, can work like a full orchestra.

There are colours and palettes in this book which may not please some people. There are no doubt some colours which are inaccurate and I'm always grateful for corrections and additions. I have tried in every case to be as scholarly as possible in matching, cross-matching and checking colours, but I do not claim that this book is an art historical reference work: the palettes and colours are, ultimately, my choices. If anything, they are abstract representations, removed from the objects or events from which they are taken. They are distillations of time, of place and of the ideas behind things. I hope you enjoy looking at them and using them.

HOW THIS BOOK WORKS

There are some 700 colours here arranged into 64 palettes. Although some palettes run over more than two pages, whenever you open a page in this book, the colours you see will form a coherent arrangement.

I could simply have provided a list of 700 interesting colours, but that would have been pointless. The choice of any colour must be an informed one. We use colour in an informed way, exploiting its perceived value and associations to convey unspoken and unwritten ideas and emotions. So, every colour in this book comes from somewhere, is connected to a thing or place or time, and is indicated as such, allowing you to make the most of its associated values if you want to.

What is even more powerful is the ability of a group of colours to convey a message, either very directly or in a more subtle and complex way, which is why nearly every colour in this book is shown as part of a group of colours, a palette.

The palettes take their inspiration from all sorts of sources. Some are accurate reproductions of the colours of decorated objects: historic tiles from the Middle East; Sèvres porcelain; Roman mosaics; Greek pottery: all objects of great value in the history of decoration and design. Others are taken from historical examples of wallpainting, whether it be Minoan or houses of the eighteenth century. Some are derived from the colours of place and country. Others are contemporary in origin, taking as their sources modern signage, the car, and new colour systems.

. You can extract colours from this book in a variety of ways: by copying an entire palette and employing the full force of any association or subtle value it may have; by drawing on a smaller group of colours; or by using just one colour. In fact, the palettes are arranged in different ways too. Some are coherent wholes, others are split into distinct sub-groups of a few colours.

Some of the palettes in this book are not assembled from one source or with any great plan behind them. They are simply collections of good colours from which you can choose at random. All the historical wall colours from the eighteenth, nineteenth and early twentieth centuries are good examples of this kind of palette, from which you can simply choose a reasonably authentic colour to paint your 1780s living room or your 1920s front door. If you do not feel constrained by the need for a period atmosphere, consult the sixteen palette section Pure Colours (see pages 12–45). They are just that: colours that I have chosen from among the 3,000 controllable colours in the six-colour Hexachrome[®] printing process (see page 11) and which I have grouped by hue (blue, yellow-orange, etc.). These selections are not comprehensive by any means, but each colour has its own separate and worthwhile character.

The palettes are not named according to their sources but according to their overall perceived character. This provides the hidden advantage of removing any prejudice you might have about a colour or arrangement of colours. You could be very drawn to a set of colours for, say, your living room, or a project, or an ad campaign you are running. Were that palette to occur in a section marked 'Wall Colours' and be called 'Early Jericho', you might be put off using it even before you had finished reading the title. Better to thumb through the book and just mark the palettes that catch your eye, than be bogged down and blinkered by words.

HOW TO FIND A PAINT COLOUR

A supplementary list is supplied with this book, with which you can find a commercial paint colour to match any colour shown here. Each colour swatch in this book has a reference: the palette number, followed by the colour number. For each of these I have given one commercial paint reference.

A NOTE ON THE COLOUR REPRODUCTION

National and international standard colours have been matched by the comparison of Hexachrome® colour swatches with approved control references (for example the colour control atlases of the Natural Color System®, or NCS®, and the International Organization for Standardization, or ISO, references) and cross-matched with accompanying published *Munsell Books of Colour*, Lab or NCS® colour references. See colour model 4 on page 11 for a fuller understanding of the Hexachrome® printing process used to produce this book.

The following four pages contain various colour models – structures that are used to explain how colours relate to each other and how we perceive them – that are all useful in helping to understand how the palettes in this book work.

Colour models have been in use for millenia; Aristotle developed the first western scale of colours, which in turn influenced Newton's decision to settle on seven colours for the rainbow (he had at various points thought there to be five or eleven). Even modern systems still refer to colour in essentially Newtonian terms.

To an extent all colour models are valid in some way. Even the most sophisticated 3-D colour models in use by scientists still cannot account for some colours, so no one model necessarily reigns supreme; they are all fallible. That's because human vision itself is not consistent and it is not neat. It's not consistent because we each of us are blessed with minutely different configurations of optical receptors in our eyes (the rods and cones). It's not neat because vision is not a logical, but a biological mechanism that has developed as an important tool for a myriad number of human activities: it is analogue, not digital, and its sensitivity to the colours of the rainbow varies (see colour model 3 on page 10).

COLOUR MODEL 1 IS THE ONE THAT WE LEARNT AT SCHOOL.

THE PRIMARY PAINT COLOURS – WHICH CANNOT BE PRODUCED
BY MIXING OTHER COLOURS – ARE YELLOW, RED AND BLUE AND
THEIR SECONDARIES ARE MADE BY INTERMIXING. THE RESULT
IS THAT WHEN THE MODEL IS ARRANGED AS A CIRCLE, THE
COMPLEMENTARY OF RED IS GREEN (BEING OPPOSITE).

COMPLEMENTARIES APPEAR TO 'FIGHT' WHEN PLACED
TOGETHER AND WHEN MIXED TOGETHER MAKE BROWN OF SOME
KIND. MANY OF THE SUBTLER AND MORE COMPLEX COLOURS IN THE
PALETTES INVOLVE THE DILUTION OF ONE COLOUR WITH A SMALL
QUANTITY OF ITS COMPLEMENTARY PLUS THE ADDITION OF WHITE
AND/OR BLACK. OTHER PALETTES PAIR COMPLEMENTARY COLOURS
TOGETHER TO DELIBERATE EFFECT. THIS MODEL IS A PRAGMATIC
ONE BECAUSE IT WORKS FOR PIGMENTS AND CHEMICAL
COLORANTS, WHICH IN TURN ARE OFTEN IMPERFECT. IT IS ALSO
KNOWN AS THE 'SUBTRACTIVE' MODEL BECAUSE AS THE COLOURS
ARE MIXED, THEY CANCEL OUT A DEGREE OF THEIR OWN
LUMINOSITY AND BECOME DARKER. SO PURPLE AND GREEN ARE
LESS BRIGHT THAN THEIR COMBINED CONSTITUENT PRIMARIES.
A CASE OF THE SUM BEING LESS THAN THE PARTS.

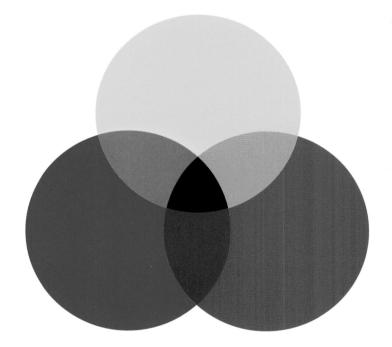

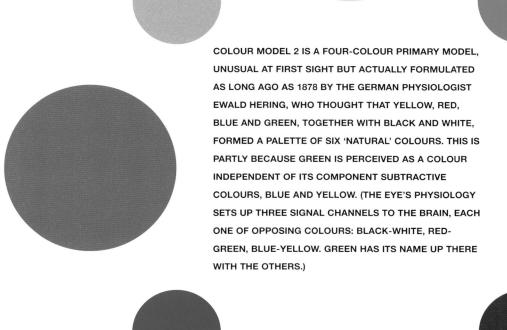

THIS FOUR-COLOUR PALETTE CREATES AN INTERESTING SET OF FOUR SECONDARY COLOURS: ORANGE, VIOLET, TURQUOISE AND LIME GREEN. ONE RESULT OF THIS, FOR EXAMPLE, IS THAT THE COMPLEMENTARY OF TURQUOISE BECOMES ORANGE AND YOU CAN SEE A MUTED EXAMPLE OF THIS COMPLEMENTARY RELATIONSHIP IN PALETTE 58. THE FOUR-COLOUR MODEL WAS REFINED IN THE TWENTIETH CENTURY, PUBLISHED AND REPUBLISHED AND THEN TECHNICALLY PERFECTED BY THE SWEDISH COLOUR CENTRE FOUNDATION, WHO ISSUED IT AS THE STANDARD COLOR ATLAS OF THE NATURAL COLOR SYSTEM (NCS), IN 1979. IT'S NOW ADOPTED AS SEVERAL NATIONAL STANDARDS AND BY PAINT AND COATINGS MANUFACTURERS WORLDWIDE. PALETTE 62 CONTAINS ALL THE PRIMARY, SECONDARY AND TERTIARY (BETWEEN THE SECONDARIES) COLOURS OF THIS FOUR-COLOUR SYSTEM.

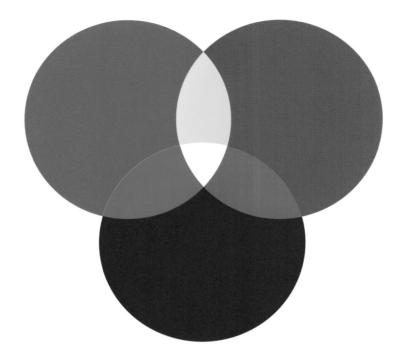

COLOUR MODEL 3 REVERTS TO THREE PRIMARIES AND THEY'RE DIFFERENT AGAIN FROM COLOUR MODEL 1. THE REASON IS THAT THESE ARE THE PRIMARY AND SECONDARY COLOURS OF LIGHT: GREEN, WARM RED AND PURPLE-BLUE LIGHT WHEN MIXED TOGETHER PRODUCE WHITE LIGHT (JUST AS RED, YELLOW AND BLUE PAINT ARE SUPPOSED TO MAKE BLACK BUT, BECAUSE OF PIGMENT IMPERFECTION, MAKE A MURKY BROWN). THEIR SECONDARY COLOURS ARE ALSO INTERESTING: CYAN BLUE (SIMILAR TO TURQUOISE), MAGENTA AND YELLOW, WHICH MOST BIZARRELY OF ALL IS PRODUCED BY MIXING RED AND GREEN LIGHT. NOTE THAT BECAUSE THE SECONDARIES RESULT FROM THE ADDITION OF TWO OTHER LIGHT COLOURS, THEY ARE ALSO MORE LUMINOUS. NOT SURPRISINGLY, THIS IS CALLED AN ADDITIVE PALETTE.

THERE IS NO MAGIC BEHIND THE CHOICE OF COLOURS AND NO ALCHEMY IN THEIR MIXING. THE CHOICE OF RED, GREEN AND BLUE PRIMARIES FROM AMONG THE COLOURS OF THE VISIBLE SPECTRUM (I.E. THE RAINBOW) IS ALL DOWN TO THE WAY WE'RE BUILT. WE PERCEIVE A VERY NARROW BAND OF ELECTROMAGNETIC RADIATION (WHICH INCLUDES RADIO AND GAMMA WAVES) AND WE CALL THAT VISIBLE PORTION LIGHT. THE THREE TYPES OF SENSOR ON OUR RETINAS THAT RESPOND TO DIFFERENT COLOURS WITHIN THE VISIBLE SPECTRUM HAVE PEAK SENSITIVITY IN DIFFERENT AREAS: ONE PEAKS IN THE BLUE PART OF THE SPECTRUM, ONE IN THE GREEN AND ONE IN THE RED. IF WE HAD SENSORS THAT WERE SENSITIVE TO INFRA-RED OR ULTRA-VIOLET (AS SOME ANIMALS DO) WE MIGHT SEE MORE COLOURS. AS IT IS BECAUSE WE HAVE ONLY THREE TYPES (PLUS ONE FOR MONOCHROME VISION), OUR ENTIRE COLOUR WORLD IS DEPENDENT ON THEM: ALL PERCEIVABLE COLOURS ARE MADE UP FROM VARIOUS COMBINATIONS OF THEIR ACTIVITIES. THAT GIVES US A MEASLY, SEPARATELY IDENTIFIABLE 16 MILLION COLOURS TO PLAY WITH.

COLOUR MODEL 4 TAKES THE SECONDARY COLOURS OF LIGHT – CYAN, MAGENTA AND YELLOW – AND WORKS THEM BACKWARDS. THE THEORY IS THAT IF YOU TAKE THREE SHEETS OF TRANSPARENT PLASTIC IN THESE THREE COLOURS, YOU SHOULD BE ABLE TO PRODUCE THE LIGHT PRIMARIES BY SUBTRACTION. THUS A SHEET OF CYAN PLASTIC FILM HELD OVER A SHEET OF MAGENTA PLASTIC FILM SHOULD GIVE A LESS LUMINOUS, BUT BLUE LIGHT. IT WORKS A BIT LIKE MIXING PAINT AND THESE THEORETICAL SUBTRACTIVE PRIMARIES, CYAN, MAGENTA AND YELLOW, OUGHT (IN OPPOSITION TO COLOUR MODEL 3) TO MAKE BLACK WHEN OVERLAID. OF COURSE THEY DON'T BECAUSE COLOURED PLASTIC, LIKE COLOURED ANYTHING (OTHER THAN LIGHT), IS NEVER 100 PERCENT TOTALLY PURELY COLOURED.

IT'S THE SAME STORY WITH PRINTING INKS. THIS MODEL LIES BEHIND MODERN PRINTING METHODS, WHICH USE CYAN, MAGENTA AND YELLOW TRANSPARENT INKS OVER WHITE PAPER (A SOURCE OF REFLECTED LIGHT) TO REPRODUCE FULL-COLOUR PHOTOGRAPHS IN BOOKS AND MAGAZINES. IN PRACTICE PRINTERS ALSO USE BLACK TO BOLSTER THE PERFORMANCE OF THE THREE COLOURS AND THE RESULTING PRINTING METHOD (WHICH IS PART-ADDITIVE, PART-SUBTRACTIVE) IS KNOWN AS CMYK PROCESS PRINTING, NOW USED WORLDWIDE.

BUT CMYK HAS ALWAYS HAD ITS WEAKNESSES, NOTABLY POOR GREENS AND ESPECIALLY ORANGES, WHICH ALWAYS LOOK DULL AND MUDDY, MAINLY DUE, AGAIN, TO THE TECHNICAL LIMITATIONS OF THE INKS. PANTONE®, ONE OF THE LARGEST COLOUR AUTHORITIES IN THE WORLD, AND CERTAINLY THE SINGLE MOST PERSUASIVE VOICE IN THE GRAPHICS AND PRINTING INDUSTRIES, HAS SOLVED THESE PROBLEMS TO A LARGE EXTENT WITH THE INTRODUCTION OF TWO FURTHER INK COLOURS, GREEN AND ORANGE, AS SHOWN ON THE LEFT. TOGETHER WITH CMYK THEY MAKE A SIX-COLOUR PROCESS METHOD CALLED HEXACHROME®. THIS BOOK IS ONE OF VERY FEW CONSUMER VOLUMES TO BE PRINTED IN HEXACHROME®; IT WAS AN ESSENTIAL CHOICE FOR THE ACCURATE COLOUR RENDERING OF THE PALETTES AND AN ADDED ADVANTAGE IN THAT IT REPRODUCES VIBRANT PHOTOGRAPHS WELL.

pure colours

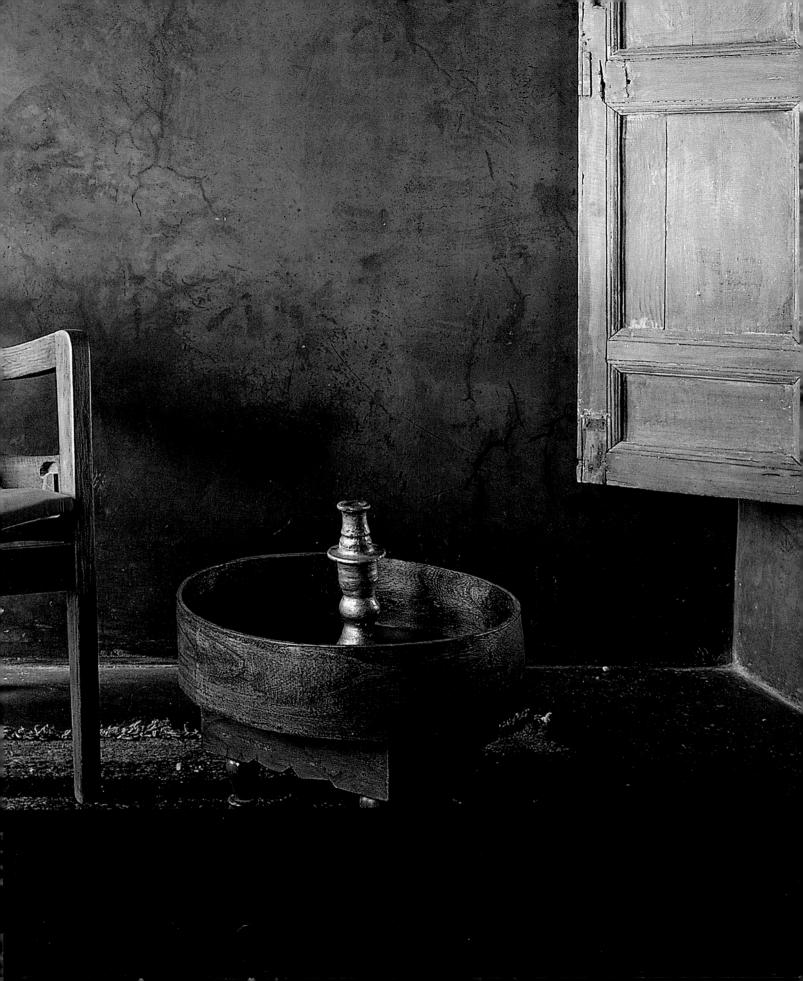

01 yellow

Starting on this page are sixteen groups of colours that sequentially follow each other around the colour wheel, starting with yellow. These are consciously subjective selections: in other words colours I like, chosen for their interest, importance or 'useability'. It's by no means a comprehensive range; that would require an encyclopaedic volume!

The 'colour' palettes are followed by a palette of pale neutral colours, one of greys and one of browns. The layout of the colours is self-explanatory although I have used an unconventional range of hues (see notes to this section in Notes to the Palettes on page 176). The palettes can be divided into sub-groups. You might find that all the colours in one column or row have a family character that can be exploited by using them altogether.

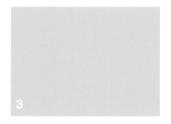

- 1 A rich chrome/cadmium yellow of pure hue. Similar to Chinese yellow the colour of Imperial Chinese robes of all periods. Use with care: this colour wrong light.

 5 Cool, pale primrose yellow. Use with care since this colour can easily appear green under the immediate wrong light.

 9 Adding the colour can easily appear green under the produces advances and together with black suggests danger.
- **2** A good bright mustardy ochre. Very useable, especially with the other colours in this column.
- **3** A clear, cool yellow with a trace of warmth about it. A colour much used on textiles during the First and Second French Empire and a typical yellow of Dresden (Meissen) porcelain.
- 4 If this yellow were any deeper it might cloy. As it is, this warm, sunny tint is approachable and unthreatening. Another yellow found in Chinese robes of all periods. Also similar to Alessandro Mendini's 'Giallo Atelier' and Norman Foster's choice for applied colour at the Commerzbank headquarters in Germany.
- 6 A deeper and slightly greener version of colour 5. Use these two colours with any from the bottom row in this palette. Another Dresden tint.
- 7 Paler than colour 9, a pretty and luminous slightly greenish yellow, the colour of emergent foliage. Use with colours below and to the left.
- 8 This warm buttery almost orange cream is the colour of a good yellow ochre tint, or more accurately, a Naples yellow tint. As such it is unlikely ever to appear greenish under blue-biased daylight, such as that from a north-facing window or from under an overcast sky.

- **9** Adding a small quantity of black to yellow immediately turns it greenish. Adding grey produces approachable 1950s-looking tones like this. Use with any of the colours immediately' surrounding it.
- **10** This is an interestingly ambiguous colour: grey-brown-yellow-green-buff. This combination of personalities must mean that it's versatile and useable.
- **11** Almost grey, a delicate and very unusual tint worth experimenting with, particularly with colours 10 and 12.
- 12 A pale cream that is neutral but with a slightly weird greenish echo: the colour that the moon sometimes takes on. Hence Alessandro Mendini's name for it: 'Giallo Lunare'.

02 yellow-orange

- **1** The kind of deep warm yellow that's tolerable to live with and the colour of the finest yellow ochre.
- **2** The colour of Indian yellow. Bright, clear and warm with none of the cloying quality of colour 3.
- **3** This rich colour is used more or less internationally as a prosaic safety colour (on construction plant, etc). Useful to suggest this idea.
- **4** The colour of lead-tin yellow, a prized synthetic medieval pigment. Deep and more complex than colour 3. Appropriate as an architectural colour.
- **5** A deep ochre with brown in it. Complex, with 'depth' and used underneath gilding.
- **6** A tint of raw sienna, a beautifully warm manila/beige that's a very useable decorating colour,

- especially with pale cream (e.g. colour 16) and as a warm, dusty antiquing colour.
- **7** A very 1950s yellow, warm and dense. Look at it with only the colours below and the three to the left.
- 8 The colour of ripe pineapples, a cheering tint that needs the duller colours on this page. Works best with the yellows in the fourth column on the page opposite.
- **9** A sludge colour, orange-yellow-green-brown. An excellent foil to all the intense yellows of the top row.
- 10 A warmer tint of the colour above it that is a more versatile decorating colour. Suggestive of sand or pale hide. Good with all the colours on the bottom row.
- **11** A vibrant, dense, thick, buttery yellow, a tint of chrome yellow, or the colour of Naples yellow.

- 12 Orange squash in a glass, and so I suppose a refreshing colour. Use as part of a palette comprising only the lower eight of these colours.
- **13** Manila or antique buff, a versatile decorating colour that is an orange-tinged raw sienna tint. Complex and especially good with other colours in this row and the intense colour above it.
- **14** An ochre tint with a hint of lemon: the perfect partner for orange squash (colour 12). Try also with colour 6 and, on the opposite page, colours 2 and 4.
- **15** Sweeter and less muddy than colour 14. A versatile ochre tint that refuses to appear green, even under the most glowering of cloudy skies.
- **16** A paler tint of colour 15 with all the same properties but greater reflectance.

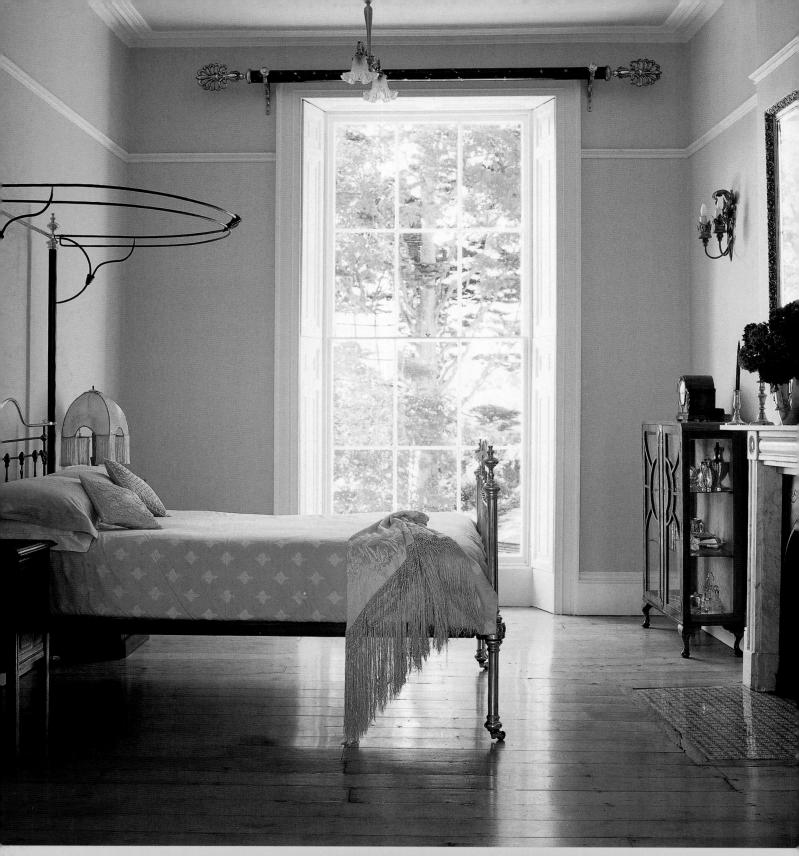

Yellow or yellow-orange are key colours in the following palettes:

- 17 early period colours (17-40)
- 19 1920s colours (1-12 and 17-22)
- 21 colours from 1950s schemes
- 25 1960s furniture colours
- 30 quarry colours
- 31 earth pigments (1-8)
- 36 the colours of pebbles
- 40 silk, cinnabar and oxblood
- 41 gilt-edged, blue-blooded
- 42 fifties vogue

- 47 natural dyes
- 48 archaeological colours
- 49 earthy primaries
- 50 northern light
- 53 brown and blue in a hot climate
- 54 colours for a new white box
- 56 the importance of brown and cream
- 57 a dash of brown to tie it all together
- 58 a little journey across the colour globe
- 59 seen through a fine gauze
- 62 and now, in full glorious colour...
- 64 full-on seaside dazzle

03 orange

- Burnt orange, almost tan. Use as an earthy detail colour with any other colour on this page.
- 2 Bright and warm, the colour of orange squash. Try it as a detail colour with all of the colours in this column.
- 3 Mid-orange hue. Intense and pure.
- Deep, rich and moving towards red, this is a deeper realgar colour, a valued pigment in use in ancient times.
- The colour of orange lacquer, with a brownish bias. A useable key or detail colour with all the colours in this row or below. (Obscure the top row to see how this works.)
- A warm umber brown that actually contains a lot of orange. Very useful because it moves towards a more neutral position and is good with all the

- colours in the lower half of this palette and many of those paler ones opposite.
- A good leather colour and a good earth colour, being that of raw sienna pigment. Look at it with just colours 6, 10 and 11.
- Clean and well-scrubbed flesh pink, slightly brown and very useful.
- A good 'natural' leather colour. Use it with the colour next to it and the other 'earthier' colours here.
- 10 A slight tint of dirty yellow ochre or raw sienna. A very complex, useable colour. Use with the colours above and below and with colours 8 and 11 opposite.
- It looks reddish but it's made primarily with orange and black inks on this page. This is a very

- warm earth colour that can support a lot of the other, less useable colours on this page.
- Rosy flesh colour. Use it with stronger colours if you want to avoid these connotations of the 1970s.
- A less intense version of the colour above, with more yellow in it. Use as a key colour with others in this row, and with colour 10 or 11.
- Variously labelled light donkey or mushroom, a popular cool beige-grey used as a decorating colour.
- 15 Is this beige? I don't know. This colour is still quite intense. Use carefully or choose a lighter version. Good with the other colours in this column.
- A really delicate mix of orange and pale grey. Use with colours from the neutrals or brown palettes.

04 orange-red

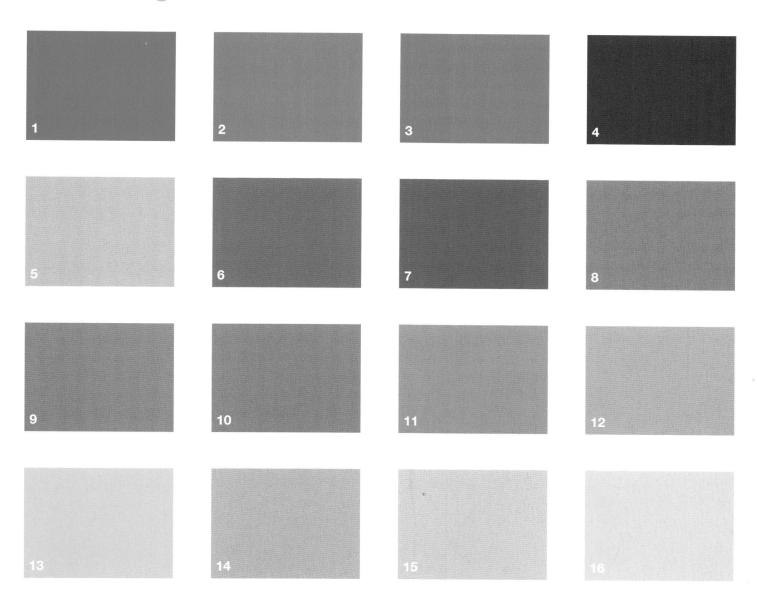

- The colour of red lead pigment that since the fourteenth century has been known as Saturn red.
- A pinker version of colour 1, a near-hue with a similarly dusty quality and equivalent to modern red lead pigment. Use these colours with the brownish reds below.
- This is a colour of many meanings, being that of a version of the ancient pigment vermilion. Much used in Western art and decorative painting and warmer than in its Chinese incarnation.
- A warm brown made with plenty of orange-red. The colour of good-quality haematite (iron oxide) pigment.
- Pale orange buff or flesh tone without any glaring orange glow. Use with any of the colours below.

- A cross between brick red and burnt orange. Intense, advancing, warm and uncompromising.
- A more approachable and muddied version of colour 6, the meeting point of haematite, red lead and vermilion pigments. Similar to BCC 'Brick Red'. Useful for decoration.
- A pretty 'bruised pink' colour that is soft and purplish. Very useable as an indoor paint colour and one that I've used a lot.
- 9, 10, 11 and 12 These red oxide tints are all useable, intense colours each with a different character. Colour 9 is orange-biased, colour 10 is cooler and more purplish. Colour 11 is pinker, a tint of Mars orange. Colour 12 is a lighter tint of colour 9. Roughly they are tonally equivalent and collectively form a base range of colours to which any other on this page can be added.

- 13 This pale plastic pink belongs in an Art Deco interior or on a neoclassical ceiling. It's a tint of red lead. Moderate it with any of the murkier colours opposite. A vibrant colour.
- A tint of colour 8 that is just as useable with an even more pronounced purplish leaning. Good with off-white or any of the colours in the row above.
- 15 A complex pale pinky-beige or warm pale brown. Can be used with off-white, but really comes into its own as a toning colour that can be used to moderate any other colour on this page or that opposite.
- **16** Another Art Deco and neoclassical colour that looks particularly good with olive greens, the murkier colours opposite, with any colour in this column and/or with colour 15.

Orange or orange-red are key colours in the following palettes:

- 17 early period colours (17–40)
- 18 early twentieth-century colours
- 19 1920s colours (1-16)
- 20 colours from 1940s New York (7-10)
- 23 colours from 1960s schemes
- 24 another 1960s scheme
- 25 1960s furniture colours

- 31 earth pigments
- 34 baked clay
- 35 deep water
- 37 the colours of shells
- 39 in the red corner, in the blue corner
- 40 silk, cinnabar and oxblood
- 43 the red and green story, part i: racing green
- 45 the red and green story, part iii:

- Italian punch
- 47 natural dyes
- 48 archaeological colours
- 49 earthy primaries
- 50 northern light
- 52 the innocence of powder blue
- 53 brown and blue in a hot climate
- 54 colours for a new white box
- 55 vegetarian primaries

- 57 a dash of brown to tie it all together
- 62 and now, in glorious full colour...
- 63 weaving the rainbow
- 64 full-on seaside dazzle

05 red

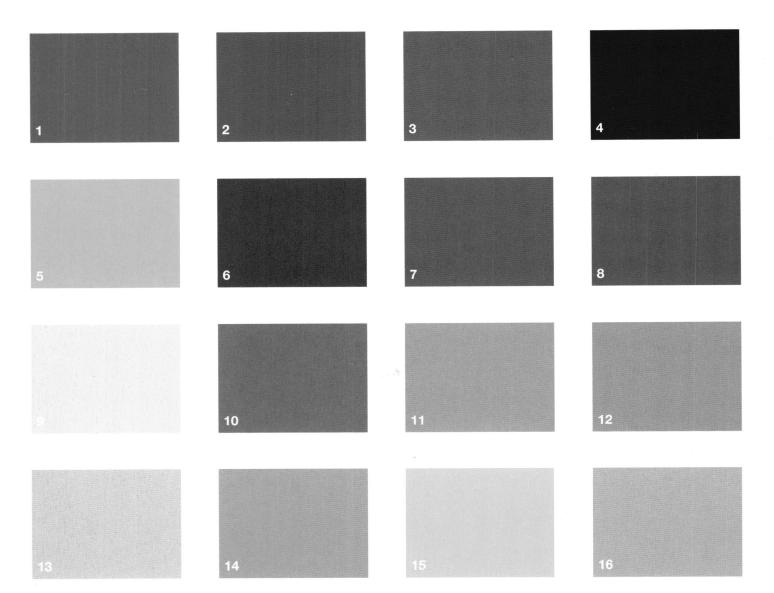

- **1** Bright mid-red hue, equivalent to 'Signal Red', scarlet or pure mid-hue vermilion pigment.
- 2 This printed swatch uses the same inks in the same quantity as colour 1 but with the addition of a black.
- **3** A dusty, slightly pink-red. Useful as a decorating colour and redolent of the colour of Oriental lacquer.
- **4** Adding black to red produces rich browns, which can be modified by adding orange, yellow or green. This is a very useable colour.
- **5** A striking intense tint of colour 1. Slightly synthetic in quality but unusual and arresting.
- 6 An interesting brown. In the right light it can be described almost as red or even as brown-pink. Dusty with a plum-coloured undertone. Very useable.

- 7 A dusty crimson with a slightly pink character.
- **8** A tone of colour 7 made more complex by the addition of brown and grey. Note that the four colours on the top right of this page all make a family.
- **9** An even lighter tint of colour 1. Cooler than its hue, but with the same strawberry character as that above.
- 10 Another intense dusty pink-brown that sits in between the colours above and beneath it: next to it colour 6 appears a straight brown while colour 14 looks innocently pink. Compare these two colours to others around them without referring to colour 10.
- $\bf 11$ A tint of another porcelain colour, 'Delft Rose'. Use with other colours in this column.
- 12 A dense and sombre tone of the bluish reds on

- this side of the page. A key moderating colour to use with the stronger pinks and reds. Complex and useful.
- 13 Its reddish tinge makes this a key moderating colour for this palette, in particular for this column and in combination with other colours on this page, where it will look beige. However, it appears almost pink when viewed in isolation, so use with care.
- **14** A pink the colour of red dusty earth and a key colour in this column of four. Again, it looks very different when viewed in isolation.
- **15** A more intense and slightly less innocent pink than colour 9, also slightly cooler. Very good when used together with the other three colours in this row.
- **16** A cleaner and even more bluish tint of colour 12, that is very useable.

06 red-violet

- 1 Warm reddish magenta, the colour of the brightest cloths dyed with madder root and similar to rose madder pigment. Also known as 'Carmine' and as 'Carmin Cramoisi' (Repertoire), and as 'Tyrian Rose' (Ridgway) from its supposed likeness to the finer light colours produced by dyeing cloth with the purple dye from the murex shellfish. These names suggest a colour that has been prized and sought after for centuries. It is an extraordinary colour.
- 2 Often called 'Pourpre de Tyr' (Repertoire) or 'Tyrian Purple', this colour is supposedly the deepest hue attainable from murex dye. It is also Pantone® 'Rubine Red', a deep and powerful hue, half-purple, half-pink and like its neighbours, bewitching.
- **3** Magenta (or fuchsine), the colour of an aniline dye named after the Battle of Magenta in 1859 and as it appears as one of the three modern process

- colours used for printing in colour. Unforgiving and totally uncompromising, as vivid a hue as you can expect to see. Use with extreme caution.
- **4** A complex deep purplish plum, a shade of colour 2. Use in place of colours 1 and 3 with any other colours in the palette for much subtler combinations. Especially good with colours in the two right-hand columns of this palette.
- **5** Another shade of colour 2, colder and harder. Soften it with any colour in the right half of this page.
- **6** Mauve, and not the delicate (actually faded) tint that we think of, but the colour of the brilliant dye invented in 1856 by William Henry Perkins. It was the first of the somewhat fugitive coal-tar (aniline) dyes and was quickly adopted as the fashionable

- colour for dress fabrics, giving rise to the 'Mauve Decade'. Overdue for revival.
- **7** A more plum-coloured, blue-tinged version of colour 5. A key colour in this palette that can be used with any other in isolation or as part of a group.
- 8 Warm intense pink but with plenty of magenta in it. Actually a slightly shaded tint of colour 1 with which it works well. Try it also as part of a group made up of colours from this column only.
- 9, 10, 11, 12, 13, 14, 15 and 16 These are a group of pinks of varying degrees of bluish coolness. Their collective character is of the 1930s and '40s and used together their differing characters are subdued under the general identity of one palette. Colours 11 and 12 are particularly complex and can be used well together, while colour 14 is also quite subtle.

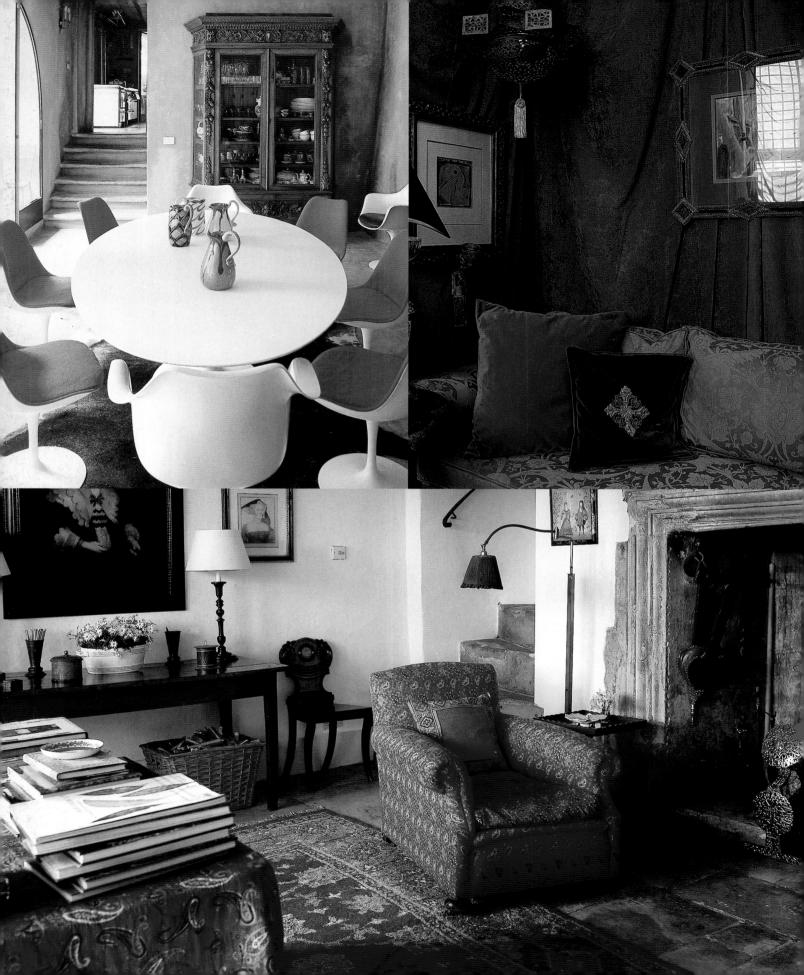

07 violet

- 1 The colour of cobalt violet pigment (cobalt phosphate) and a name in use since 1859. A vibrant purple infused with magenta that works with other colours in this row or those in this column.
- 2 Reddish purple, again a colour that vibrates and is tinged with magenta. Use with any other colour in this palette. The colour of mineral, or manganese, violet.
- **3** Purple, if such a thing exists without any obvious blue or magenta content. Very close to spectrum violet. More particular than colour 2 as to which colour it likes to keep company with.
- 4 Purple often occurs in this book as a pivotal colour in a palette, especially when muted with either grey or brown or both. When shaded or toned in this way, purple can take on a brooding, bruised look but also an interesting, complex quality.

This colour and colour 12 illustrate just how pleasingly ambiguous purple can be.

- **5** Purple-grey: a name which is frankly off-putting but a colour which is not. Intense and useable, especially in complex palettes of many colours.
- **6** Deep lilac, uncomplicated and direct. Use it with any combination of colours from this row and below.
- **7** An attractive bluish purple tint that hovers between being intense and dusty. A tint of a colour associated for several centuries with the Dauphin of France.
- **8, 9 and 10** are all lilac tints of varying degrees of purity. Colour 10 is the most complex.
- **11** Deep lavender blue, a colour right on the cusp of purple and blue and one that will

- consequently change character according to prevailing lighting conditions.
- **12** A cool neutral that is very useable on its own but also with any other colour here. Subtle.
- **13** Another lilac colour, slightly bluer than colour 10 and more complex.
- **14** Even more grey than colour 13. A good and unusual decorating colour and another useful half-neutral colour that will work with any other here.
- 15 Powdery lavender blue-violet.
- **16** Palest grey-lilac. Try it as part of just this column of colours, or as part of just this row, or as part of just the lower half of this palette.

08 violet-blue

- 1 A good clean and bright red-tinged violet, a colour that appears vivid under sunlight and heavy and brooding indoors.
- 2 Deeper than colour 1, the colour of ultramarine blue pigment. A colour of great depth and purity.
- **3** A lighter and less purple ultramarine hue, closer to the architectural detail colour used in Greece, etc.
- **4** A colour of indigo-dyed cotton. An intense but useable and almost hypnotic tone of violet-blue. Use as a key colour with any other here, particularly colours from this row and below.
- 5 Warm, greyed violet. The colour to use indoors if colour 1 appeals. All the colours in this and the lower rows on both pages have been partly chosen for their 'aerial' qualities (i.e. their suggestiveness of sky or air).

- **6** A warm pretty tint of a reddish ultramarine blue. An intense colour, the zenith of an evening blue sky.
- **7** A more assertive and vibrant version of colour 8 with more of the interest of colour 4.
- 8 Another indigo or woad colour.
- **9** A tint of colour 5. Less brooding and complex and a little perkier.
- ${\bf 10}$ A more useable tint of the colour above it, complex and warm. Perhaps the most versatile colour here.
- **11** A tint of colour 7 with plenty of airy depth to it. Sufficiently greyed to make it interesting.
- 12 This delicate greyish-brown purple and the colour below it almost belong in the next palette

but for the fact they are slightly too warm. A useable decorating colour that is very complex and satisfying to look at.

- 13 This colour connects back to purple. It's a clever mix of grey and bluish violet that evidently makes a successful architectural colour since Norman Foster chose it for his Research Centre at Stamford.
- **14** A pretty powdery tint of the colour above. Like colour 10, it is saved from tweeness by the grey.
- 15 About as pale (and still warm-looking) as blue can go without appearing grey. A pretty colour but with a bit of sobriety.
- **16** Bluish pale lilac with a cool atmospheric 'aerial' quality. Delicate and sophisticated.

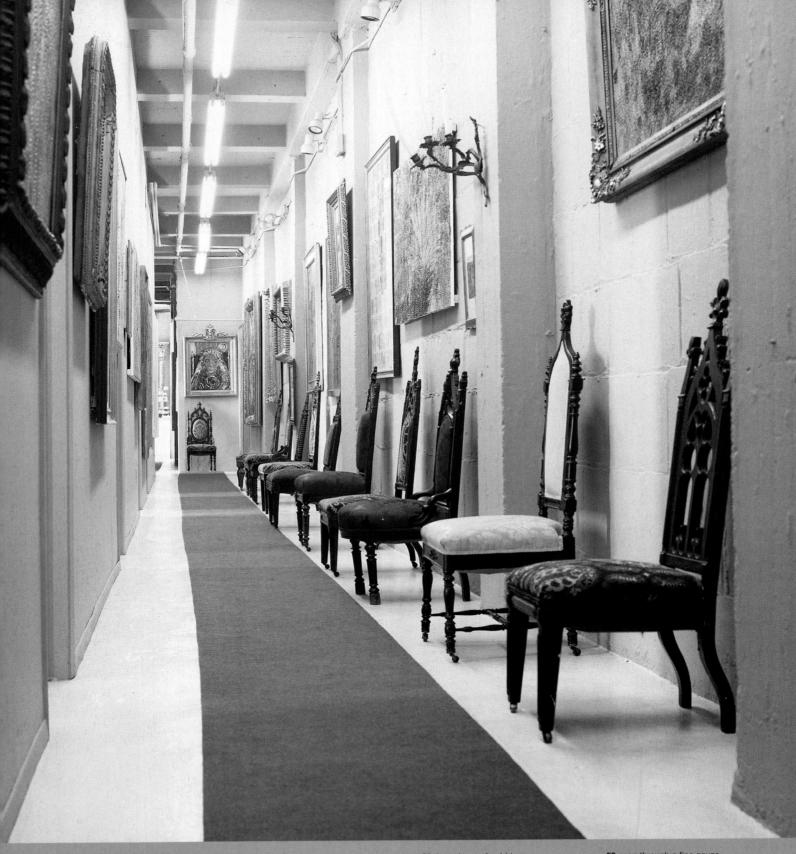

Violet and violet-blue are key colours in the following palettes:

- **19** 1920s colours (1–12)
- 20 colours from 1940s New York
- 23 colours from 1960s schemes
- 26 haze
- 27 a Norse legend
- 29 field and forest
- 31 earth pigments (9-24)
- 35 deep water

- 36 the colours of pebbles
- 51 chocolate ice-cream sundae
- 52 the innocence of powder blue

57 a dash of brown to tie it all together

- 54 colours for a new white box
- 59 seen through a fine gauze
- 60 blue adventure
- 61 an aniline trip on class A colours
- 62 and now, in glorious full colour...
- 63 weaving the rainbow

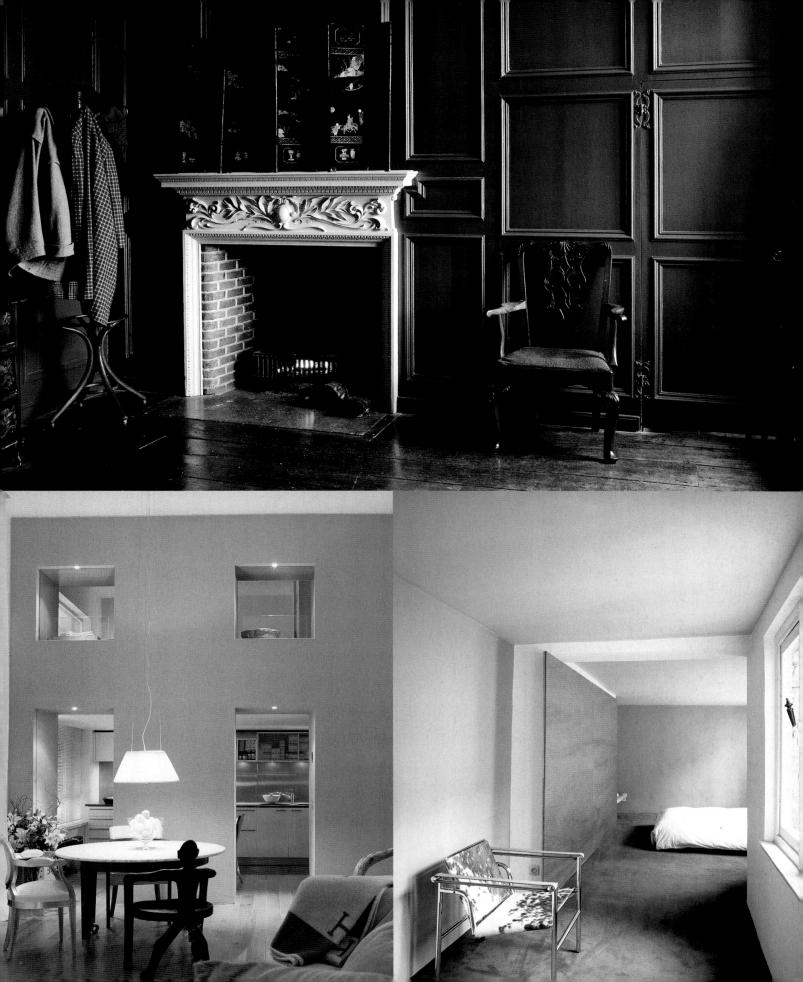

09 blue

- **1** A deep, velvety and powerful blue, invasive indoors but an assertive and fashionable colour outdoors.
- 2 A colour of cobalt blue pigment, mid-blue with no bias to red or green. A magical and under-used hue of great purity, redolent of the deepest summer skies.
- 3 A slight shade of colour 2, cooler and less strident.
- 4 This blue is deeply shaded, restrained and a little ambiguous. It finds a lot of exterior uses as a sort of 'soft black': it's therefore good on front doors. Try it against the cooler colours on the page opposite.
- **5** An intense milky tint. Red-tinged, this colour neither advances nor recedes, but hovers atmospherically.
- **6** A pure cobalt tint, as refreshing as its hue, above, but more useable and more suggestive of the sky's

- zenith. Try it with all or some of the colours below.
- 7 This blue veers towards cyan: it is cool and powerful. Fresh and bright when used as a detail colour with others in this column.
- 8 A pale tint of the colour above, this is a pleasing warm grey-blue that can be used as a background to any colour on this page. A good decorating colour.
- **9** An intense milky violet-blue that has a slightly cloying quality because unlike cooler pale blues, it does not appear to recede. A luxurious colour.
- 10 A good deep sky blue with great optical depth. Suggestive of open space. Note how all the colours in this lower half of the page have an 'aerial' quality.
- 11 Bright dusty mid-hue blue, a tint of cobalt and an

ingenuous and clean blue for it.

- 12 A tint of ultramarine blue. An exquisite decorating colour with depth and character. Any colour in this row has a good relationship with the violet-blues in the preceding palette.
- **13** Delicate, cool and pale. Use with all of the other colours in this row.
- **14** Another innocent blue, but cleaner and much paler than colour 11. Very elegant.
- **15** A smokier version of colour 14 with a harder edge and so more complex. Good indoors.
- **16** Pale, greyed and slightly violet, this blue is a good background colour with any combination of colours from this column, this row, or the preceding palette.

10 cyan

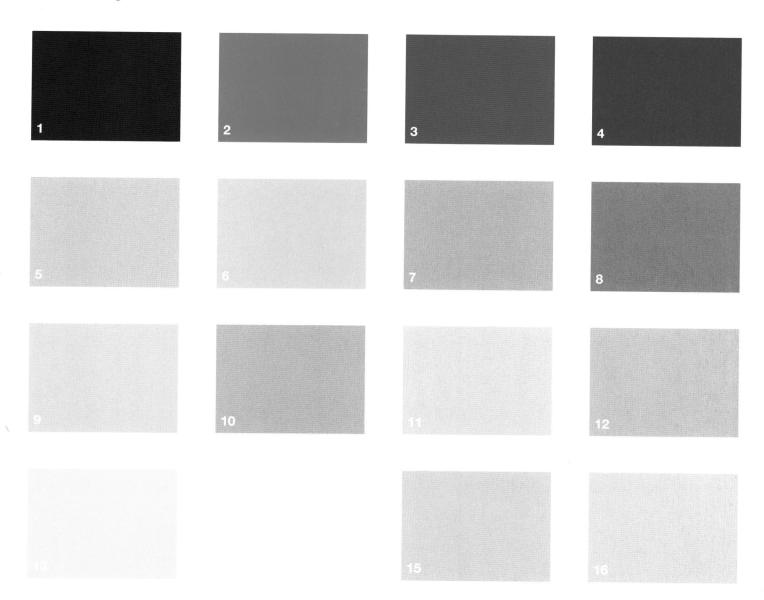

- 1 This deep marine blue is a good foil for most of the colours on this page or with deep greens. The colour of impure azurite.
- 2 This colour is cyan, a modern printing colour in full-colour lithography and a vivid, uncompromising hue. That is because, like magenta and yellow, it is an optical secondary colour, produced by the stimulation of two out of the eye's three groups of colour receptors.
- **3** Deep porcelain blue, redolent of Middle Eastern and Oriental ceramics and more complex than colour 2. Should be used more, especially outside.
- **4** Adding black to colour 3 produces a harder, inky petrol shade, popular last in the 1960s as a car colour.
- 5 A cool blue-grey that unlike the other tints on this

- page has no green in it. Very versatile with colours on this page and opposite and with pale ochres and other earth colours.
- 6 Not an easy colour to live with, but loud and clear. Surround it with other subtler blues, as here, to good effect.
- 7, 11 and 15 Here are three tinted tones of a delicate blue-green-grey: complex and ambiguous colours that will all subtly change character according to the prevailing lighting. They are cusp colours on the edge of blue/green that defy our colour memory the brain's powers of self-persuasion and look different under direct sun, cloud, or tungsten lighting. Colour 11 is cleaner and slightly more green.
- 8 This is a more acceptable and less sulky tint of

- colour 4 above. Like the colours beneath, an interesting tone that can be used as a detail colour with any of the colours in this row and below.
- 9 and 13 Two tints of a clean greenish blue that are very useable and important in 'lifting' the character of the lower half of this palette. Colour 13 is of unimpeachable delicacy: it is the colour of my kitchen.
- 10 For a dirty tint, this colour still hums. It looks like a ceramic colour or something from the eighteenth century. Strong but useable.
- 12 and 16 The most watery, glass-like colours on this page. Colour 16 is particularly useable for decoration, while colour 12 is slightly harder and better suited as the controlling partner to colour 8.
- 14 Pale duck egg blue. Delicate and slightly icy.

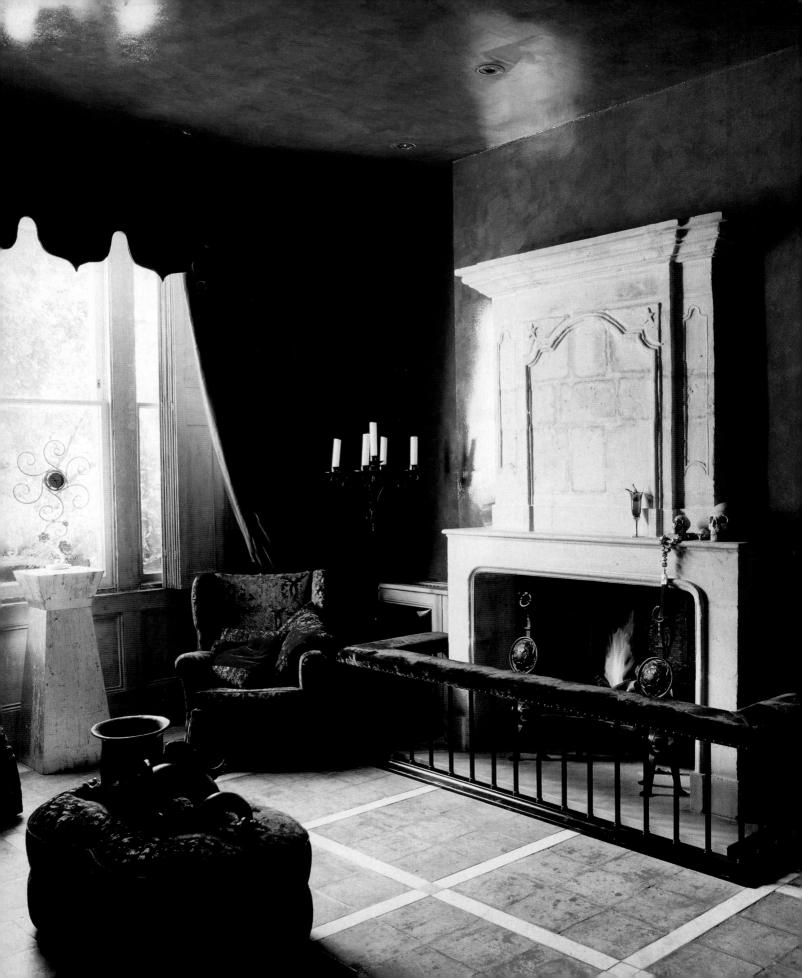

11 turquoise

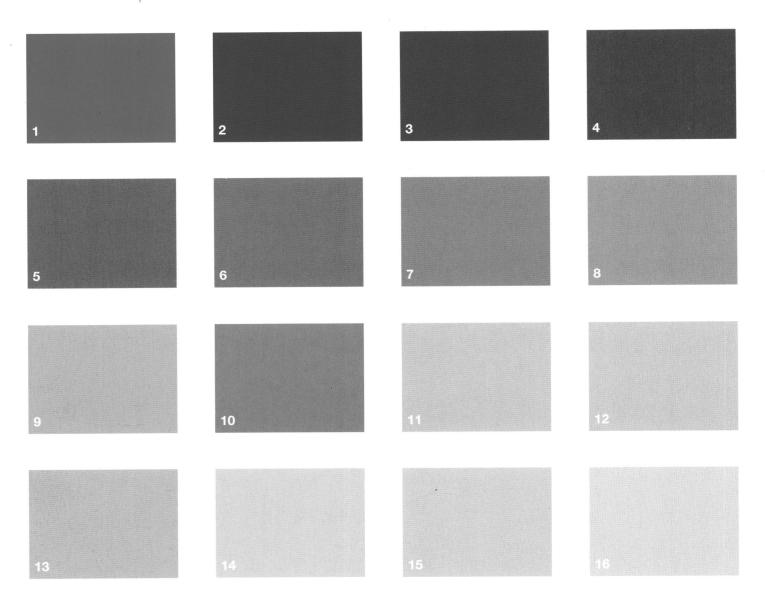

- **1** Turquoise blue. Use as a detail colour with any other on the left-hand side of the page.
- **2** As turquoise moves towards green so it appears darker. Use with any colour from the lower three rows.
- **3** A hard bluish green. Use as a detail colour against any of the bluer tints, left, to soften its synthetic quality.
- **4** A deep foliage colour. Less synthetic than colour 3. Like many of these colours, suggestive of the sea.
- **5** Petrol-blue, a greyed tone of turquoise, and more useable as a result, although lacking in immediacy. A powerful colour with a brooding aquatic quality.
- 6 Jade. More useable and delicate than colour 5, veering towards green. It has a dusty appearance, particularly when used with the colours in the top row.

- **7** Use this as the dominant colour in a palette consisting of this row alone.
- 8 This deep and ambiguous blue-grey-green is a cusp colour: it changes character under different lighting conditions. Use as the dominant colour with others from this row.
- **9** A hard, cool and slightly synthetic turquoise tint. A clean and invigorating colour.
- 10 A pseudo-historical, slightly brownish tone that will work very well with any colour on this page and 'root' any mixture of them. A complex and deep colour.
- 11 A delicate and subtle 1920s-flavoured green with a clean mint colour. Use with any of the colours in the right-hand column to invigorate them.

- **12** A tint of colour 8 and more useable for it. Use as a core or dominant colour with any of the others on this page. A cusp colour.
- **13** A highly versatile and brown-tinged pale turquoise that is slightly ambiguous and soft in its effect. Use with any of the colours on the lower half of this page.
- **14** A tint of the colour above, this is a delicate but not washed-out pale grey-blue with a hint of green. Ambiguous and a good partner for the colour to its right and with any in the right-hand column.
- **15** A cooler mint green than colour 7 and subtler too. Use with the right-hand column and the bottom row.
- 16 Subtle, washed out and atmospheric, this is the colour of grey sea. When used with more intense colours it will appear grey and hazy.

12 green

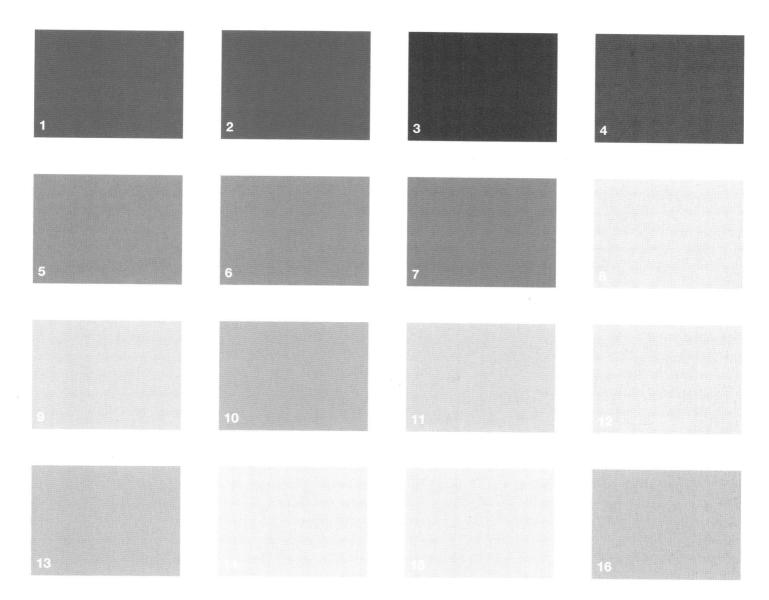

- **1** A slightly bluish emerald green with a synthetic quality. Use in small quantities with any colour on the opposite page.
- **2** A pure and vivid hue green, corresponding to the pigment emerald-green.
- 3 This deep green contains enough black to render it approachable. But it retains the vivacity of the hue.
- **4** Deep and toned, this bronze green is good outside. The colour of terre verte or chrome oxide pigment.
- **5** The most complex colour on this page, an almost sea green. Good with the two colours beneath.
- **6** A more vivid version of colour 5, dense and appealing. Its bluish cast suggests an almost synthetic quality, yet it is the colour of deepest verdigris.

- **7** A dusty tint of colour 3, suggestive of grass. This is a useable, reasonably intense green that will accommodate other intense colours such as orange and red, because of its grey content.
- 8 A light eau de nil, so named because the Nile's water is this colour. Another restrained, milky colour.
- **9** A colour right on the edge of blue and green and so a cusp colour that will respond to changes in light colour. A key colour for combining with any number of the paler examples on this page.
- 10 A good mid-verdigris colour, bright and clear, suggestive of 1820s and 1920s Oriental interiors.
- **11** A pale and ambiguous bronze green with character. Another good decorating colour, the colour of a terre verte tint.

- **12** An extremely subtle milky tint that is almost grey. Understated and refined.
- 13 A chalky pale verdigris, bluish and toned with grey. This is a very useable colour, which is similar to many 'historic' or 'Scandinavian' greens. A cusp colour.
- **14** A greener and lighter version of colour 12. A subtle green-blue that works well on walls. A cusp colour and a very flexible ground colour for many other colour combinations.
- **15** Delicate and slightly yellowish, a good 1920s pale peapod colour.
- 16 A warm green-grey (warm because of the small amount of yellow present). Very useable because of its depth and ambiguity.

19 1920s colours (13–16)

20 colours from 1940s New York

27 a Norse legend

28 seascape

29 field and forest

31 earth pigments (9-24)

32 the lost colours of the Kalahari

33 colours obscured by age

35 deep water

38 water and air: Oriental elements

43 the red and green story, part i: racing green

44 the red and green story, part ii: English chintz

45 the red and green story, part iii: Italian punch

46 the red and green story, part iv: French pinks

47 natural dyes

50 northern light

53 brown and blue in a hot climate

56 the importance of brown and cream

58 a little journey across the colour globe

59 seen through a fine gauze

60 blue adventure

62 and now, in glorious full colour...

63 weaving the rainbow

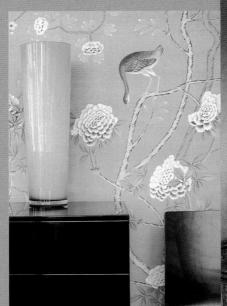

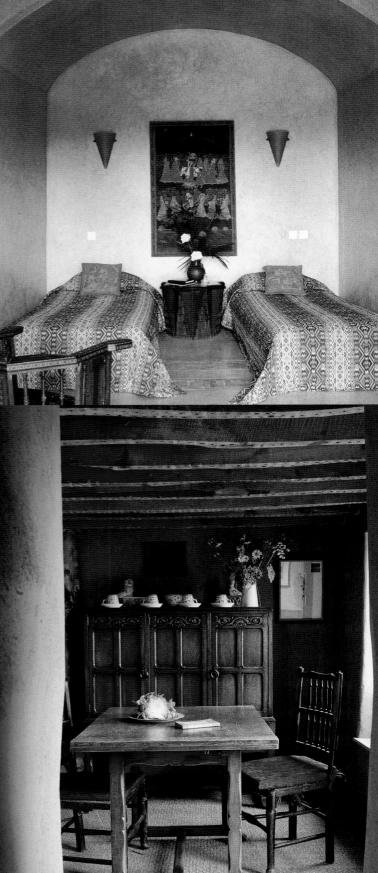

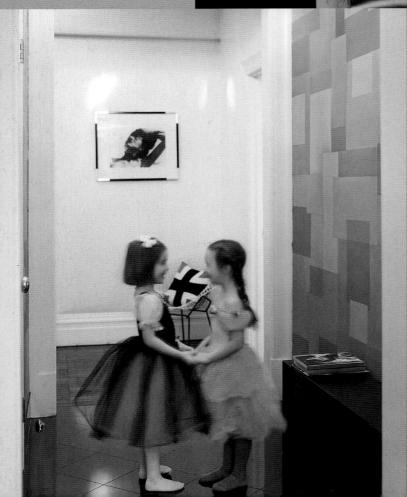

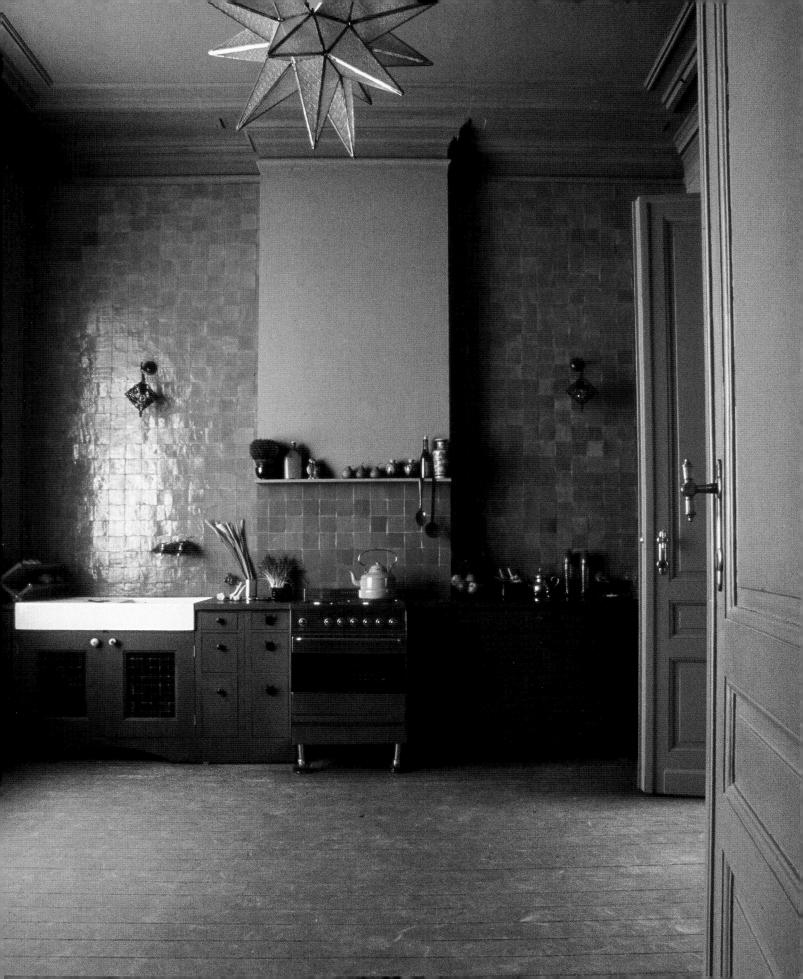

13 green-yellow

- **1** This vivid hue is as clear and bright as green gets before it becomes obviously yellow-biased.
- **2** Another good grass or foliage green, particularly good with the paler colours, below right.
- **3** A clever way of using lime green is to moderate it by darkening but not to the point where it turns dull. This shade is often employed in commercial fabric dyeing and printing because of its useability.
- **4** Moss colour, or bright olive. Appears almost brown when placed with bright greens and so can be used to moderate a scheme that uses them.
- **5** This is an interesting colour because it seems to be slightly veiled with blue despite containing a large quantity of yellow. A key colour when used with the surrounding brighter colours.

- **6** Hovering between lime green and green, this is the colour of spring foliage. Use with all the colours surrounding it or more specifically with only the colours in this column.
- 7 This is lime green at pretty well its most intense (although fluorescing versions appear brighter). A popular decorating colour during the late 1990s.
- 8 This is a tint of colour 4 and is much more cheerful, complex and useable. Use it with brighter greens such as colours 2, 3 and 7.
- **9** The bright colour of wool dyed with woad (blue) and then overdyed with weld (yellow) to produce green.
- 10 A very useable and subtle green that retains some intensity. Use it as a key colour among a palette of neutrals such as those below.

- **11** Almost creamy grey, this ambiguous green is a flexible decorating colour. Use with off-white and any other colours from this muted section of the palette.
- **12** A light olive colour with a real period feel. Use with the colours to the left and below.
- **13** A popular early twentieth-century colour, another muddy tint that can be called eau de nil.
- **14** A very clear and assertive 1920s colour. Use with the stronger colours, above and to the left and right, to control it.
- 15 Bluer version of colour 14 and even more useable.
- **16** Greenish greys have a fresh but still antique character. They work best with 'natural'-coloured contemporary schemes.

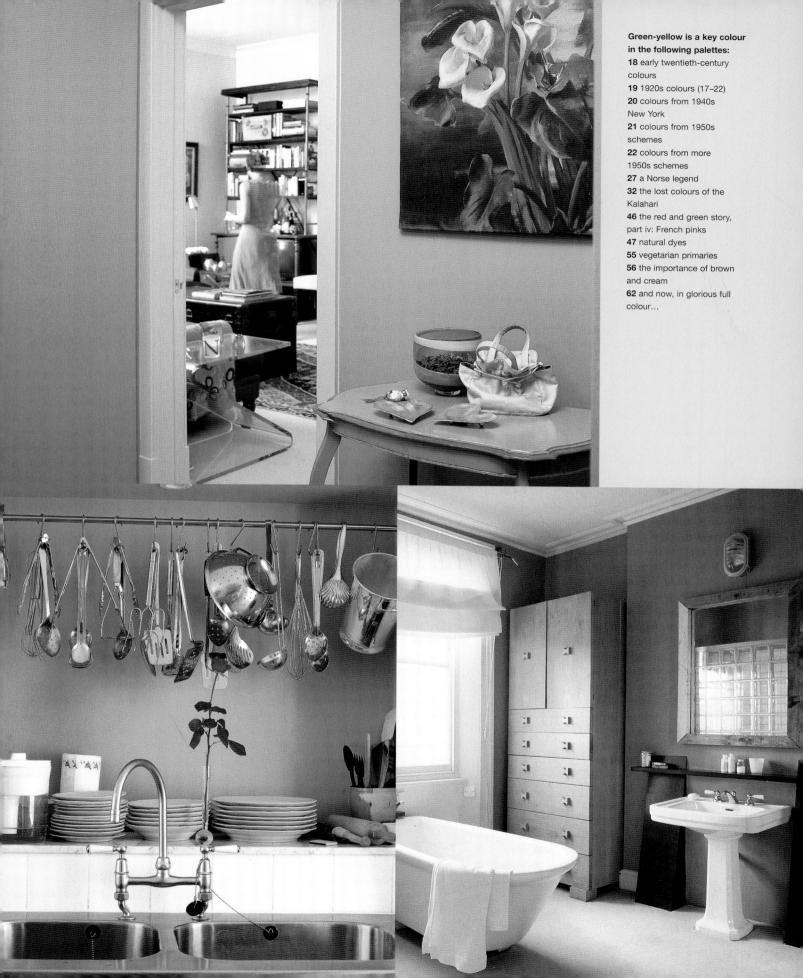

14 grey

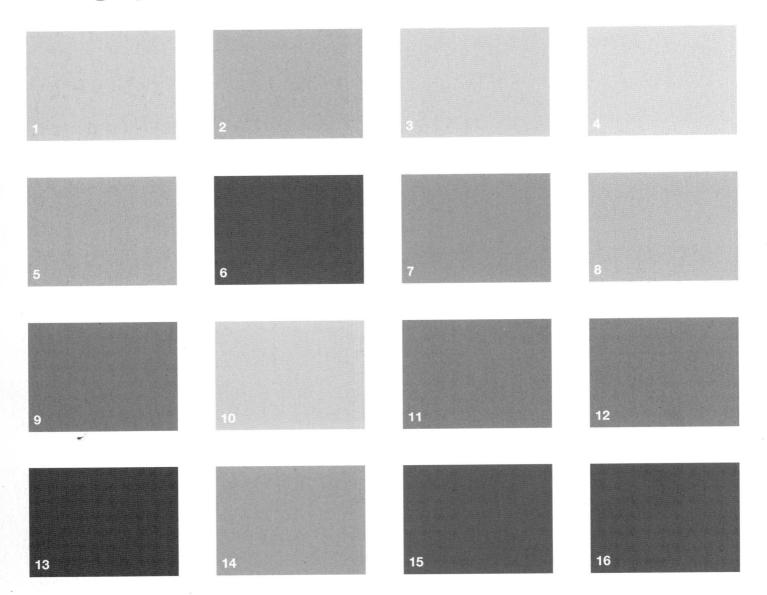

ou may not think so, but grey is a very useful colour, especially as an additive to other more intense shades. This is particularly true in decorating. Try mixing your own paint colours and you will inevitably, in the end, have to add a little grey, simply in order to render the colour softer and more lively. This simulates adding some of a colour's complementary, a time-honoured artist's technique for livening up a colour so that it appears less synthetic.

- 1, 5, 9 and 13 The four colours in the first column are made just by printing varying intensities of black ink. The greys they make depend obviously on the colour of the paper used for this book, but generally these are neutral: neither warm nor cool. Mixing white with black pigment (especially vegetable carbon) produces bluish tints; so blue in fact that an eighteenth-century method for pale blue was to add vine black to white distemper. In comparison, colour 13 looks positively warm, the kind of deep battleship grey adopted in World War I.
- 2 and 6 These are other tints of black, but colour 6 has some blue in it. This smoky colour was used by Sir Norman Foster to paint the Century Tower in Tokyo.
- 3, 7, 10, 11, 14 and 15 Colours 10 and 14 are both tinged with green, giving these greys an austere character, whereas colours 3, 7, 11 and 15 (the third column) are all coloured with warm red. The resulting deep tone (colour 15) is almost brown but with a suedy dustiness. Colour 11 still looks brown, but the two tints (colours 3 and 7) have a truly ambiguous character: warm grey in some lights, fawn in others.
- 4, 8, 12 and 16 The final column contains brownish greys made with raw umber and white. Colour 12 is perhaps the most beautiful colour on this page and a versatile decorating colour. Colours 4 and 8 are excellent off- and dirty whites for use in period decoration. Never underestimate how white these can appear when in the company of other more intense colours.

15 brown

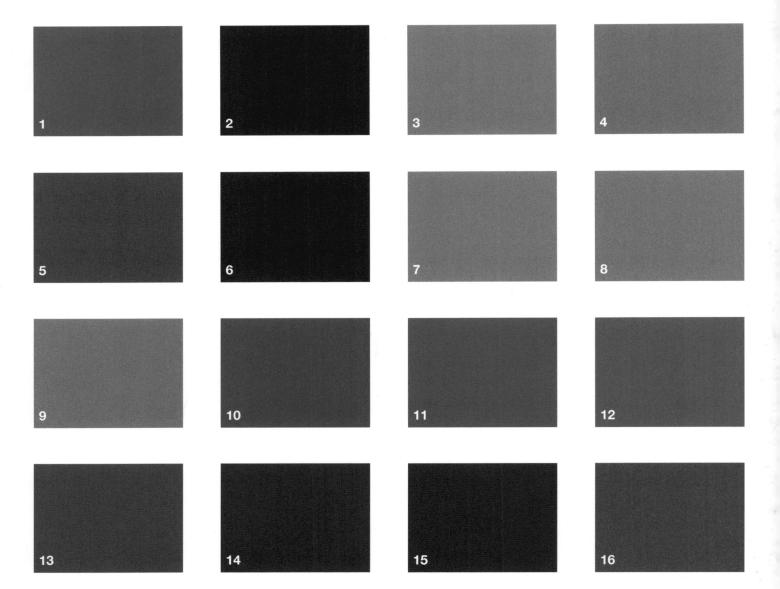

f adding grey softens a colour, adding brown renders it even more supple and muddy. Each brown has a bias: to red, green, orange, yellow. The most resolute colours are those with a red or green content. The most interesting are those with a joint orange and yellow bias.

- 1 Tan: half-brown and half-orange. Oriental in origin.
- 2 The purplish hue of deep red oxide.
- **3** A clear tint of burnt sienna. A beautiful deep plaster pink.

- **4** This purplish brown yields beautiful, ambiguous tints when mixed with white or grey. Even when this intense it has a dusty subtlety.
- **5** An interesting brown: apparently cool, it is made with pink, orange and some olive green. A clever mix.
- **6** The colour of rich red ochre, a hue which will yield subtle strawberry pinks when mixed with white.
- **7** Use this warm donkey brown with colour 5. Subtle and mature, it makes a good decorating colour.
- **8** A tint of colour 11, with more yellow in it. Another powerful but good decorating colour.
- 9 A hot deep ochre or raw sienna.
- 10 A beautiful brick red.

- 11 Light raw umber, greenish and dry-looking. Perhaps the most versatile brown for adding to other colours, for tinting white and for use in glazes and waxes.
- **12** A pretty pale cocoa or chestnut, not unrelated to colours 5 and 7 with which it works very well.
- 13 A yellow-orange brown, like deep raw sienna. Good with orange and green.
- **14** Cooler than colour 6, more like burnt sienna and so good with colour 3. Another ancient pigment based on iron oxide.
- **15** Deep raw umber, very greenish and almost khaki green or olive.
- **16** Another complex brown, made with yellow and orange but with a cool cast. Powerful.

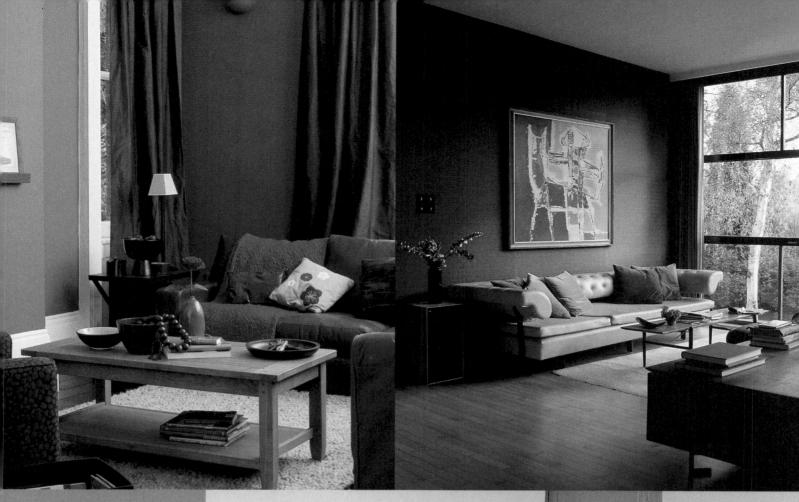

Brown is a key colour in the following palettes:

- 17 early period colours (17-40)
- 18 early twentieth-century colours
- 19 1920s colours (1-12)
- 29 field and forest
- 30 quarry colours
- 31 earth pigments (9–24)
- 32 the lost colours of the Kalahari
- 33 colours obscured by age
- 34 baked clay
- 37 the colours of shells
- 38 water and air: Oriental elements
- 40 silk, cinnabar and oxblood
- 50 northern light
- 51 chocolate ice-cream sundae
- 54 colours for a new white box
- 55 vegetarian primaries
- 56 the importance of brown and cream

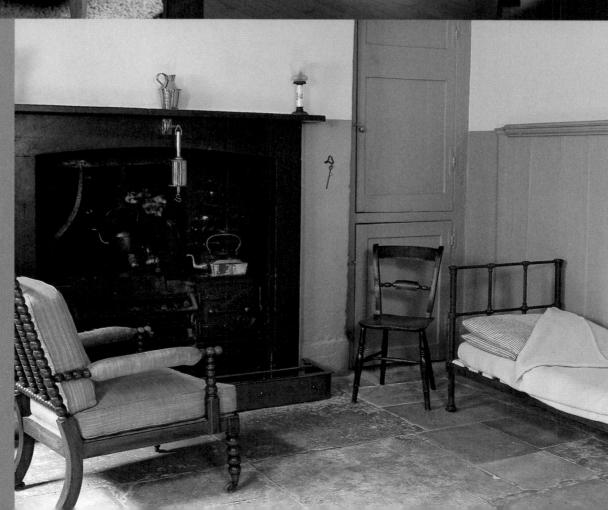

16 neutral

palette of 'neutrals' might strike you as irrelevant and already out of date, but in fact these colours are often the hardest colours to get right. The problem comes in producing a colour that is truly neutral, and that depends on the right choice of pigments: ones that have a broad earthiness about them. Given that most interiors and other human environments are composed of a fair proportion of grey-brown shadow, and given that we light our spaces with predominantly warm light and that we furnish them with many natural warm-coloured materials (stone, wood, skin, even cement), it follows that neutral colours in such a setting often need to be warm. This very useful palette represents mixes of ancient earth pigments such as raw and burnt umber and raw sienna. The colours are indispensable.

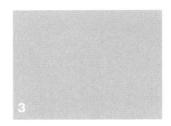

- **1** This delicate pale beige is a good wall colour. It's warm and parchment-like.
- 2 This deep and sandy beige is a complex warm colour. Good for intimate spaces because it advances. Also good as a warm 'antiquing' colour when used as a wash or glaze on furniture etc.
- **3** A cooler colour than 1, 2 or 4. An excellent warm off-white to use with deep or rich reds and browns.
- **4** Mid-beige, halfway between colours 1 and 2. A clean and useable wall colour with sandy undertones.

- **5** An excellent 'dirty' off-white. Good for 'historic' interiors. Has an umber cast.
- **6** A warmer off-white than colour 5, with a purplish cast. Good with deep warm colour schemes.
- **7** Warm umber grey. An excellent 'antiquing' colour, being suggestive of dust.
- 8 A cool umber grey, suggestive of dark concrete. Excellent on walls and powerful.
- **9** The most delicate off-white here (printing limitations prevent the accurate reproduction

- of really pale colours), warm and slightly old-looking.
- **10** Between the dirtiest of whites and umber grey. A very useable wall colour, but perhaps less appealing if you decide to call it 'mushroom'.
- 11 Cooler than colour 7, an excellent grey made with white and raw umber not black. Consequently very approachable, sophisticated and useable. A colour of concrete.
- 12 A deep tint of umber, redolent, like many swatches on this page, of suede, stone or fur. This is a colour with luxurious connotations.

Neutral tints are key colours in the following palettes:

17 early period colours (17–40)

20 colours from 1940s New York

27 a Norse legend

31 earth pigments (9-24)

32 the lost colours of the Kalahari

36 the colours of pebbles

37 the colours of shells

38 water and air: Oriental elements

44 the red and green story, part ii: English chintz

50 northern light

53 brown and blue in a hot climate

59 seen through a fine gauze

period colours

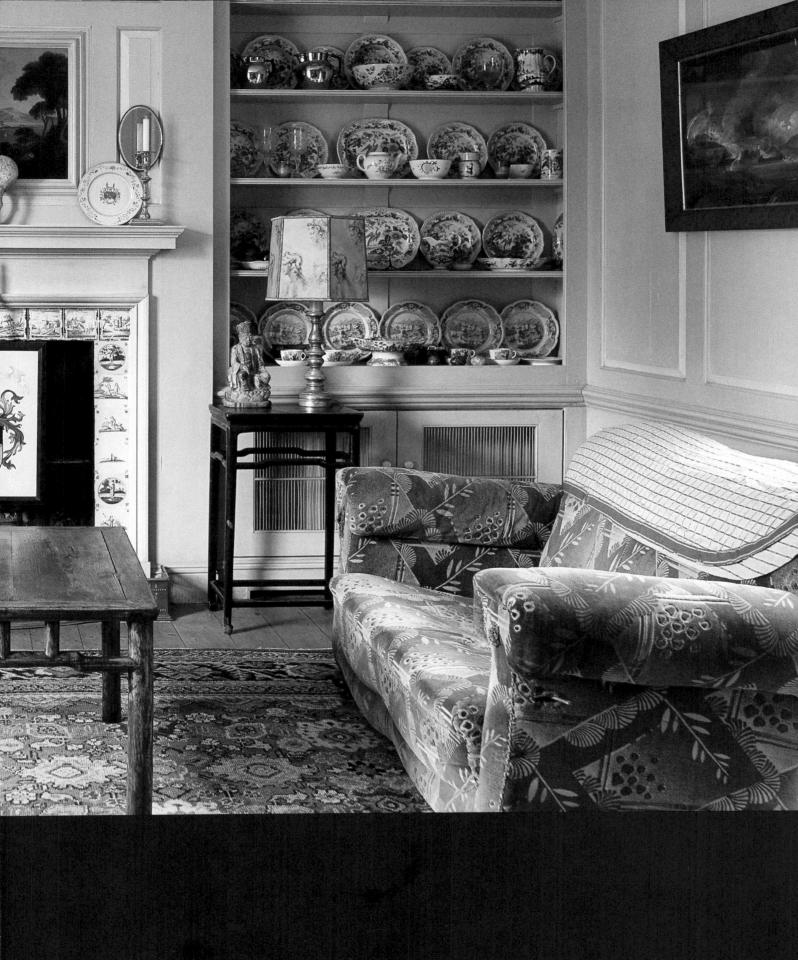

17 early period colours

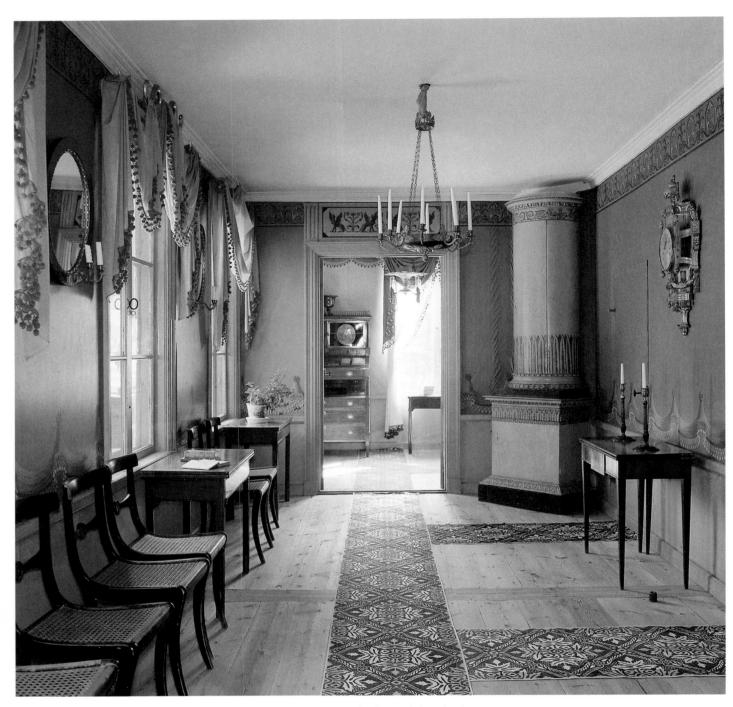

ABOVE: Skansen is a museum village in Sweden in which houses and cottages of various periods and styles have been brought from all over the country, including this interior, which is an essay in the art of painting with green. Note how yellowish and bluish greens are combined.

1 A deep green, almost black, that was famously employed in the eighteenth century for painting railings and fences, hence its name: 'Railing Green'. The colour is lost against shaded foliage.

Many of these colours are bluish greens; in fact, it is interesting how fresh these colours seem and how few greens of the period had any noticeable yellowish glare.

- 2 A warm muddy green with plenty of period overtones. A cooler version of it has been found on woodwork at Trinity Church, Newport, Rhode Island, made from Prussian blue, verdigris and white lead.
- 3 Described as 'Mineral Green', a name often associated with the mineral pigment malachite. However, the colour probably came from a processed copper chloride or Brunswick green.
- **4** A greyer tint of colour 2 and a more delicately 'antiqued' colour. Complex and very useable.
- **5** Was in use throughout Europe. It's a useable, warm green made with yellow ochre.
- **6** A tint of a pigment known as 'Green Verditer' (which was much more readily manufactured than its blue version see over). A deep minty green.
- 7 Commonly known as 'Pea Green', this is similar to a woodwork colour at the William Trent House (1719) in Trenton, New Jersey.
- **8** A tint of colour 6, this is a clean and pure colour of great luminosity. Redolent of 1930s, 1830s and 1730s interiors.

h, the endless trauma of getting the right period colour that doesn't make your house look like a museum. How do you do it? Firstly by dispelling a myth. The popular view of historical colours (fuelled in most cases by visits to old buildings and from looking at paintings of period interiors) is that in the past interior decoration was dull, dirty and intolerably gloomy.

This perception comes mainly from the way in which many paints deteriorate and discolour with age and partly because of the burgeoning number of 'dirty', supposedly historical, paint ranges around.

The truth is somewhat different. Our forebears loved colour, although only those who could afford it bought bright colours, a fact which underlines how expensive bright pigments were until the late nineteenth century and how class-related colour schemes were.

This palette of forty colours, all authenticated and researched by the colourist and historian Patrick Baty, contains several popular 'common' colours made from cheap pigments and a considerable number of mid-price colours, all from the eighteenth and early nineteenth centuries. Many of these colours were used across Europe and the United States; many are earlier; many are still popular today.

17 early period colours

- 9, 10, 11 and 12 These are colours that sit between blue and grey and which are of obvious appeal for their ambiguity. Colours 9, 10 and 11 are tints of the same bluish grey that could be easily created by mixing a form of carbon black made from burnt vegetation into white paint. Burnt vine wood yielded the nicest blues. Colour 12 is subtler and less steely in character. Their cool subtlety makes them very useable.
- 13 This is the colour of cobalt glass frit, which served a unique purpose for strewing over wet oil paint to produce an intense sparkling blue, particularly on metalwork, known as 'Smalt Blue'. Modern ultramarine blue pigment will produce this colour.
- 14, 15 and 16 These colours are clearer blues that were prized, being pigmented with blue verditer. The process of making this pigment, a by-product of silver refining, had been perfected in England in the seventeenth century and it was extensively used in oil and in distemper for walls as a 'fair blew'. It was later superseded by Prussian blue and synthetic ultramarine. Colour 14 is similar to one found on woodwork in the Independence Hall, Philadelphia (1732–48). Colour 15 was sometimes known as 'Blue Verditer' and 16 as 'Sky Blue'. It's a lighter version of a colour found at the Charles Carroll house, Annapolis, Maryland of the 1730s. All three colours are immensely useable, especially with the grever swatches to the left.

ote that the swatches in this section are representative and cannot in every case convey the exact nuance of what are often highly complex colours. They should also not be read as definitive absolutes but as 'rungs' on a ladder of tints. Hence, any colour could be justifiably lighter or darker. These colours are available as paints: see the entry in notes on the provenance of this palette on page 177. Refer also to palettes 18 and 19 for early twentieth-century and 1920s colours.

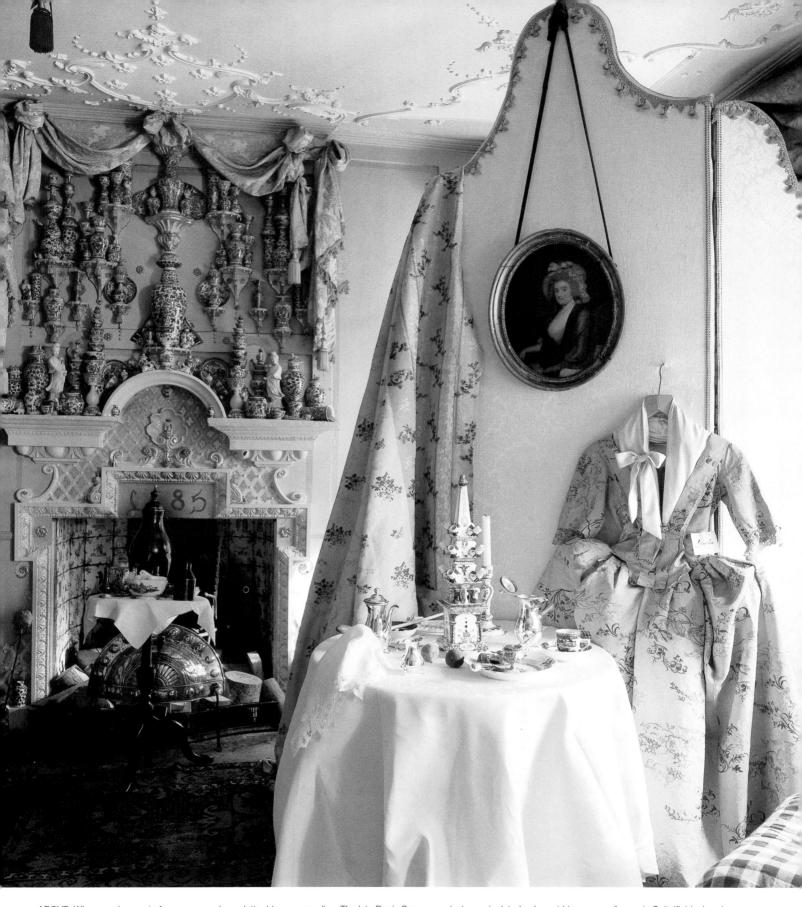

ABOVE: When used as part of a more complex palette, blues come alive. The late Denis Severs precisely manipulated colour at his museum/house in Spitalfields, London, shown here. See the Northern Light palette 50 for examples of pinks and earth colours that combine with blues in this palette to produce similar combinations.

17 early period colours

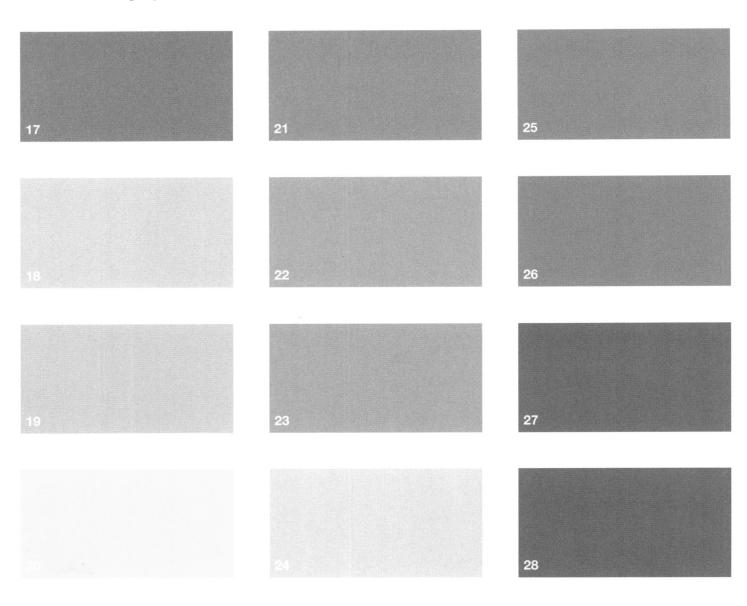

17, 18, 19 and 20 Colours 17–20 are variously pigmented versions of ochre and sienna earth colours, producing beautiful, complex creams and stone colours. Many variations existed. Colour 17 was known as 'Roman Ochre', while a yellower version was referred to as 'Spruce Oker'; when muddied, it was called 'Oak' or 'Wainscot colour'. Colour 18 is a delicately balanced tint of a lemon colour, cool and useable, especially in south-facing rooms. Colour 19 was described as 'Dutch Pink' (from the middle seventeenth-century word 'pink',

which was used to describe a particular yellow made from a vegetable dye lake. The word 'lake' was used for red dye pigments, and 'pink' often for yellow ones. Its previous definition had been 'a very small thing', coming probably from the early Dutch word for small: 'pinck'. In the eighteenth century 'pink' also meant the height of perfection. Smith in the 1670s refers to the colour as 'Pink-yellow'). Colour 20 is a classic cream made with yellow ochre and white: warm, pure and useable in even a north-facing room.

21, 22, 23 and 24 Colours 21–24 are warm greys and steely blues, reminiscent of bright and tarnished silver. It's worth obscuring the columns on either side to appreciate the delicacy of these tints, made with raw umber, white and blue.

25, 26, 27 and 28 Swatches 25–28 show a typical range of tints that could be produced from common haematite iron oxides like red ochre. Like the earthy yellows, the stone colours and the browns, these were cheap 'common' colours.

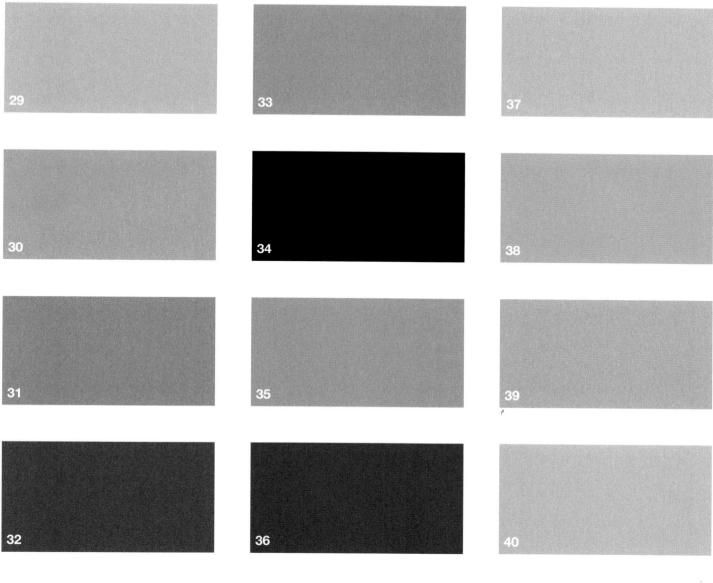

29, 30, 31 and 32 Colours 29–32 suggest names like 'putty', 'drab' or just 'dirt'. Colour 31 was in fact sometimes called 'Dark Stone' and colour 32 'Olive colour'. It's similar to a colour found on woodwork at Gunston Hall, Lorton, Virginia (built in the 1750s).

33, 34, 35 and 36 Colours 33–36, like all those on this page, were achieved with relatively simple pigments, most of them cheap powdered earths: Spanish brown and red, umbers, raw

and burnt sienna and yellow ochre, mixed of course with white (chalk and lime for walls or lead carbonate for oil paint) and sometimes a little soot black. They made inexpensive and widely available paint. No wonder they were often called 'common colours'. Colour 34 was enticingly named 'Chocolate', while colour 36 is similar to a colour called 'Walnut Tree'.

37, 38, 39 and 40 Colours 37–40 are more popular eighteenth- and early nineteenth-

century tints. Colour 37 is another warm grey. Colour 38 is an hilarious (and to our eyes overpowering) puce called 'Peach Blossom colour', colour 39 is a more useable and greyed tint of it. Colour 40 is a complex and beautiful indigo grey. Although there is hardly any evidence for this pigment being used in commercial house painting in the UK, it has been found in paints in America, France (as 'Bleu de Lectour') and elsewhere.

17 early period colours

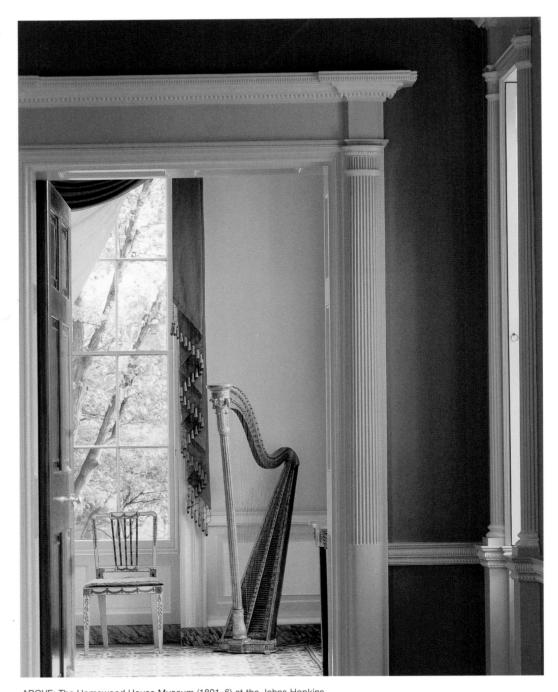

ABOVE: The Homewood House Museum (1801–6) at the Johns Hopkins University, Baltimore, Maryland is decorated with an archetypal combination of period colours: soft mint and pea greens and cool clean pale blues among others. These were not common colours, but polite and rarified tints for a discerning palate.

OPPOSITE: More colour sensibility from the late Denis Severs' house in Spitalfields, London. Cream and off-white are used to modulate an otherwise sugary pink.

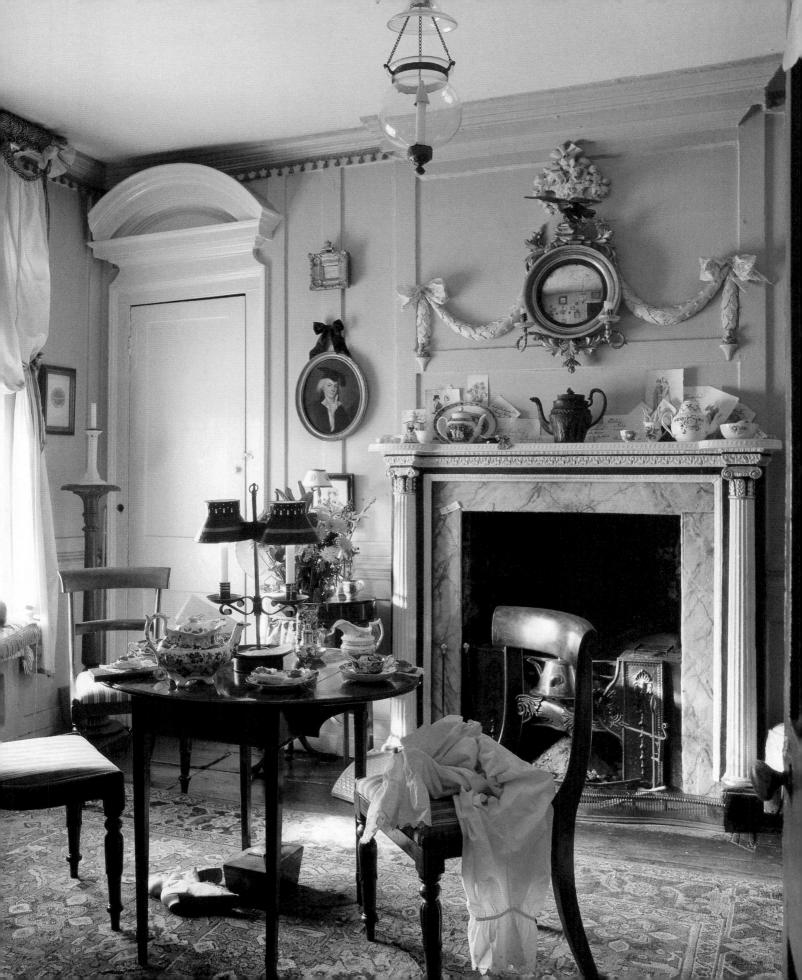

18 early twentieth-century colours

- 1 'Oxford Blue', a standard 'clubbish' and now institutionalised colour.
- 2 Brilliant green, unmistakeably nothing else.
- 3 Peacock blue, an unusually complex dark colour and rather sophisticated placed against some of the other colours here.
- **4** Light battleship grey, a useable grey because it contains brown to warm the colour.
- **5** Dark blue, a deep cobalt colour, used full strength.
- 6 Slate, a beautiful, complex dark and warm grey.
- 7 Turquoise blue, a complex and greyed version of turquoise, the colour of the sea. All these blues work beautifully together as a palette of four equally intense hues.
- 8 Eau de nil, perhaps a typical green of the period.

hese are paint colours of the first few decades of the twentieth century, taken from a wider standard range of the time. To some extent they represent international taste, simply because the colours were developed not just by paint manufacturers, decorators and architects, but also by engineers, the military and shipbuilders, all of whom were interested in codifying colour. As a result of advances in pigment technology in the nineteenth century, it had only recently become possible to use a wide range of colours that were cheap and permanent. The resulting agreed collection of colours, which was British, was the first standardised paint range to be published.

It predictably contained colours such as 'Signal Red' and 'Light' and 'Dark Battleship Grey', which were developed in World War I. But surprisingly there were many more approachable tints and shades with more romantic names that were suitable for domestic decoration: 'Light Indian Red', 'French Grey', 'Azure', 'Salmon Pink', 'Quaker Grey' and 'Sea Green'. Because these sixteen colours are taken from a range, not a 'palette' of colours, there is no obvious cohering structure to relate them all to each other, save two things: a preponderance of brown colours and a chromatic intensity that even the pale colours share. Compare this palette with palette 19, a collection of decorating colours from the late 1920s.

- **9** 'Signal Red', a new and important hue then, it has won its spurs as an invaluable signage and branding colour around the globe.
- **10** Salmon, a virulent tint that needs strong other colours around it.
- **11** Venetian red, a good orange-biased iron oxide colour, typically arranged with the other colours in this column or with colours 4 and 6.
- **12** Middle brown. A good warm brown, useful for 'anchoring' other colours.
- **13** Deep buff. Use this colour as the key component of a four-colour palette with the swatches below and to the right.
- **14** Pale cream. Interestingly, this early twentieth-century cream is dirty, whilst those of the eighteenth century (see palette 17) are entirely clean and fresh.
- 15 Deep cream. Cleaner than colour 14, but still with a muddy hint.
- **16** Primrose. A cool yellow, actually beloved in all periods. An interesting palette can be made using this and the other three colours in the bottom row.

18 early twentieth-century colours

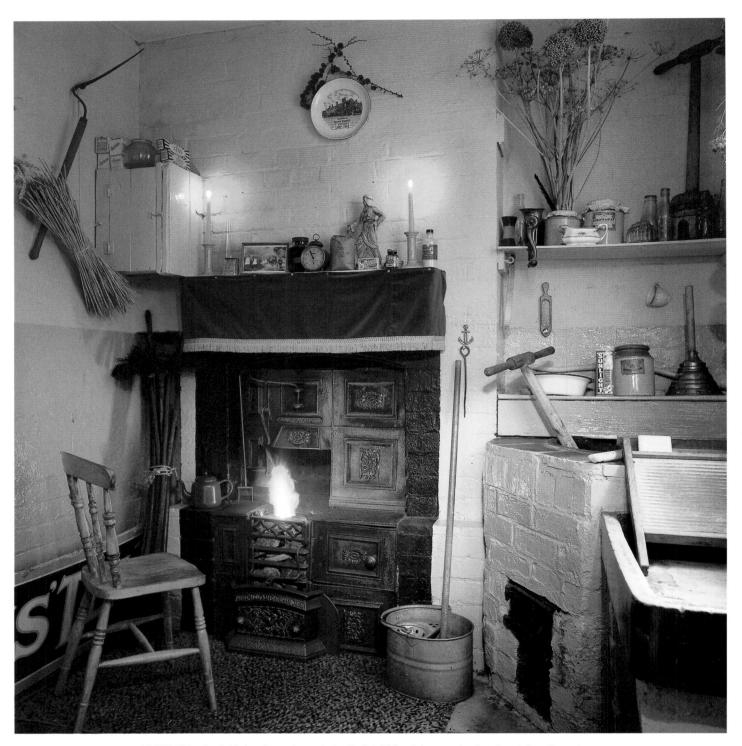

ABOVE: This miner's kitchen from a house in the English Midlands has remained unaltered since the early twentieth century. Colours 4 and 15 from the preceding pages would help in recreating it.

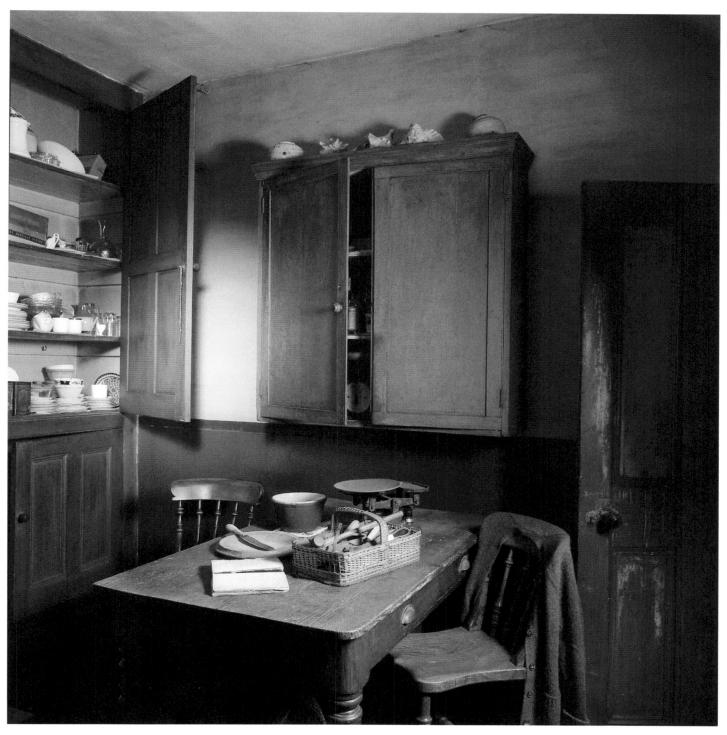

ABOVE: The kitchen in William and Walter Shaw's house, Nottinghamshire. The bay-fronted three-storey Edwardian villa is like thousands of others built at the turn of the twentieth century. William and Walter lived here for fifty years. They preserved the house as it was when their parents died in the 1930s. They ignored modern conveniences such as central heating, the telephone and television. The house features 1920s wallpapers, Victorian furniture and household objects. Standard lowly paints like colours 2 and 8 (brilliant green and eau de nil shown here) would have been widely available for this expanding housing market.

19 1920s colours

- 1 A pretty bluish green similar to some of the eighteenth-century colours. Clean and uncomplicated. Its blue-green ambiguity means it is a cusp colour.
- 2 This delicate pink is of the sort made with an Indian/Spanish-type native red ochre, which gives it a bluish cast. Also a cusp colour.
- **3** A very slightly grey yellow, a chalky tint of primrose yellow. Could appear green in some lights.
- **4** A delicate clean watery violet colour. Good with the cool pink, blue colour 5 or pale blue colour 7.

- **5** A very useable and pale indigo grey-blue and an important one. Use it as a predominant colour in combination with detail/secondary use of any other colours in this palette.
- 6 An uncomplicated baby blue. Guileless.
- 7 Almost grey, the kind of pale blue that can be made with vegetable black pigment and white.
- ${\bf 8}$ Light olive green, good with the pinks above and right.
- 9 This orange ochre-pink is a typical Art Deco

colour, particularly in conjunction with the more sludgy colours in this palette.

- **10** A cool and very slightly purplish grey. Unusual and good in combination with its equally muted complementary, colour 8 or the pinks here.
- **11** Another unusual colour, a slightly dusty bronze brown.
- **12** Glaucous sea-green. Ambiguous and a cusp colour.

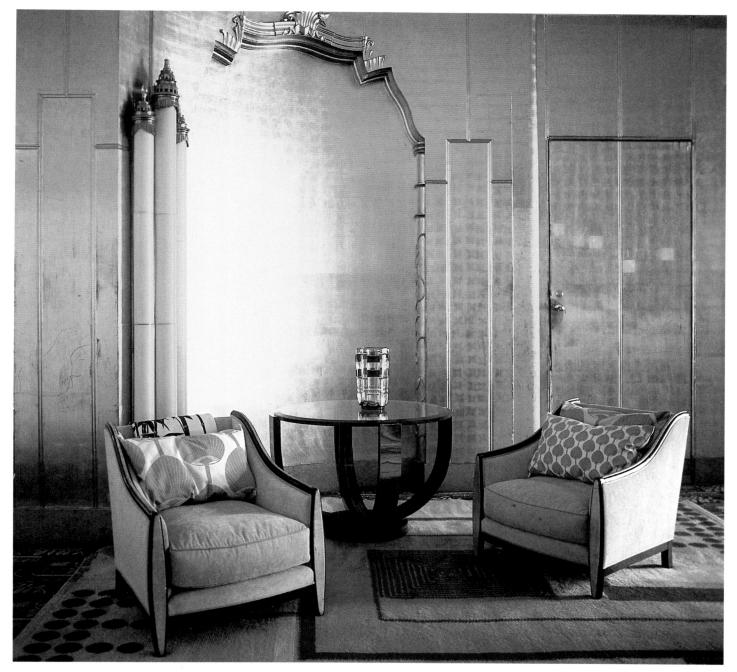

ABOVE: This palette is a collection of shell colours, mother-of-pearl and the iridescent sheen of silver leaf. These delicate ideas and materials were essential components of early Art Deco schemes and the 1920s rococo typified in this room.

his is a palette of paint colours from the mid-1920s, and one which, although sampled from paint colours from the period (taken from manufacturers' colour cards) possesses a fascinating coherence, a character which unwittingly and succinctly epitomises the time. In fact all the 'palettes' (or collections of colours) in this period chapter do the same: the eighteenth-century palette is deep and clear, biased to blue, grey and orange; the early 1900s palette is rich and slightly muddied with an emphasis on brown and dark principal hues. This palette has a very complex character: it is slightly muddied, hazy and greyed and tonally extremely light. These colours are very appealing to modern taste because they are not too strong and difficult to use. They are pastel tints, redolent of the Art Deco period that they precede and innocent of the brooding quality of colours that predated World War I.

Although the paler tints are sugary, they're all slightly toned by the addition of a little grey and are presented against deeper and more complex colours such as olive green, dusty chocolate and glaucous blue-green-greys. Overleaf are one or two darker colours of the period. These also have muted characters.

19 1920s colours

- 14
- 15
- 16

- 13 A magnolia orange-tinged pink. This is an almost impossible colour to use by itself but it's very useful with the strong clear greens below.
- 14 A deeper tint of the same colour. This palette is really all about a much older game: the complementary relationship of red and green, explored elsewhere in this book (see palettes 41, 43 and 55).
- **15** Pale grey-green, a delicate and clean pale minty colour. Use combined with the colour below.
- 16 Grey-green. This is the kind of chrysocolla 'Mountain Green' that Nero is said to have strewn across the floor of the Coliseum before appearing on it dressed in the same colour as a proclamation of self-renewal. It may well have a calming and balancing psychological effect; it certainly suggests vitality and growth.

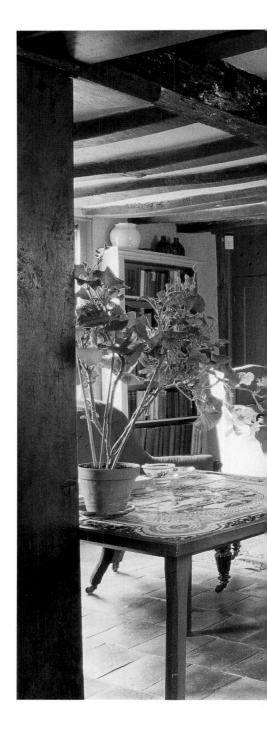

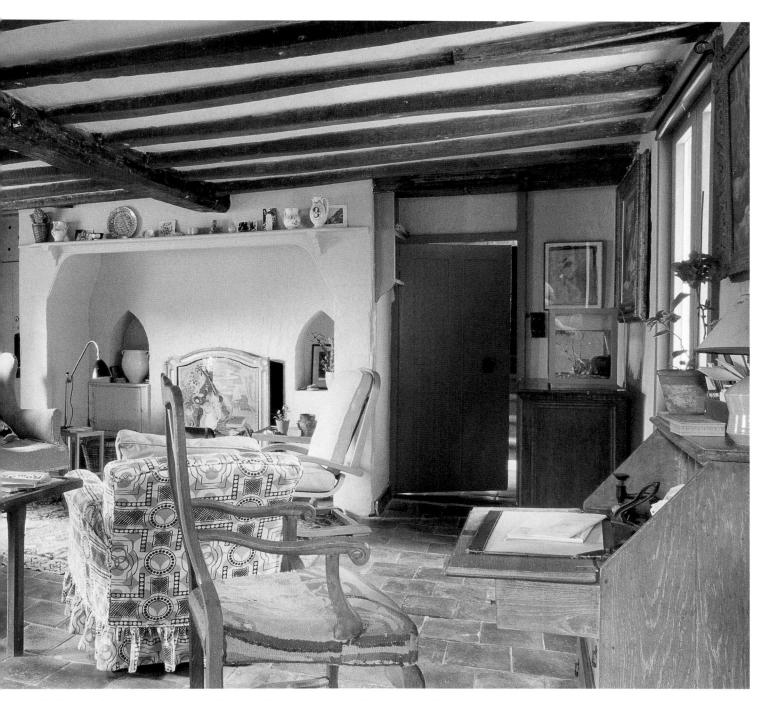

ABOVE: This sitting room, in Virginia Woolf's home at Monk's House in East Sussex, is painted in her favourite colour – one available from several contemporary paint ranges. It was vibrant and clean colours such as these that were adopted by artists in the Bloomsbury Group.

here is a more muscular side to 1920s design and decoration, rooted, not in period revival, but in the vibrant late nineteenth-century traditions of the Arts and Crafts movement, and swayed by continental, American and even primitive African influences. The Art Deco movement found its energy and abstraction in primitive art and applied pattern; from Assyrian sculpture to tribal painting and Egyptian architecture. The intellectual and artistic movements of the time were equally spellbound by primitivism, only they were less entranced by the trappings and baubles of these cultural sources, than by their magic and superstition. This palette, like the others for this period, is taken from a commercial colour card of the time. But these are not the cheap utilitarian workers' colours of World War I, colours that seemed simply an incidental side effect of the protective paint layer. Nor are they just a trivial and gay Art Deco palette for cinema decoration. They point to something new, which is more fully explored overleaf. They speak of a refreshed, clean world, post-war, and an interest in the ancient magical properties of colour to heal and restore the soul.

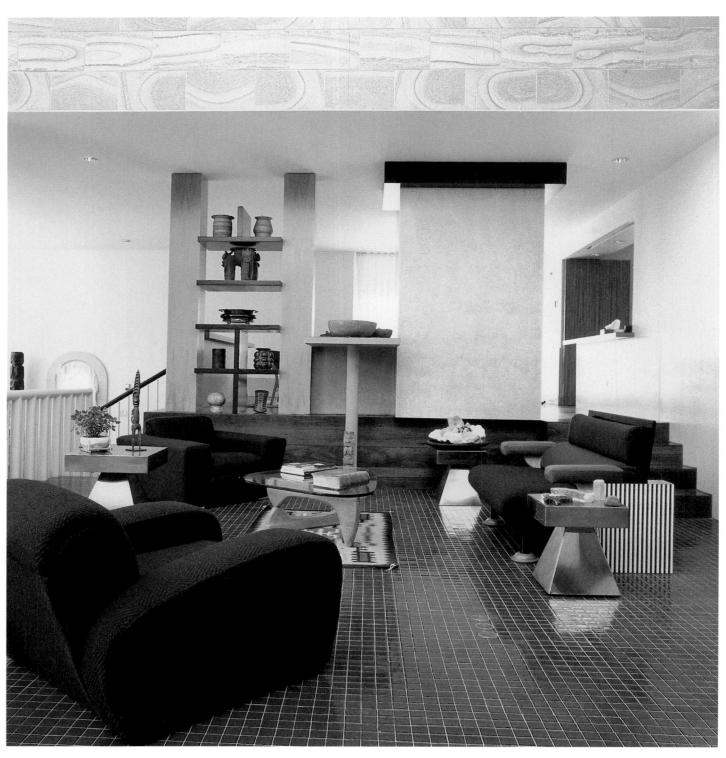

ABOVE: This Los Angeles home employs colour in a complex and confident way. Note that all the colours used are in some way 'off': dirtied by brown or black. This trick homogenises them all.

19 1920s colours

- 17 A rich, greyed cream that still manages to retain some warmth. That's quite some feat.
- **18** A pretty pale warm grey. Use with the green or the blues.
- **19** This typical 1920s green was called 'Mignonette' by the manufacturer. Bluish, complex and useable.
- 20 Fancifully called 'Persian Red', an intense and slightly shaded cool red. Try it with just the colour above and below for a very 'informed' look.
- 21 A complex blue but one that is still intense.

 Called 'Myosotis Blue'. These exotic names suggest a rather sophisticated approach to colour.
- 22 'Sky blue', apparently a simple clear tint, but in fact a complex balance of white, blue, grey and green. Very useable.

f Art Deco colours were guileless and Bohemian 1920s taste ran to vibrant hues and tints, then serious architects were pursuing yet another colour story. Although we think of Modernism, that great 1920s invention, as a monochrome visual language, that is nearly always because photographs of Modernist buildings were in black and white. In fact many inter-war new buildings were coloured – on the outside as well as in. These six swatches are less innocent than those on the preceding page: they are all shaded with a little black. It's as though this palette has

been muted for a more sober use. The colours certainly suggest the influence of building materials like wood, stone and cement. Or if you like, references from other cultures: Oriental ceramics, tribal woodcarvings and Roman wallpaintings. That's where these colours also appear.

Whichever way you look at it, this is a grown-up palette with serious intentions. It looks very sophisticated when used in an interior like the one shown opposite.

f you remove the greens from this page (especially the lime green) you're left with an uncontroversial but rather beautifully composed set of colours. Add the greens and you have an Art Deco Miami palette or a typical late-1990s popular paint range as sold in DIY sheds: colours which are slightly shaded with a little black or toned with a little grey.

But this palette doesn't come from Miami or from the 1990s. It is derived from sophisticated interior design schemes from New York in the 1940s, a decade when brown, to an extent, dominated design of all kinds. The six colours below formed a proposed scheme for a dining room (opposite there is one more proposal) where the brown-grey was to be the predominant wall colour. That recommendation is probably one worth following.

Opposite are four colours proposed for a library: a sombre scheme tinged with blue, brown and purple and heightened with scarlet for line or detail. This is a sharp set of colours with no hint of the musty associations of the 1940s (or libraries for that matter). It's one funky palette.

- 1 A neutral pale 'donkey' colour similar to John Fowler's pet wall colour of the period, 'Mouse's Back'. Very useable, particularly without all the colours below or in combination with the blue and violets.
- 2 A tiny quantity of black takes the lurid edge off this green. Look at this with just the blue below and brown left.
- **3** A good complex blue that can be used with offwhite and the colours above and below.
- **4** You can build a very dynamic combination with this clean turquoise green, the violet below and the lime green, in contrast to the other three, much softer tints.
- **5** All the colours in this column have a similar tonal value that connects what are otherwise disparate hues. The brown-grey and this tint bracket the cleaner colour in between.
- **6** Build a palette with only these lower four colours, or mask this violet for a three-colour palette of even greater innocence.

VIEW THIS PALETTE AGAINST WHITE OR WITH THE GREY VIEWER

LEFT: It's not surprising to find very modern design which echoes – or just copies – colourways and schemes from historical periods. By delving into the past and raiding it, a designer can imbue a product, a building or an interior with a magical extra value: the subtle echo of an association with something other than the here and now. Like all the pictures in this book, this one was found after the palette had been researched and compiled.

- **7** A typical early twentieth-century 'Dark Battleship Grey' and a good lead or slate colour.
- **8** Cooler than the pale violet on the opposite page and a pivotal colour between the swatches above and below.
- **9** A complex and interesting mixture of violet, grey and brown that will change character according to prevailing lighting conditions (a cusp colour). This and colour 8 are wonderful and important colours that give this palette of four real maturity.
- **10** An uncompromising scarlet or vermilion red that is moving towards orange. Try the other three colours without this one for a safer combination.

21 colours from 1950s schemes

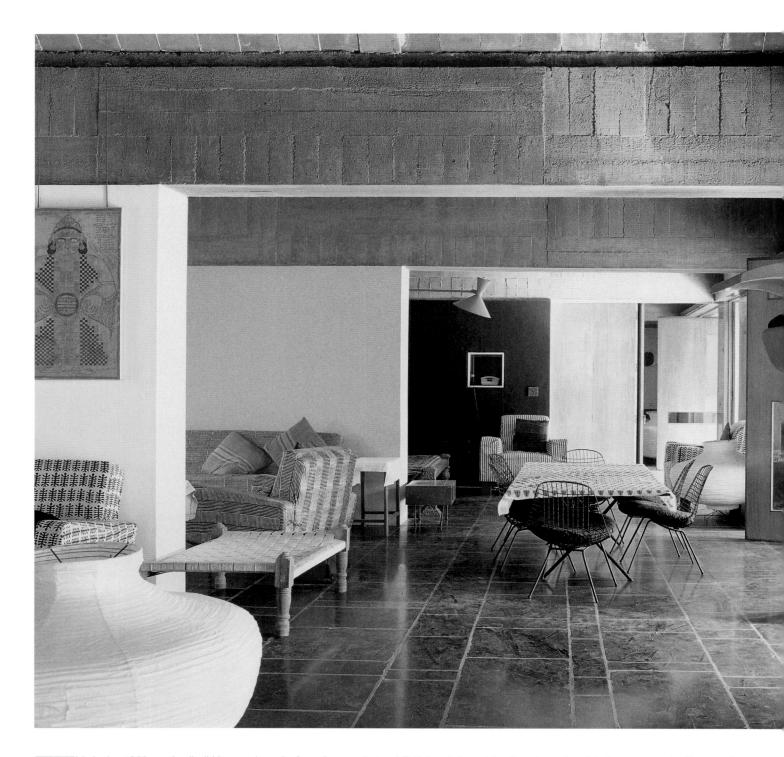

his is the 1950s embodied! Here and overleaf are three archetypal British palettes of the time, based on interior schemes by Raymond Rust and Lucienne Day. In palette 22, the scheme ideas are more muted and subtly resolved; the colours on this page are louder and, for the period, intense.

All speak eloquently for that decade, not least because of the five colours assembled here and the eight overleaf, ten have some degree of black in them – even the pink, which is slightly shaded. The exceptions are the two yellows opposite and the one overleaf, which, if tinged with black, would markedly change in perceived colour towards a sludgy green.

ABOVE: Perhaps no twentieth-century architect has experimented so widely with colour as Le Corbusier. This is his Villa Sarabhai in India. There's a genetic link – a similarity in the use of black to slightly stain a colour – between this scheme and colours from the 1920s (see palette 19).

- 1 This is a pale and innocent primrose yellow, which is likely to turn immediately to green if it even gets a whiff of grey or black. Use on top of the red or green for best effect.
- 2 The main core tension of this palette is the red/green complementary effect, although it has been restrained by muting the hues of these colours with grey.
- 3 This is a complex and useable green, an equable mixture of green, yellow and black that is particularly good when just used with the primrose yellow, above.
- **4** The secondary core tension of this palette is the contrast effect of black versus yellow. A difficult colour to use by itself, but an important part of this scheme.
- **5** Not only is black used to shade colours in these palettes, it also appears as a solid colour. Here it also sets off the yellow.

22 colours from more 1950s schemes

- 1 This is a very slight grey with just enough yellow in it to relate to the colours below. Probably a good colour for indoor decoration.
- 2 Another, rare, colour with no black in it. Like the yellow on the previous page, this green has an aggressive relationship with the black, although this whole palette is less dynamic.
- **3** An important colour in this palette because it bridges the green-yellow and the black.
- **4** Black is again used as a solid element in this scheme, as well as a shading element in other colours.
- **5** This grey casts a slight shadow over the whole palette. Obliterate it to gauge its effect.
- **6** There is a small quantity of black in this pink which takes the sugary edge off it. Carefully used, this is an unusual and effective decorating colour.
- **7** A very useable colour, soft and grey enough to be versatile. Particularly good with just the pink as a slightly tarnished 'baby' scheme. Mmmm.
- 8 A bronze green, the colour of dead moss and clearly the pivotal colour in this scheme, with or without black.

ust as many decorating colours of the 1940s were cast with a brown content (see palette 20), so brighter colours were being introduced in the 1950s after a period of relative austerity. So it's not surprising to find designers modulating them a little in order to make them accessible. It's interesting to compare the colours on these pages with the equivalently muted tones of printed colour media of the 1950s, such as magazines (see palette 42) where technological limitations resulted in both poor colour reproduction and an excess of black and grey on the page. It's also interesting to see how the British textile designer Lucienne Day in the 1950s was using pink and bronze together – in a way that fellow British textile designer, Eddie Squires, was to do more vibrantly in the 1960s (see palette 24).

23 colours from 1960s schemes

- 2
- 3
- 4

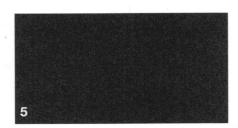

- **1** A clean, cool and intense pink. Its naïveté is typical of the 1960s.
- 2 A stronger Pink Panther tint of the same colour.
- 3 Slightly greenish, this bronze colour is pivotal to the entire palette. Use it also with just the pinks to give them a veneer of depth and interest, or with just the brick red and purple for a more severe and savoury palette.
- **4** This brick red is slightly evasive: dusty, browntinged and veering towards orange. Its ambiguity means that it performs differently according to prevailing lighting conditions (a cusp colour).
- 5 This purplish plum exerts a powerful controlling effect over the pinks, even when used in small quantities. It also has a difficult, strident relationship with the brick red (they can be used together to disconcerting effect and their relationship moderated with the bronze).

Brown, it must be said, can often work as an anchoring colour in a palette, not just because it's a dark and indeterminate colour, but because it is the colour nearly always obtained by mixing two complementary hues. A 'useful' brown will veer either towards a principal colour in a palette or towards its complementary. So, in a palette of blues, a brown made with yellow or orange (complementaries of blue) will have a more heightening effect than one made with green or red (which are close to blue).

This palette uses brown – or bronze – with a delicate poise. The colour is yellowish brown with a hint of green that if it were any more intense would strike the eye as an obvious complementary of magenta – the hue from which the two pinks are derived. The central position of the pinks is reinforced by two near colours, the brick red and purple: together they form a phalanx of cool and warm red-based colours all ranked in the subtlest of opposition to the bronze colour.

In short this is a palette of delicate tints with relationships that are half-hidden. Not surprisingly, these colours are from one of the masters of '60s commercial colouring, Eddie Squires, who used them together in wallpaper designs. There are more overleaf.

24 another 1960s scheme

- 1 This deep ultra blue is a sharp foil for (and near complementary of) the orange and of the magenta pink in this palette, but it's also the outsider here. Experiment with varying amounts of this colour.
- **2** A deep hue, no-holds-barred full-on orange that partners the magenta in the lead role in this palette. Both can be used together with just the blue or just the bronze colours.
- **3** This bronze brown in fact contains a high proportion of orange. Consequently it's quite amiable to the colours either side of it but is an effective complementary brown for the blue.

- **4** Another intense full-hue colour, a slightly warm magenta, partner to the orange.
- **5** This colour could be called moss green or bronze green. Either way, its yellowish tinge places it in the direct complementary path of the magenta, although its brownish complexity weakens the effect. These two colours can be used to great effect by themselves.

VIEW THIS PALETTE AGAINST WHITE OR WITH THE GREY VIEWER

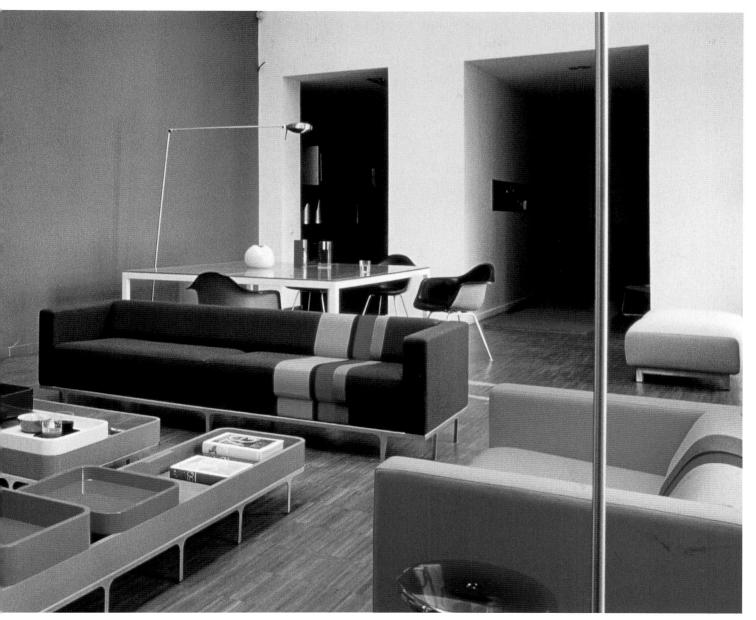

ABOVE The Paris home of Florence Baudoux, a furniture and accessories designer, is a twentyfirst-century retro dream. The 'Long Stripe' sofa is from Florence's own Oom collection. The leather 'PK22' chairs are by Poul Kjaerholm. The chairs around the table are Eames side shells. Note the extensive use of bronze on the walls to calm this riotous scheme down.

ere are five more colours from Eddie Squires. The bronze and pink combination reworks the ideas explored on the previous page but this time with stronger hues (and so stronger complementary browns). The blue and orange combination is added here because it shows just how far the man was prepared to go when it came to putting complementary colours together: these two hues – Prussian blue and a wholly synthetic orange – are just about as intense and pure as colour can get.

Seen as a palette of five colours the orange and magenta scream get up and go. Thank goodness for those bronze swatches. They know how to keep everything under control.

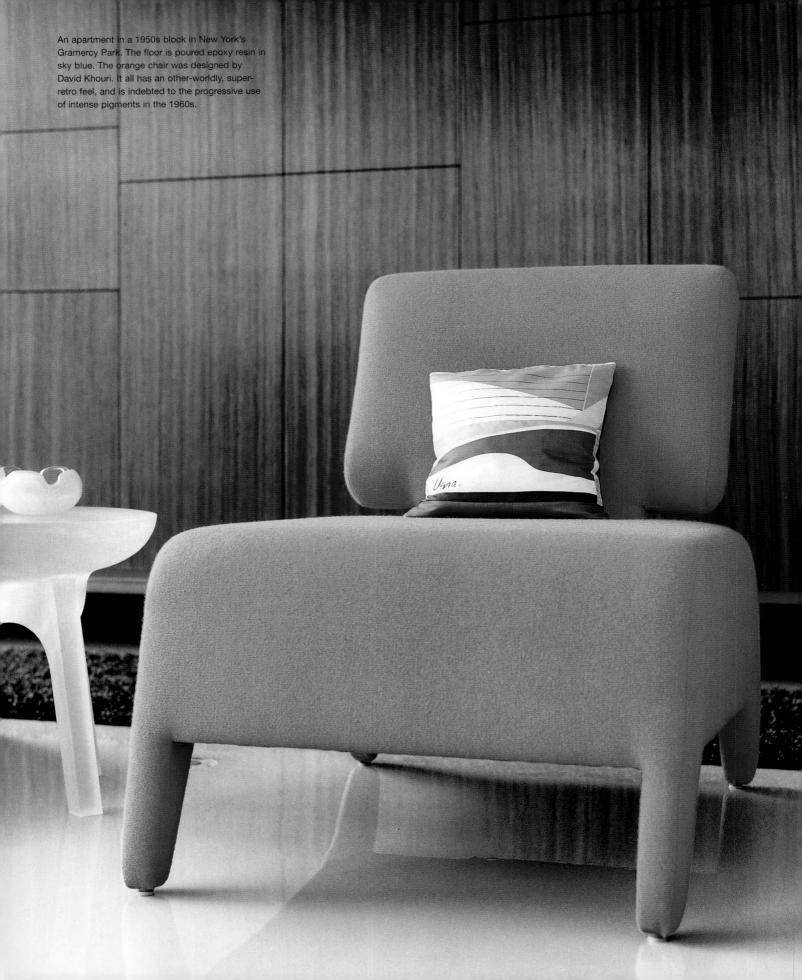

25 1960s furniture colours

- 1 A bright chrome yellow (but made with a new generation of synthetic dye pigments). Clean, intense and uncompromising. The orange tinge to this colour means it won't tend to green in poor lighting conditions. Very similar to yellows used internationally in signage and on construction/infrastructure equipment.
- **2** A slightly muddier version of the colour to the left, this yellow approaches the colour ochre. Its muted hue means it will form a well-anchored relationship with any other colour on this page, especially colours 4, 5 and 6.
- **3** A beautiful, warm and brilliant orange, again uncompromising, but less industrial in its associations than the yellow, above. Try it alone with the green, blue or especially the cherry red, below right.
- **4** An almost pure red. Difficult to handle by itself, but try it with the orange, left, or the green, its subtractive complementary.
- **5** A slightly burnt orange that as a result is easier to use and less strident than the colour above. It takes on a new vitality when placed against the green or the blue.
- **6** A light cherry red, a toned red that is moving slightly towards purple and so has a cooler cast than the red above. Try them together and watch the internecine struggle of two advancing colours thrashing it out.
- **7** A deep emerald green, difficult to use by itself but especially good with the oranges and orangered above.
- **8** A clear intense blue that is tending slightly to green. Especially good against colour 3, its complementary, or the darker orange colour 5. Or try these colours plus the yellows.

hese eight colours belong to plastic fantastic. They are the groovy, intense – and permanent – hues of the psychedelic generation.

I mention permanent because these colours did not just appear as the hallucinatory result of some designer hippy trip. They were in fact the outcome of several decades of research. Bright synthetic pigments had been around since the beginning of the twentieth century, and bright synthetic dyes from the 1860s, but many of them were fugitive: they faded. For the colour chemist, the holy grail of colour synthesis remained a range of artificial pigments resistant to chemical and ultraviolet effect, and by the 1960s, developments in petro-chemicals, plastics and dye manufacturing had made such a range possible. It's interesting that we associate such colours with the hippy generation of the late 1960s, whereas these colours were available much earlier. Some occur in late 1950s interiors, most of them date from early 1960s furniture and one, colour 5, dates from 1946.

The cleaner colours are the top four, and, if you like, can be used as a palette together. The four below are slightly shaded and also work well as a group. Note the juxtaposition of the similar yellows, red and oranges. When used together, these close vibrant colours make the eyes do a lot of work, appearing to move and shimmer.

natural palettes

ABOVE: This was a popular palette in the later neoclassical eighteenth century. (Wedgwood was after all only supplying ceramic goods in the popular architectural colours of the time.) The fashion set for these delicate tints in England and France was then adopted throughout Europe, particularly in Scandinavia. This is Bernshammar in Sweden.

- 1 A pale and delicate Wedgwood blue that historically has found much use as a decorative colour, being nearly grey. Exquisite. It should be used much more.
- ${\bf 2}$ This misty reddish purple is the anchoring colour for this palette. Surprisingly, purple often is.
- **3 and 4** Both these deeper tints are also very effective decorative colours, although they are best employed as part of this overall palette.

his a very balanced set of colours. The original source is Wedgwood coloured ware, but this palette is lifted from the 1937 edition of Parsons' *Historical Colours*, a volume which says as much about the taste of the interwar years as it does about any of its historical references. These four colours are presented as here, on one page together, all equally milky and greyed. It is as though they were being seen through a soft-focus gauze filter.

Another similar milky palette can be found in palette 59. This palette works by taking three tints of a neutral mid-blue that are underpinned by a purple, deeper in tone and relatively distant from the blue, since the purple is moving towards red. It's a clear case of purple being used as an anchor in the palette, a device that pops up surprisingly often in the history of design and hence in this book.

27 a Norse legend

- 1 A slightly greenish warm grey, useful against all the colours below and a very useful decorating colour, both as a wall colour and as a deep offwhite for woodwork and ceilings.
- **2** A clear and slightly purplish blue, very sharp and cool. Useful against the blues and greens below.
- **3** This subtle grey-blue has great character in a decorative scheme. It has an almost lavender tinge.
- **4** This is a very solid, dense green that nevertheless works to great effect when used in small quantities against the other colours. Or try it as the dominant colour.
- **5** Do not underestimate the power of purple in a palette. This may be a subtle version, but despite its quietness, it has a pivotal role here. Cover it to see for yourself. Especially striking against its complementary: the green, above right.
- **6** An intense smoky turquoise green that is chromatically far removed from the colour above. Another pivotal colour in this palette: try it with just the colours in this column or as part of the four lower colours. A very exciting colour.
- 7 In contrast to colour 3, this is a cooler blue but still toned with grey. Use it as an antidote to the greens and also as part of a four-colour palette in this column only.
- **8** A subtler and less blue version of the colour above, this is a cusp colour that changes character according to different lighting conditions. Especially good when subdued with large quantities of colour 3.

his is the palette of a summer landscape and sky: a landscape where the greens are hazy and shift towards blue in the middle distance, and where the blues are soft and light, the colours of cloud and mildly overcast skies. They are, in short, the outdoor colours belonging to a temperate climate and similar in feeling to the Northern Light palette 50.

These colours bring opportunities for all kinds of combinations of varying character. Nearly every one is subtly muted with an adjacent hue plus brown or grey. So, the greens are a little muddled and are mixed with either yellow or blue and the blues are a little muddled and are mixed with either purple or green. As a result, almost any combination of these colours will be interesting. The exception to this principle is of course the grey, which is brown-green tinged.

That this palette comes from Scandinavian interiors shouldn't surprise anyone. These colours – and rooms containing them – were well-publicised and featured in magazines throughout the 1980s and '90s. What is interesting is how many Scandinavian interiors, especially those of the eighteenth and nineteenth centuries make use of these landscape colours with a lightness of touch and sensitivity for their aerial quality.

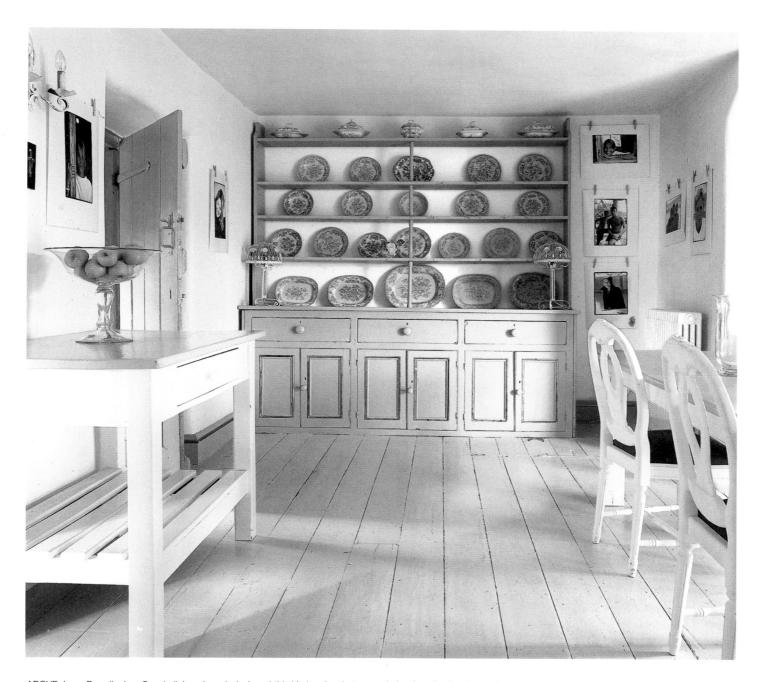

ABOVE: Lena Proudlock, a Swede living abroad, designed this kitchen in what can only be described as her native style. It makes use of a great deal of white combined with some of the colours in this palette.

28 seascape

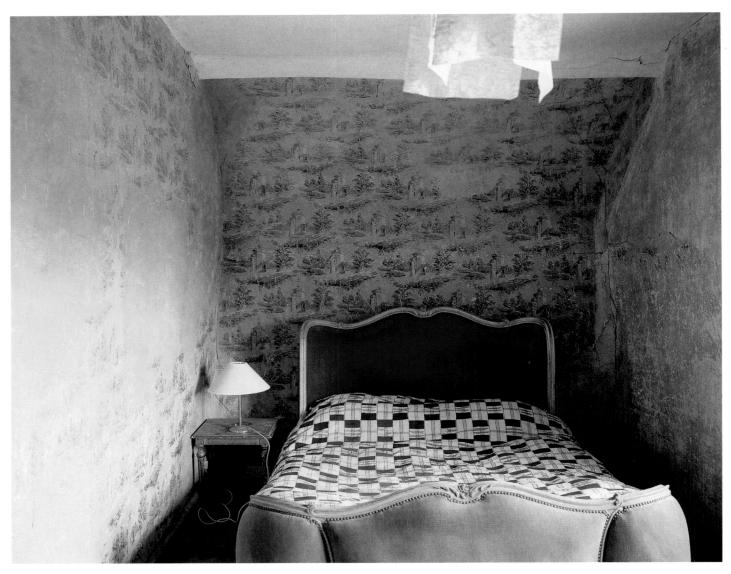

ABOVE: The walls of artist potter Rupert Spira's house in Shropshire were stencilled in about 1830. Other rooms in this home appear elsewhere in this book (see palettes 50 and 53). All illustrate the same greyed subtlety in the colours that can be found in this palette.

here are several palettes in this book which are marine. Some come from the turquoise Aegean, others from the coast of Africa. Others harbour the limpid colours of a Scandinavian or American seascape. There are several other palettes in this book that reflect the colours of the sky: aerial grey-blues, deep cobalt summer hues or the muted tones of Northern skies.

This palette is a subtler collection of softened, blended tints and tones, the ambiguous colours of a mid-ocean seascape. It does both marine and aerial. That's because it comes straight from the navy and air force; or rather, this is a selection of colours that sailors and airmen have had their boats and planes painted since World War II in countries around the world. Separately, they are functional colours. Put together, they are beautiful.

1 A generic camouflage green that is satisfyingly greyed and complex. A colour suggestive of deepdyed green wool, or suede, because it has a slightly dusty quality. Use with the colours immediately around it for a combination that is mature and sophisticated.

10

- 2 The deep colour of duck eggs and a hazy greygreen-blue tint that is part aerial, part aqueous. A delightful 1940s and '50s decorating colour, good for walls, to be mixed with the colour to its right.
- **3** Another period twentieth-century colour, although harder and deeper than colour 2. Use as an accent colour with it, or with the other colours in this column.
- **4** This is a delightful warm grey but with no nasty brown 'mushroom' connotations. A very useable colour, especially with colour 2, or with off-white.

- **5** A good deep smoky grey with the requisite touch of blue. A good contemporary furniture colour and good with the other colours in this column.
- **6** Another aerial and atmospheric light blue to use with the other colours in this column, or for a less naive and classier combination, with the colours in this row. Much more interesting because it's a cusp colour that changes identity according to the prevailing light.
- **7** A flexible colour that willI work with any other on this page. Beautiful. The colour of deep seawater.
- 8 A real seascape colour, part green, part blue and mainly grey. A fabulous, complex colour to use with any other on this page. An important anchoring colour for this palette.

9 A guileless cool blue tone, slightly greyed and very fine with colours 2 and 4.

12

- **10** The kind of hard bluish grey produced by mixing carbon black and white pigment. Good with the other colours in this column.
- 11 Another one of those deep ambiguous colours that seems to have everything else thrown in it: smoky, oily with a hint of luminous green. This colour will appear black when used in small quantities, deep and powerful when used over large areas.
- 12 There is the vaguest hint of warmth to this blue that makes it difficult to use with many of the greentinged colours on these pages. Best paired with colours 4 and 8.

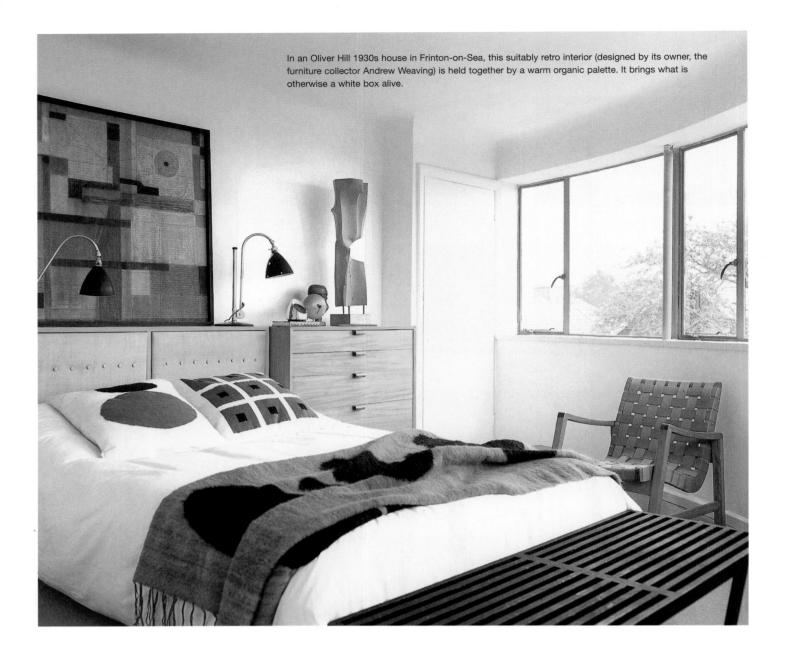

- $\ensuremath{\mathbf{1}}$ Deep forest green, the shadow colour of foliage. Velvety and rich.
- **2** Deep moss green, matt and brown-tinged. Use it with the deep forest green, left.
- 3 This is a very useable colour, a warm stone grey similar to the concrete colours in palette 30). A cooler version of colour 5, opposite, with which it can be used in a sophisticated combination.
- 4 A chestnut brown to lift the two greens above. A good soil colour or that of deep tanned pigskin and suede. Very good with the violet colour 12, opposite.

29 field and forest

- **5** A warmer colour than colour 3 but still a good stone. Use in abundance with all the colours in this palette.
- **6** An unusual sandy-green-yellow, a sort of khaki drab that has a suede quality. Use with colours 5, 7 and 8 at the top of this page to lighten it.
- 7 This deep ochre underwrites these top four colours and also works with the four colours below it.
- 8 Warmer than the colour above it, but this colour needs the yellow, left, and red, below, to kick-start it into any kind of life. If this drab swatch can be described as anything, it is organic.
- **9** If you take all the colours in this palette together, the colours that take a positive, proactive role are colours 3, 6, 8 and this one, a warm terracotta. The colour of sand dunes at sunset, hence chosen by the SAS in the 1991 Gulf War for their Land Rovers.
- **10** Brick brown, that with the violet below, wakes up the colours above and makes a really interesting arrangement out of this column.
- 11 Darker than colour 1, great with the colours around it and when viewed only with the other swatches in this column.
- 12 The most interesting colour in this palette, deep and with the same dusty quality that many of these colours share. Where purple appears in a palette, it often takes a pivotal role. Brown sometimes takes the same role. Here it is shared between them. Try pairing colours 4, 10 or 12 with any other single colour here to see some interesting combinations.

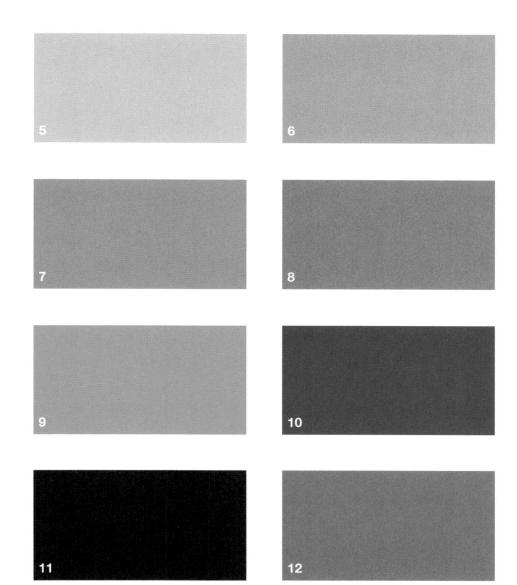

rom mossy rocks to deep forest, wooded hillsides to open moorland, these are the colours of the great outdoors, a wilderness palette of rustic colours: foliage, earth, sand and rock. They are deeper and lusher than the colours of the Savannah (see palette 32) or those of the earth (see palette 31). Mineral colours are here, but they're balanced by the greens of deep summer – or jungle – foliage.

These are colours for posh country front doors or the colours that farmers should paint their grain silos and slurry tanks, and for good reason. Every swatch on this page is taken from a selection of military camouflage schemes covering the last sixty years.

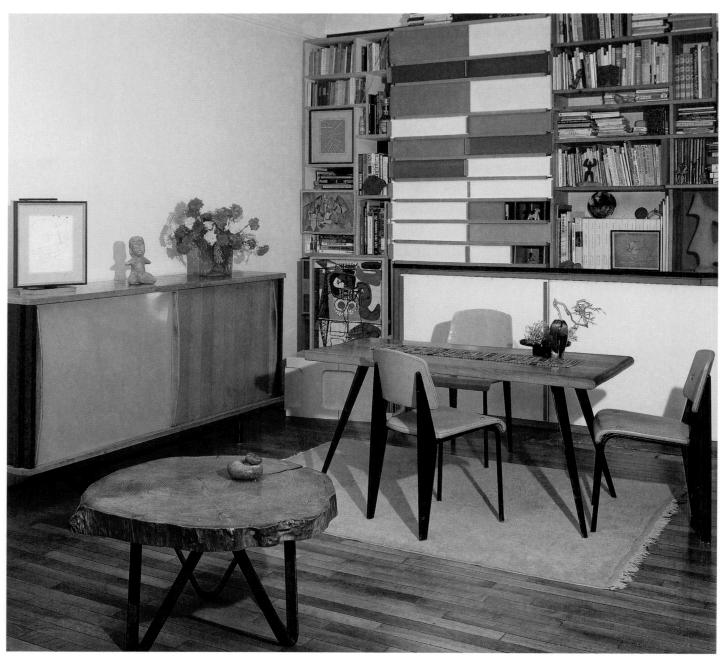

ABOVE: You might have thought this palette so off-the-wall that we couldn't find an interior to illustrate it. But here's a rather funky 1950s dining room that encapsulates the colours here. Even the yellow is there.

30 quarry colours

- 1 One of the available colours of red oxide paint, this colour is a warm, orange-tinged red suitable for outdoor work.
- 2 Pale mid-neutral grey, the colour of galvanised (zinc-dipped) steel and of micaceous iron oxide grey primer used on steelwork everywhere. Also a concrete colour.
- **3** This warm grey is almost beige. A good concrete colour when used with the other greys on this page and a very approachable decorating colour.
- **4** A darker version of the colour to the left and another good colour for the home.
- **5** A mid-warm concrete colour, pinker than the other two.
- **6** Bright and warm chrome/cadmium yellow, the colour of construction machinery. Try covering this swatch to radically alter the palette.
- **7** A warm iron oxide colour with plenty of orange in it. Another good exterior (and historic furniture colour). A pale colour of rust.
- 8 Deeper rust and also the colour of the Red Iron of Oxide paint used for 120 years to paint the Forth Bridge in Scotland (incidentally).

t might be difficult to guess where this palette comes from. Perhaps the yellow betrays the source. These are all everyday colours from civil engineering, from construction sites and heavy manufacturing industry around the world. It is a familiar palette, taken from the colours of concrete, metal primers, rust and of course the yellow of construction plant. With or without the yellow, this is a very useable palette because of the warm neutralising effect of the greys, the colours of warm-coloured concrete. The colour of concrete will vary according to the colour of its components: rock or aggregate and sand. The base colour of cement is a cold bluish grey but as a material it is never employed alone. Colour 2 is the coldest concrete colour here.

31 earth pigments

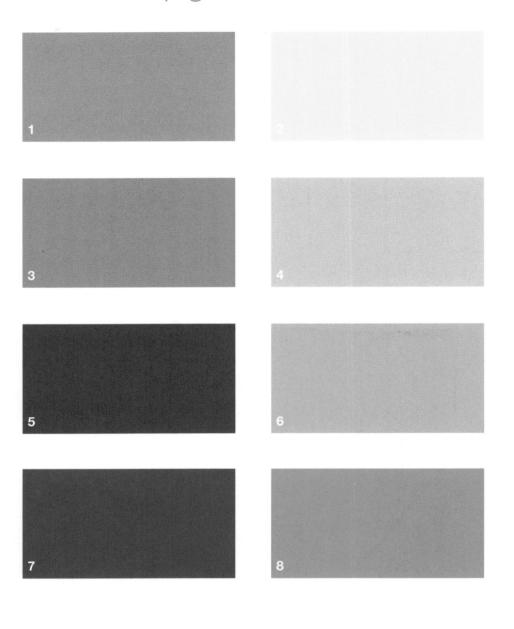

- 1 Correctly known just as ochre. Widely used, it is a strong muddy yellow that is usually more brilliant when mixed with a little white.
- **2** A tint of colour 1. This is an immensely useable colour in decoration and will appear a warm yellow when it reflects on itself in a room. Ochre is the only yellow with which to make a decent cream.
- 3 This colour is that of a very warm and pure ochre of the highest quality, such as the best grades of that produced by the Roussillon mines in France. However, commercial 'Golden Ochre' is often a mix of ordinary ochre and chrome yellow.
- **4** A tint of colour 3. This looks correspondingly warmer, although when ochres and oxides are mixed with white pigments, their hue changes, turning slightly cooler. A deep creamy yellow, very useable.
- **5** A dark and cool red oxide with a purplish undertone. It has powerful tinting properties.
- **6** A tint of colour 5. The purple undertone is clearer in a tint. Cool bluish pinks like this have been used for centuries, especially indoors, partly because the colour appears much cleaner and fresher than imaginable for an earth colour and partly because the resulting tints are not 'sugary'.
- 7 Some haematites and ochreous earths produce much warmer, orange-tinged pigments that have always been more highly prized than the more common purplish varieties. Because it has no hard bluish edge, this colour has often been used at full strength, for example to paint the city walls of Taroudant in Morocco or parts of Rome.
- **8** A tint of colour 7. Tints of warm red ochres have a correspondingly warm bias. They occur on the exterior of buildings as part of a vernacular vocabulary throughout the world: in Morocco, India, Europe and Central America, and frequently appear in this book.

his is an oddball palette. It's not based on an object or place, nor an historic scheme. Nor is it representative of a colour code or an artist's period palette. These colours belong to something called the 'earth' palette, a collection of simple, cheap, totally permanent and uncomplicated pigments that have been in use for tens of thousands of years and which are still widely available. Although not bright, they still form the basis of artists' palettes because of their delicate ambiguity and muddy tonality. These are properties of every earth colour, creating a strong family likeness. As a result this palette has an overall very coherent character.

The pigments rely (mainly) on simple iron compounds for their colour – in other words rust. Because iron makes up the bulk mass of the planet, earth pigments can be easily mined all over the world, being often refined from clay or found in soft stone deposits. So not only are they historical colours, they are also international ones (although strong regional variations and combinations exist). Most interestingly, because these iron compounds also colour our rock, sand, marbles and soils, the colours of earth pigments take on those associations: buildings painted in them appear to immediately 'root' themselves in the landscape. Earth pigments (like all mineral pigments) are mined in almost every country, so wide local variations of colour occur. The swatches here are representative of the significant main types that have been recognised since Greek times and which are now codified as standard artists' colours. Read this palette in conjunction with palette 17 for historical 'common' colours, which included earth pigments.

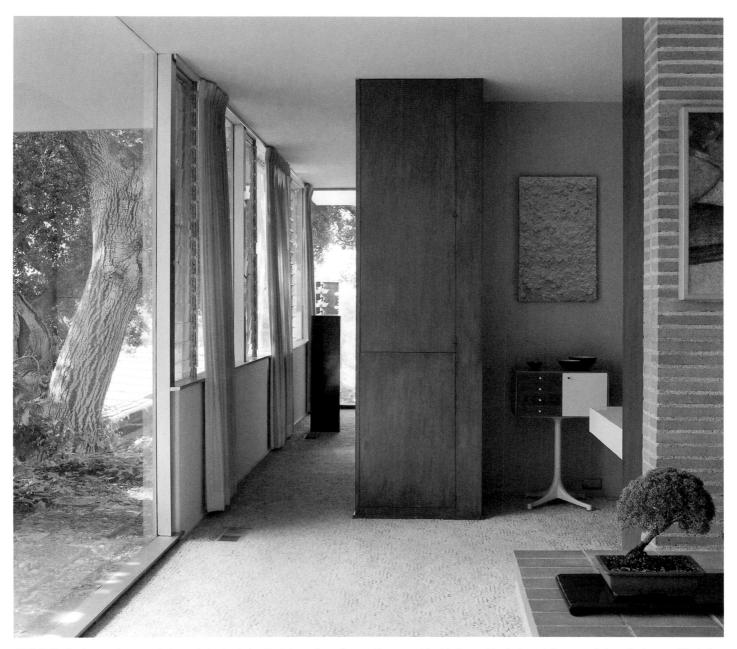

ABOVE: Earth pigments have an obvious role to play in 'rooting' decorative schemes. Because of the big brown bias to the palette, an earth-based scheme will include other natural materials other than clay pigment, such as wood, terracotta and stone. The last two, like many marbles, sands and plasters, take their colour from the very same oxides that colour the pigments.

31 earth pigments

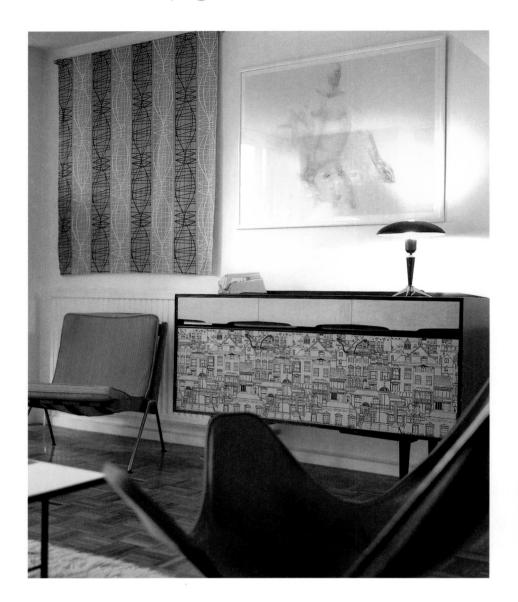

ABOVE: The use of earth colours is universal and timeless. The pigments are so cheap and useful that now, as hundreds and thousands of years ago, they still form the basis of many paint ranges and an important part of the artist's palette. Architecturally they pop up in all sorts of periods. This is a studiedly retro 1950s interior in London belonging to architectural historian Neil Bingham.

- **9** Burnt sienna has become a standardised artist's pigment. It is a useful glazing colour for transparent work and an invaluable pigment for marbling, woodgraining, staining and varnish work. It has a warmer more brownish cast than some of the haematite red oxides.
- 10 A tint of colour 9. When burnt sienna is mixed with white it loses its fiery undertone and becomes cooler. Tints of this colour are useful for suggesting the colour of plaster or for mixing with yellow ochre for the colour of terracotta. This is a restrained and cool earthy colour with a hint of warmth about it.
- 11 Terra verde or green earth. This is a much less effectual colour than the others, being pale, a weak colourant and almost transparent in most media. Despite this, artists and decorators have persisted in using it because of its permanence and

cheapness, its qualities as a glazing pigment and its soft colour (which varies enormously from bluish to yellowish according to the source). Most famously used in Greek icon and medieval tempera panel painting as the under-colour beneath flesh tones.

- 12 A tint of colour 11. Because of this pigment's weak tinctorial power, it is almost useless when mixed with white.
- 13 Raw sienna. The pigment is rich, deep and golden when used undiluted and is more opaque than ochre. As its name suggests, it is an 'uncooked' or raw version of burnt sienna, deriving originally from the area around Siena in Umbria.
- 14 A tint of colour 13. The best grades of this pigment produce a tint the colour of manila envelopes, a rich warm beige. A very useable decorating colour.

VIEW THIS PALETTE WITH THE GREY VIEWER

- **15** The name Mars indicates a synthetic iron oxide. Traditionally, naturally occurring purplish iron oxides have been processed and used in small quantities, although the colour was often weak as represented here. Modern Mars violet is deeper than this.
- 16 A tint of colour 15. A delicate greyish violet tint and very useable in decoration because the earthiness of this pigment prevents the colour looking too synthetic.
- 17 When raw sienna and raw umber are mixed, a neutral brown results that is similar to many shades of mined sienna and mined umber pigments. This is a useful colour in decoration, a neutral muddy nothing brown for antiquing and ageing other colours both when mixed with them and in a glaze or varnish coat.
- **18** A tint of colour 17. This is one of the most versatile and useful earth tints for artists because it has a greyish

- 'dust' like colour without the coldness of a raw umber tint or the obvious 'coloured' warmth of a raw sienna tint. A beautiful wall colour and one which appears in many regional/vernacular palettes in this book.
- 19 Orange ochre/Pozzuoli red/Mars orange. This is a dark colour that was historically superseded by red lead (a bright orange), realgar or orange-biased vermilion. However, there are many recorded cases of these more expensive pigments being adulterated with red earth pigments, for which an orange version would no doubt have been useful.
- 20 A tint of colour 19. A good terracotta colour.
- 21 Raw umber. This colour is added to many pseudo-historical colours because it's very good at suggesting dirt. It does form the base of one or two deep sludge hues of the eighteenth century (see

- also palette 17) and is a very useful toning/shading colour when used in small quantities in mixes because of its cool neutrality.
- **22** A tint of colour 21. Artists often prefer greys made with white and raw umber: the greenish brown bias is obscured and the resulting grey is warm and very useable.
- 23 Burnt umber. Raw and burnt umber take their name from Umbria in central Italy whence the finest grades once came. They complete the set of six basic modern earth colours. Burnt umber is deep, heavy and chocolatey in character.
- **24** A tint of colour 23. A grey pink-brown, a significant colour of design and decoration in the 1940s (see also palette 20), although it occurs in many other periods.

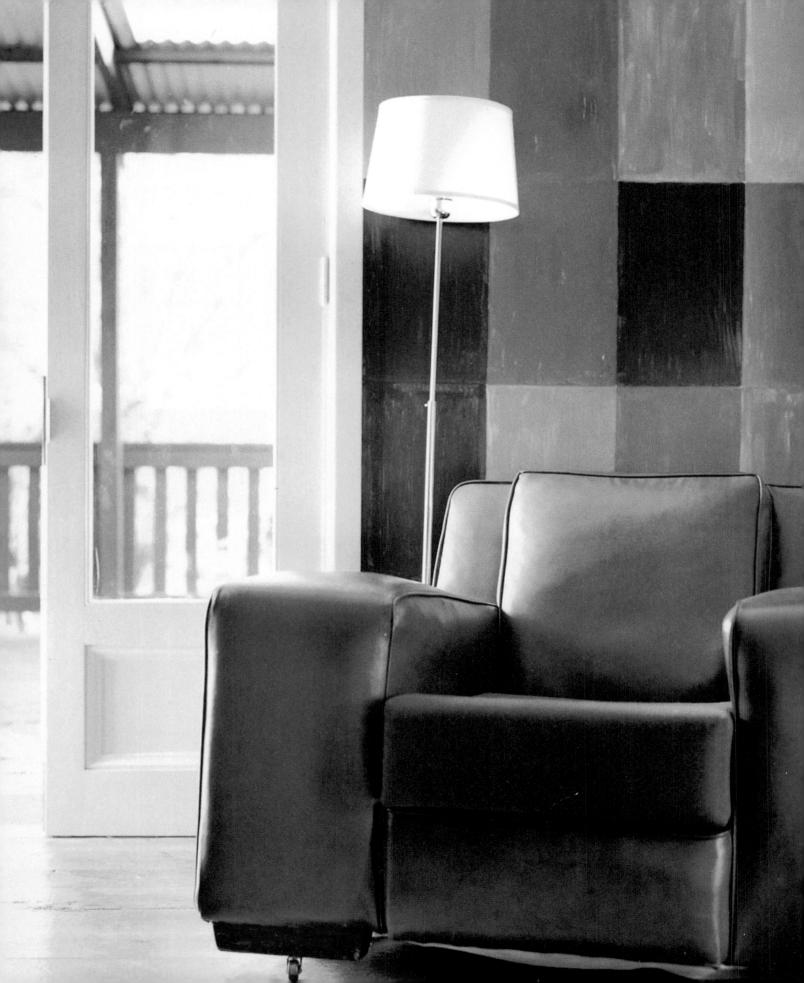

32 the lost colours of the Kalahari

- **1** A good colour to suggest moderately bright bronze, a muted and ambiguous yellow-brown-green.
- **2** A very useable warm buff colour with no nasty traces of orange. Like a manila paper.
- 3 This is the cleanest colour in this palette, an ochre cream that is essential to keep the whole palette from appearing too dingy.
- **4** A strong sage green, the colour of ancient textiles overdyed with weld (yellow) on top of woad (blue). For other colours of this derivation see palette 44.
- **5** This moss/khaki colour has enough blue and grey in it to make it useable and ambiguous. A possible cusp colour.
- **6** A deeper version of colour 5. Use with the other colours in this column, especially the brown, to control if
- 7 A slightly greenish petrol blue or is it green? An interesting cusp colour suggestive of a faded version of colour 4, where the woad (blue) prevails.
- 8 A key colour in this palette but also for the four lower colours by themselves. This is a rare thing: a very useable true brown; slightly greenish, slightly grevish.

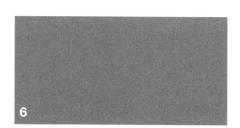

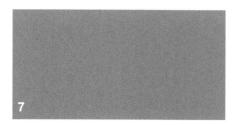

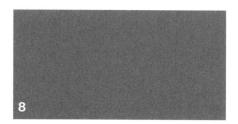

hese are Savannah colours. The dried-out straw colours of grasses and sandy soil, the greens and browns of foliage, bark and caked mud. These aren't clean colours (they are in fact all taken from Verdure tapestries), they have been made complex by the addition of brown or grey or a little of a colour's complementary (which has the same effect) or by the pollution of a colour's hue by the adjacent hue (such as colour 7, which is a green that is almost blue). In fact, in every case a combination of complicated changes has affected the original hue, so that colour 4, for example, is an emerald green, tinted with white, discoloured with a little blue and muted with brown and grey.

It is complex mutations like this that make colours interesting (up to a point), especially when groups of such colours are brought together. By contrast, if this palette consisted of clean, simple browns, greens and yellows, it would have seemed coarse and childlike. Instead, its complexity gives it sophistication, both here and in use.

OPPOSITE: Green isn't always an easy colour to manipulate indoors. Breaking up surfaces and employing a number of different greens together helps. This is what designer Lisa Stafford and her husband, horticulturist Patrick Shaw, have done to their home in the Otway Ranges, west of Melbourne.

33 colours obscured by age

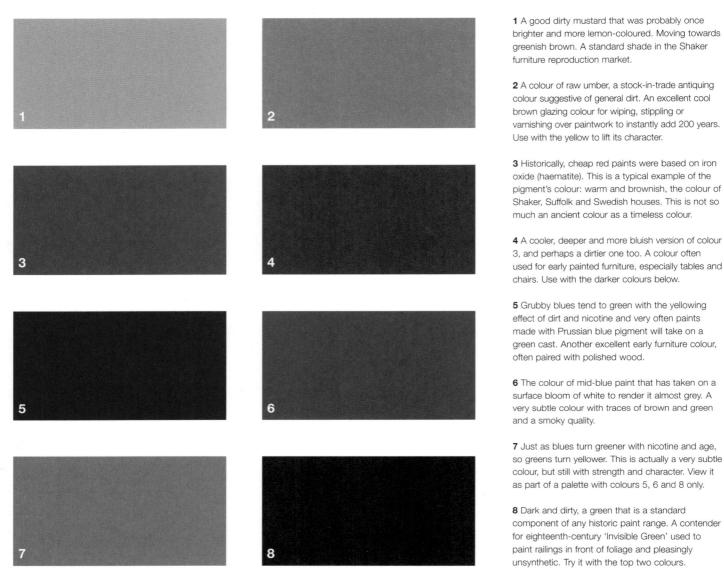

everal paint manufacturers sell deliberately 'dirty' or 'aged' paint colours as 'pseudo-historic' colours. Others produce 'heritage' ranges.

They all use the same idea in their production: they add brown pigment to the colour to dirty it. Some might add a touch of a colour's complementary – a much more subtle touch and one that produces a colour that is complex rather than just grubby. The colours here

By comparing this palette against colours from, say, the seventeenth to nineteenth centuries (see palette 17), you can see that these attempts are often pretty hopeless: colours in period decoration were in fact often very bright and clean; it's usually centuries of smut and nicotine that produce the tones that are then copied and marketed as 'authentic' period colours.

But if you're painting a reproduction chair and you want to suggest that it's a 200-year-old Shaker or Pennsylvania Dutch piece, then these are perhaps the colours for you. They're the colours of theatrical fakery and of instant heritage.

represent both those techniques.

34 baked clay

ome of the most powerful and universal palettes are based on geology: on the colours of clays, of baked earth, of the desert, of rock, of earth pigments. This isn't at all surprising given that they all depend on the most common of all naturally occurring colourants, iron oxides. This palette demonstrates a range of colours that can be procured by cooking clay and consequently cooking the iron oxides inside the clay. It is based on typical ancient Greek pottery and so carries with it another associative value, that of the ancient world. It also appears in early nineteenth-century Greek revivalism as a base palette for late nineteenth-century polychromy and in Greek-inspired interiors from the 1930s.

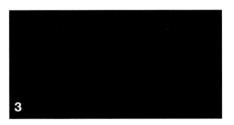

purple. This is a beautiful cusp colour that will markedly change character according to the prevailing light.

- 1 A good deep terracotta, redolent of the detail work on ancient Greek pottery. Particularly vibrant with the plum colour, below and to the right, since they are tonally equivalent.
- 2 A good warm iron oxide colour with an orangeish undertone. Looks good and rich against black. This kind of warm red that was prized in the past as an outdoor paint colour.
- **3** Black, a dominant glaze colour on Greek pottery, often used for background and line work.
- **4** A paler terracotta more suitable for larger areas.
- **5** A greyish, brownish plum: a bruised and complex colour that hovers on the red side of
- 6 Cream detail and panels (and later, backgrounds) occasionally surface on Greek pottery. As part of the entire palette, it is a highlight colour to be used with restraint.

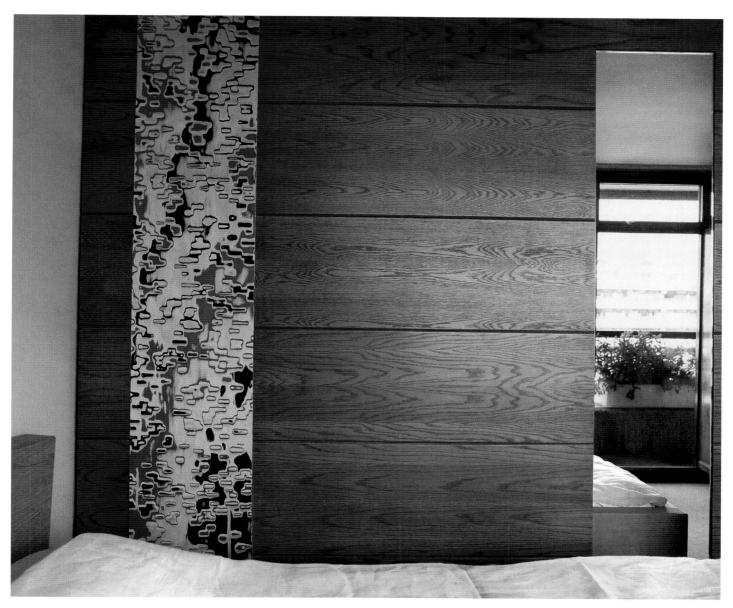

ABOVE: This palette is very easy to assimilate because the colours are all so approachable and because they're so similar to the colours of other natural materials: stone, pottery, marble and even wood, used here in the expert hands of designer Paul Daly.

35 deep water

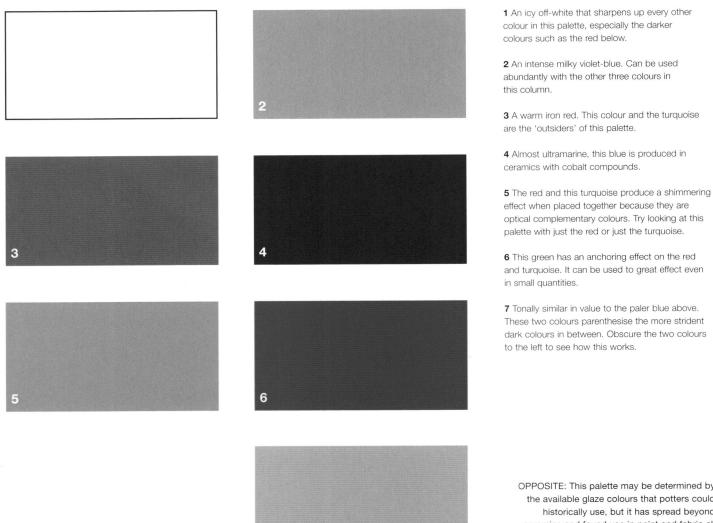

OPPOSITE: This palette may be determined by the available glaze colours that potters could historically use, but it has spread beyond ceramics and found use in paint and fabric all over the Middle East. Stephen Skinner's house in Marrakesh.

erhaps it is the turquoise and sea-green in this palette, perhaps it is the general predominance of blues and greens, or the general cleanness of these colours, but this arrangement seems very clear and fresh, like the waters of the Aegean. Of course colours have all sorts of emotional power and effects. Blue, particularly pale blues, are apparently calming; they certainly recede and so a blue room will appear to be larger than it is. Green is supposedly the colour of balance and refreshment; Nero is said to have once appeared entirely clothed in green on the floor of the Coliseum, which itself was covered in green chrysocolla pigment; all in an attempt to rejuvenate both himself and his reputation.

The red and the turquoise are the two mavericks here and both can probably be used in minute squirts to spice up the other colours. All are in fact taken from Middle Eastern (mainly Turkish) tiles. These ceramics can be distinguished from their Oriental equivalents by the more liberal use of turquoise and green in their (basically blue) patterns.

Note that the red, although somewhat shaded, is the approximate complementary of the other colours, which make a broad band of blues and greens.

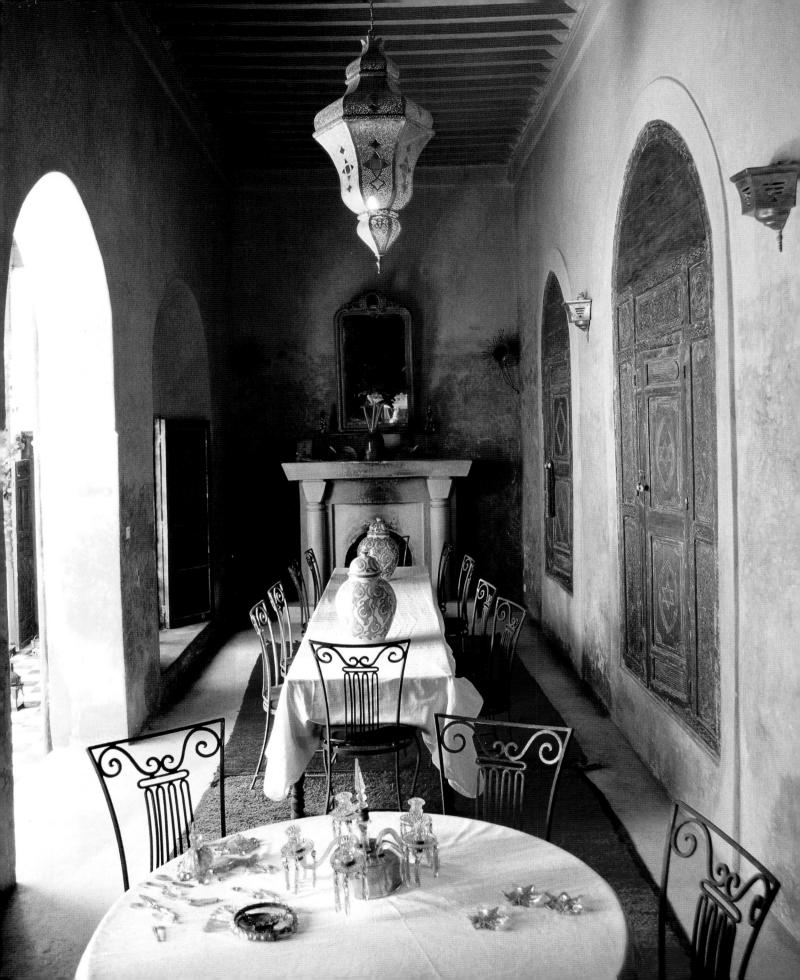

36 the colours of pebbles

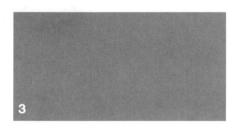

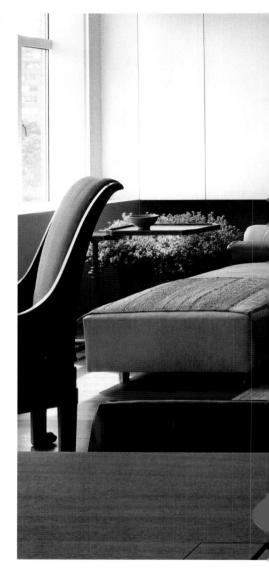

- ${\bf 1}$ A good clean pale yellow ochre, which cheers up this entire palette. Very useful as a house colour.
- 2 This purple-stained brownish grey is a pivotal colour on this page. Try covering the lower half of this page and then add colours 9 and 10 of palette 37, overleaf, for a very subtle six-colour palette.
- 3 An almost green-brown, useful for its ambiguity.
- 4 A dirtier and more restrained version of colour 1.
- **5** This blue is slightly greenish and dirty, the colour of a clear blue paint that has yellowed under

- varnish. Delicate and very useable. A cusp colour and therefore useful indoors.
- ${f 6}$ A warm buff that is an essential component of this palette, as are all the neutrals. A good complex and ambiguous colour.
- 7 A much warmer and less ambiguous colour than colour 6, but as a result of being pinker, it enlivens greens much better.
- 8 This deep olive intensifies the character of the palette on this page. Try obliterating it to see the difference. Use especially with the blue and ochres.

ABOVE: The advantage of working with a large palette of connected colours that have one coherent provenance is that it's not difficult to find objects and furnishings that fit into the overall scheme *somewhere*, such as in this room by New York-based architects Tsao & McKown. But with this kind of eclectic approach, it's important to get the objects together first, then paint the room in colours that will help 'stitch together' the entire palette.

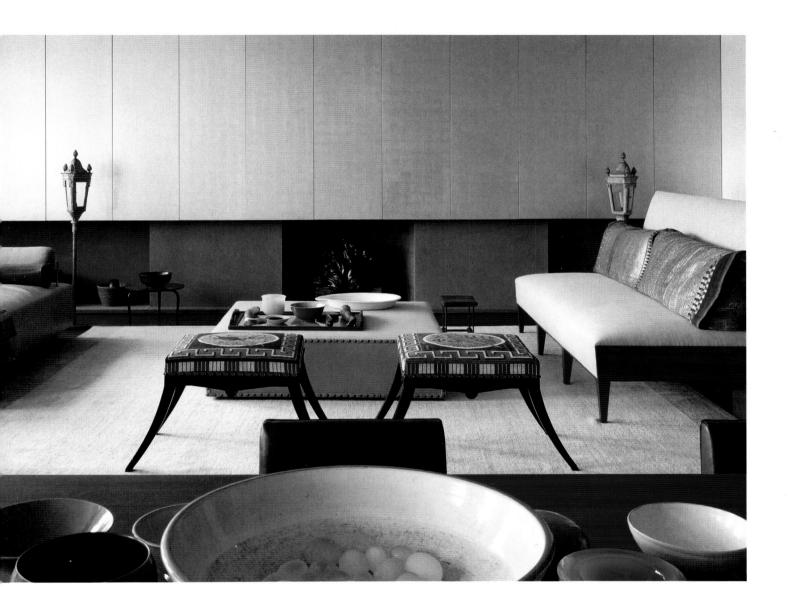

ere and overleaf is a collection of twenty colours that are all of a family. They have an earthy subtlety that suggests the palettes of North European cities. They could be the colours of Scandinavia or of American East Coast seaboard houses. Their collective identity is strengthened by the suspicion that each colour has something of all the others added to it.

Although they're different, there appears to be a common ancestry behind this entire palette, and this phenomenon will ensure that any combination of colours that you choose from this palette will work well together.

37 the colours of shells

- 1 A warm, slightly brown off-white. Particularly good against the reds and pinks in this palette or the greens in palette 36.
- 2 The darkest colour in this palette, but one that can be used to great effect to 'point up' a combination of other colours, a trick that occurs in many mosaics.
- **3** A good warm neutral mid-grey. An invaluable colour, not least because it suggests fur or suede.
- **4** A slightly more yellowish off-white. Use with yellows, reds and pinks in this palette and especially the blues in palette 36.

he reason for these colours' common quality is that they are all derived from minerals.

These are the colours of rocks and stone, colours that are never bright hues but which nevertheless represent every segment of the colour wheel. In this case they also represent every corner of the Roman Empire, since they are taken from a number of Roman mosaics from around the Mediterranean. So these are also the colours of ancient floors.

- **5** The most neutral off-white in this palette and an excellent wall and ceiling colour.
- **6** A very clean pinkish iron red. Try using it as part of this column only, and with the greens in palette 36. A cusp colour.
- 7 A neutral grey.
- **8** An off-white veering towards buff. Its greyness keeps it neutral and interesting.
- **9** A cooler, greener version of colour 8. Try using them together with reds or greens.
- 10 A soft stoney pink that relates to all the other reds on these pages. Use it with the greenish neutrals colours 9, left, and 12, below or with the greens or blue in palette 36. A very beautiful colour for interiors.
- 11 A brick red to use with the greens in palette 36.
- 12 A good brownish grey, the colour of a grey made with raw umber and white. Very useable in all media because it suggests grey without looking bluish.

38 water and air: Oriental elements

- **1** A delicate and subtle blue, which was a medieval Chinese ceramic colour.
- 2 'Duck Egg', another export Chinese ceramic colour. All the colours on this page represent glazes that were applied as single colours to very simple forms. This blue-green is very useable and is a cusp colour, sitting on the edge of blue.
- 3 This brown is the key colour to this palette. Remove it and all the other colours appear more bland. Even a small quantity of this colour will enhance a combination of the others. Try it with any one of the others for a very robust relationship. From medieval Chinese bowls.
- **4** A robust and slightly dirty greenish cream, from a seventeenth-century teapot. Both the object and this colour were copied in 1930s ceramics. Use the colour as an 'old' white.
- **5** An exquisite sage green, immediately suggestive of Chinese porcelain and a very subtle colour. Try using it with just the other two colours in this column.
- **6** Another delicate colour, very 1920s in feel (see also palette 19). Try using it with just the other two colours in this column.

ere are the colours of water and air pitched against those of chalk and earth. A very modern palette ideally suited to the New Modernist mantra of 'light, space and clarity'. But like so many apparently up-to-the-minute palettes in this book, it is actually much, much older, and has its roots in ancient Chinese ceramics.

The trade routes to the Orient were opened up by the Dutch in the seventeenth century, but contact with Oriental culture was limited to a small number of designated ports. Consequently, both China and Japan quickly established manufacturing industries producing items specifically for export to the West that were made to cater for Western tastes, which means that since the early 1600s our understanding of Oriental colour and design has always been controlled at source. All the colours on this page are taken from Oriental ceramics (all of which are listed in the Notes to the Palettes section on page 180). The colours form a coherent palette redolent of the 1920s and even of nineteenth-century Orientalism (William Morris used this palette in his wallpapers).

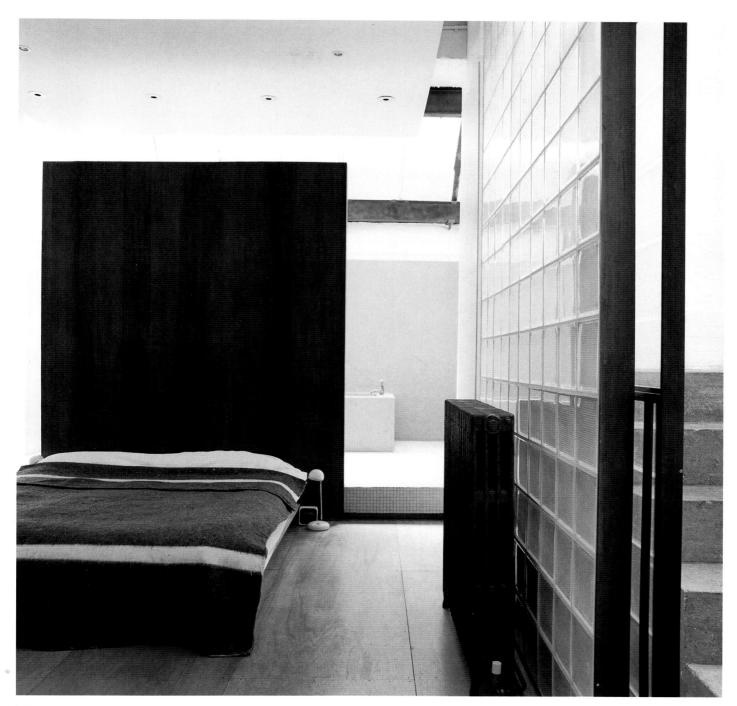

ABOVE: The aquatic and aerial connotations of this palette are brought out in this room through the use of materials (such as glazed tiles and glass) and by zoning the colour so that blue is used only in the bathroom. Brown appears as dark wood, which connects to the other story here: the use of natural or simple materials like wool and concrete.

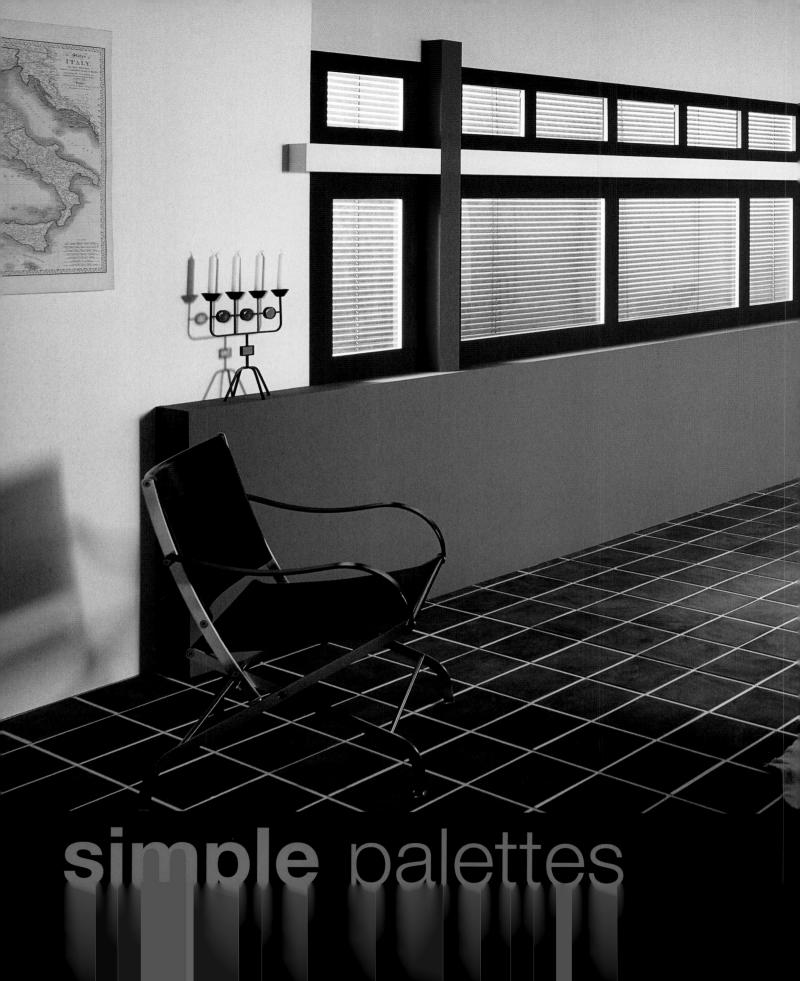

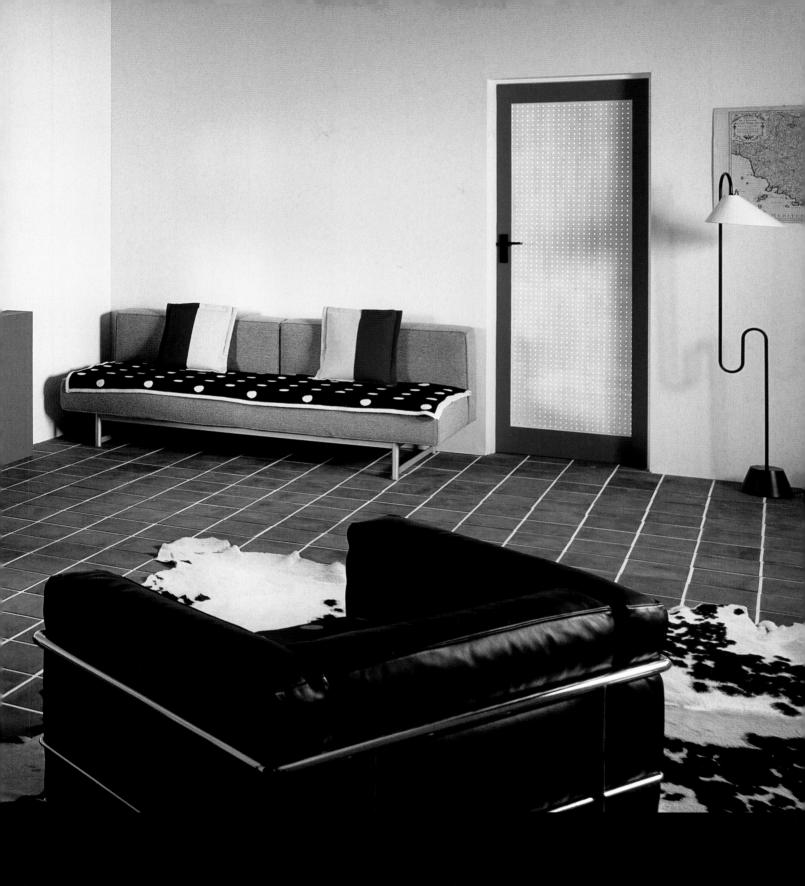

39 in the red corner, in the blue corner

- **1** Aka, thought to be red, and the finest, makka, is bright vermilion red. No holds barred.
- 2 White is shiro and at its finest, masshiro.
- **3** Black is *kuro*, and the purest pitch black, *makkuro*.
- **4** Blue, *ao*, is the fourth colour and when refined it is *massao*, or sky blue. Only these four colours can be prefixed with the superlative *ma*, meaning true or perfect.

his is one of the few palettes in this book which represent a philosophy – here it's a set of ideas that underscore a culture, Japanese culture. It might have been possible to put together a palette representing the modern country, but the modern Japanese visual zeitgeist is now so Westernised and chromatically fractured that it is difficult to pull out of the wreckage of advertising and youth culture any coherent visual statement. So here instead are the colours of old Japan, which are still revered, used and referred to daily. The four-colour palette on this page represents a traditional decorative palette of refined pigments that were mentioned in the first Japanese history dating from the eighth century, have been formally codified through the centuries and are still engrained in Japanese culture. Twelve centuries on, the four colours remain the basic structure on which Japanese colour perception and nomenclature are based. They make one powerful palette.

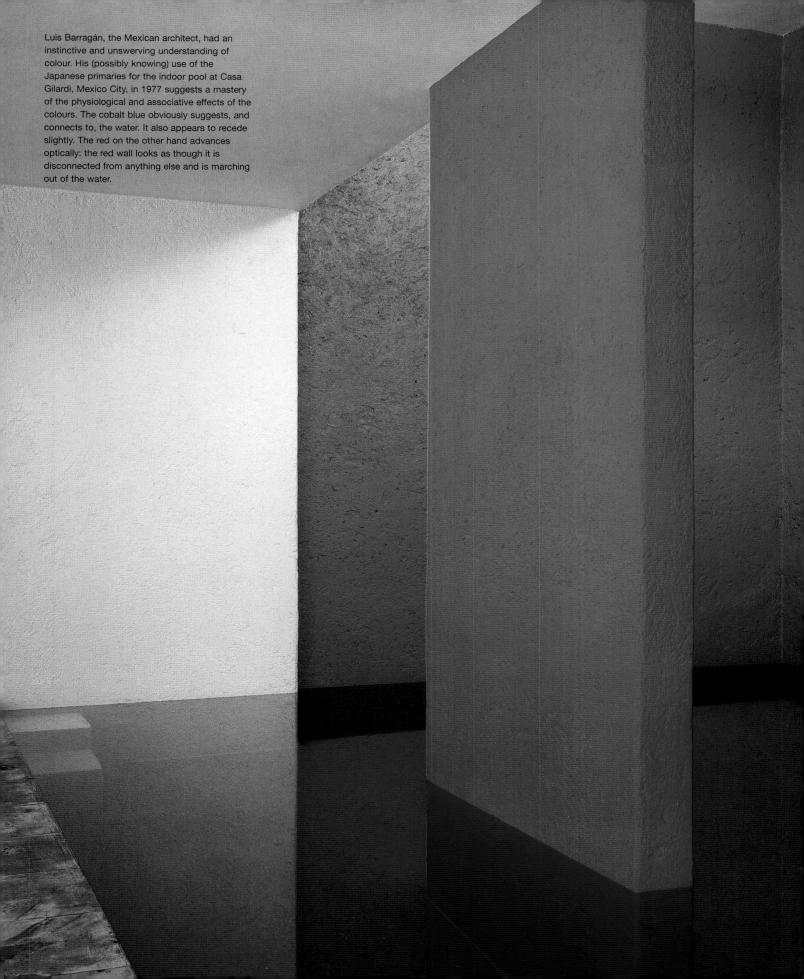

ABOVE: When blocking colour in a room, a common cheat is to find objects, like this cushion, which pull all the colours together in one place. Of course, it's so much more clever to find a cushion you like and design the scheme around it. No one will know the difference.

40 silk, cinnabar and oxblood

ere's a palette that can hardly keep itself under control. Mercifully, a good dollop of brown brings it into order. But despite its recklessness, it has a venerable history. Until the twentieth century, our society's understanding of colour was heavily dependent on the use and availability of pigments, dyes and glazes that could be formulated, refined and processed from naturally occurring materials. Reds were extremely difficult to procure: bright red pigment was highly prized, permanent dye almost impossible to achieve and red glaze elusive (note the complete absence of red from palette 59). The Chinese and Japanese, however, successfully processed large quantities of red colorants for use in manuscript writing, lacquer work, silk dyeing and ceramics. These three reds are, to an extent, the West's impression of Far Eastern culture. They are, if you like, 'trademark' Oriental colours that have reached far into our collective cultural consciousness. As such, they are very powerful markers of all things Eastern. They're matched with an intense yellow, the colour of dyed silk robes from all Chinese periods.

In palette 38 there are more trademark Oriental colours that are especially suggestive of the late nineteenth and early twentieth centuries. See also the Oriental ceramics palette 60, as well as palette 46 for more trademark export pinks and greens.

- 1 'Silk Red', a colour achieved by intensive dyeing with madder. A warm orange-red of pure hue. Very appealing; a colour that optically 'advances' towards the viewer.
- 2 The colour of Chinese lacquer. Although carved lacquer is derived from a tree resin, its typical red colouring is from the addition of cinnabar (mercuric sulphide) that was ground into the resin. Chinese vermilion pigment is manmade cinnabar and is still exported. See also palettes 39 and 45 for vermilion matches from other sources. A beautiful rich red that sits between the hue left and red oxide.
- 3 'Oxblood', derived from a ceramic glaze developed in the early fifteenth century and improved in the seventeenth century into this colour. The glaze was made with copper and was notoriously unreliable, so products glazed in red were therefore expensive. An eighteenth-century variant was 'Peach Bloom', a mottled, more intense and even pricier version. Brown was never more expensive.
- **4** Chinese yellow, an intense and warm colour that is characteristic of robes of all periods.

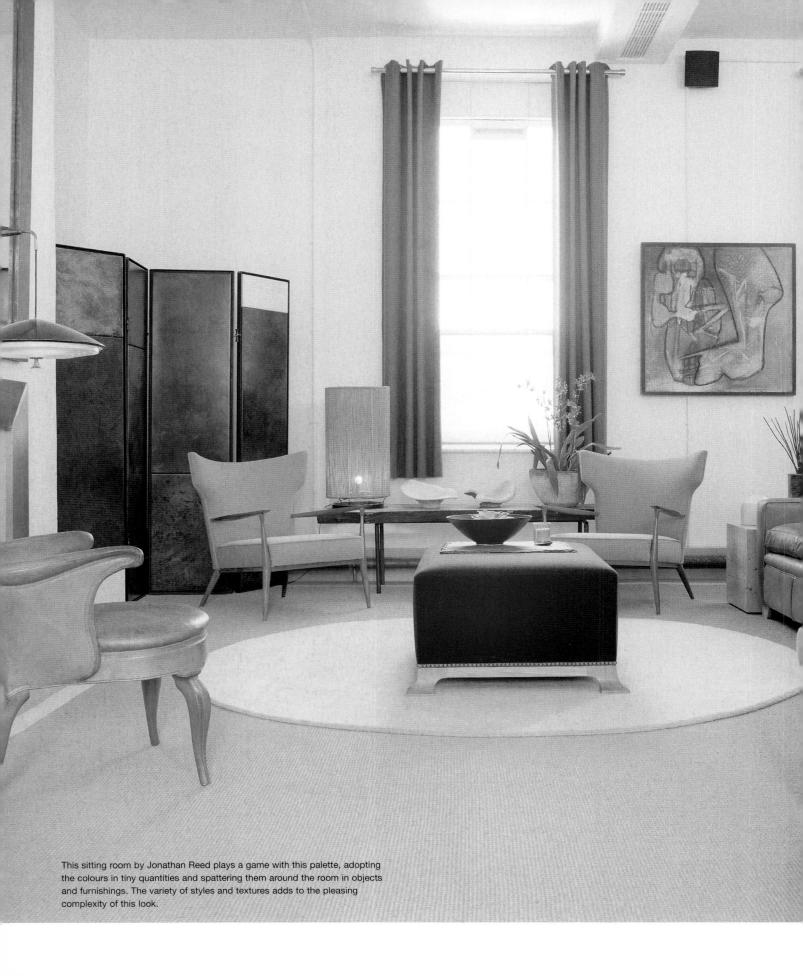

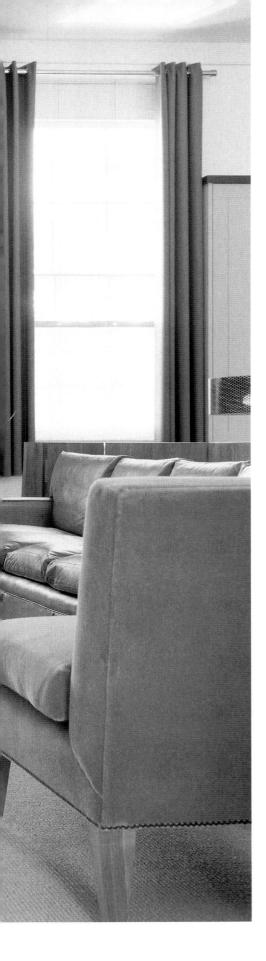

41 gilt-edged, blue-blooded

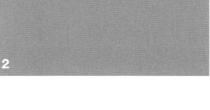

- 1 A bright ochre-like yellow, but more vibrant, like a lead-tin yellow. A little milky and subdued and so very useable.
- 2 An equally milky tint of cobalt blue, pure and untainted by either green or purple. Its strong relationship with the yellow derives from their shared restrained tonality against the black and white of the page. That's a very refined relationship between them and one worth exploiting for its edgy balance.
- 3 A key colour in this palette. Try looking at the blue and yellow through the grey viewer while covering the black. They need black and white to provide a resonating contrast.

his is one of those palettes of colours that repeatedly pops its head up through history. It is one persistent set of colours. The relationship of green to its complementary, red, is a dialogue that has been explored in every sphere of the pure and applied arts (see palettes 43, 44, 45 and 46). But this palette is far more particular and well-balanced: a neutral dusty cobalt gently complements a bright ochre tint. The three colours here, together with white, form part of the Minoan and early Greek palettes. They also appear in the early nineteenth century as English ceramic colours and in twentieth-century ceramics. They're the colours used in tile schemes in some Moroccan palaces and they're even similar to the muted primaries of 1950s lithographic printing (see palette 42). This may look like an innocent and anonymous team of colours, but it's actually a powerful combination.

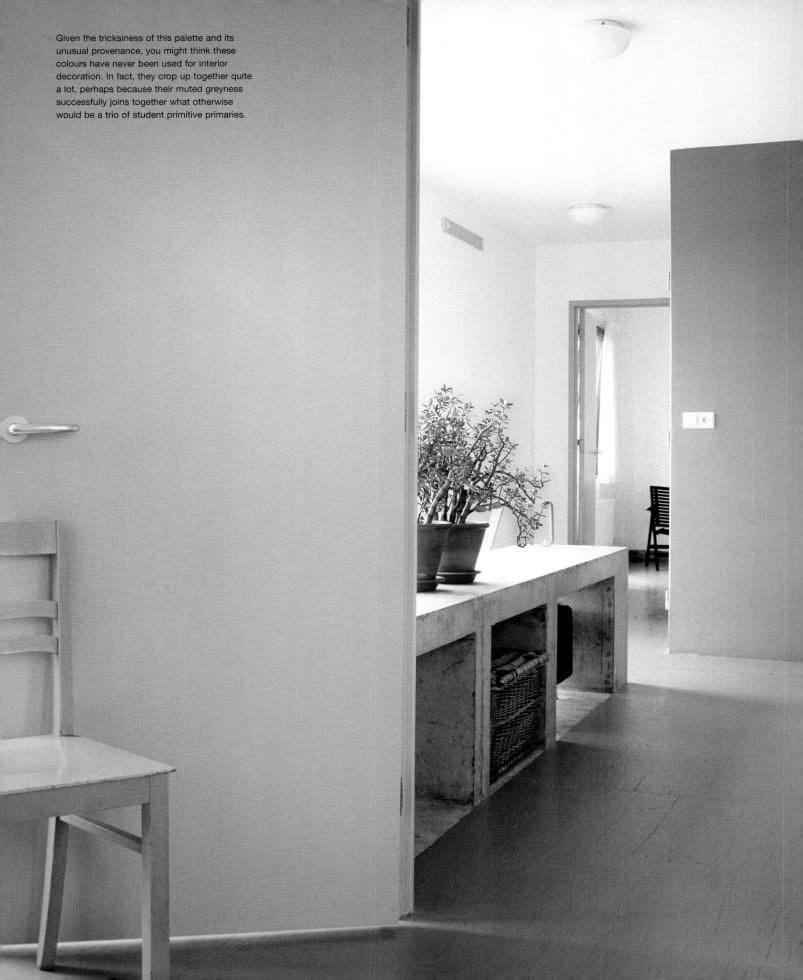

42 fifties vogue

f these primary colours have a vintage feel, you've already been hooked: hooked by your memory onto the lure of the palette's origin.

These are actually Egyptian colours of the fourteenth and fifteenth centuries BC, but they're here principally because they are also colours of the 1950s and '60s. However, these are not the colours of buildings or interiors of these two decades, nor of bright modernist furniture, nor even of fashion. These are the colours of how the times were communicated then. In an age of grey newsprint and of black-and-white TV, these are three colours from the world of glossy magazines, the swinging primaries of offset lithography. Of course, the basic ink colours of commercial lithographic printing are nothing like these colours (see colour model 4 on page 11); these are the dull cousins of bright hues that offset lithography strives to produce through combinations achieved by layering inks. Forty years ago, these colours were often the best technology could achieve.

The red, yellow and blue shown here are a tribute, not to '50s and '60s design, but to how it was seen by millions, and because of ink fading, how subsequent decades saw it. Interestingly, blackened colours like these have recently been used to sell a reborn '60s icon, the Mini Cooper.

1 A warm red formulated with an overprint of 20 per cent black (to give you an idea of its grubbiness). Because of this mix of greyness and warmth, this is actually a very approachable and useable red.

2 A complex yellow with 10 per cent black and 6 per cent orange to prevent it turning green. Not strident, so good with the red or blue.

3 The intensity and permanence of phthalocyanine pigment in cyan printing inks means this colour is least affected by poor print quality, over-abundance of black and fading. Fifteen per cent black ensures this colour is complex and interesting.

43 the red and green story, part i: racing green

- 1 A deep 'rosso' red. For those supercar buffs, 'rosso' is simply the Italian word for red. You could almost get away with painting your dining room this colour.
- **2** A brighter red that contrasts vividly when set against the green, below. Since World War I, red has been the agreed international racing colour of the Italians.
- 3 This green is almost black and is about as accurate a match as is possible to the chimerical 'British Racing Green' or to be correct, 'Napier Green'. This was the racing colour for British cars, although the greens actually used varied wildly.
- **4** Off-white or 'Vintage White' seems to accompany many other colours and was the prewar German racing colour. After the war the Germans raced in silver or even bare polished metal earning them the title 'Silver Arrows'.

his is the start of our red and green story, one of the greatest love affairs in the torrid history of colour. But here they are paired almost accidently because this palette is based not on one object or place but on international racing car colours. Researching car colours is, on the whole, a waste of time. Manufacturers don't keep records of the colours they used fifty years ago; colours change at the whim of owners and factory owners; cars rust and their paint fades outdoors. Even Ferrari, who are famous for one colour, have used possibly dozens of different reds over the years. However, there are scraps of scholarship available and I have listed a brief and interesting history of racing colours in the Notes on the Palettes on pages 181–2. So this palette is an informed but still very personal selection: two sports car reds, one British Racing Green, one Vintage White. A small choice. Henry Ford would have cautiously approved.

OPPOSITE: David Carter is a designer who will never avoid an issue. In the home he shares with his wife, Lizzie, in London, he's grabbed this palette by one red horn and one green horn and given it a good kicking. He has made the scheme more pliable by underpainting the green with gold paint and by adding opulent 1930s and '40s furnishings. This is an exciting and intriguing space.

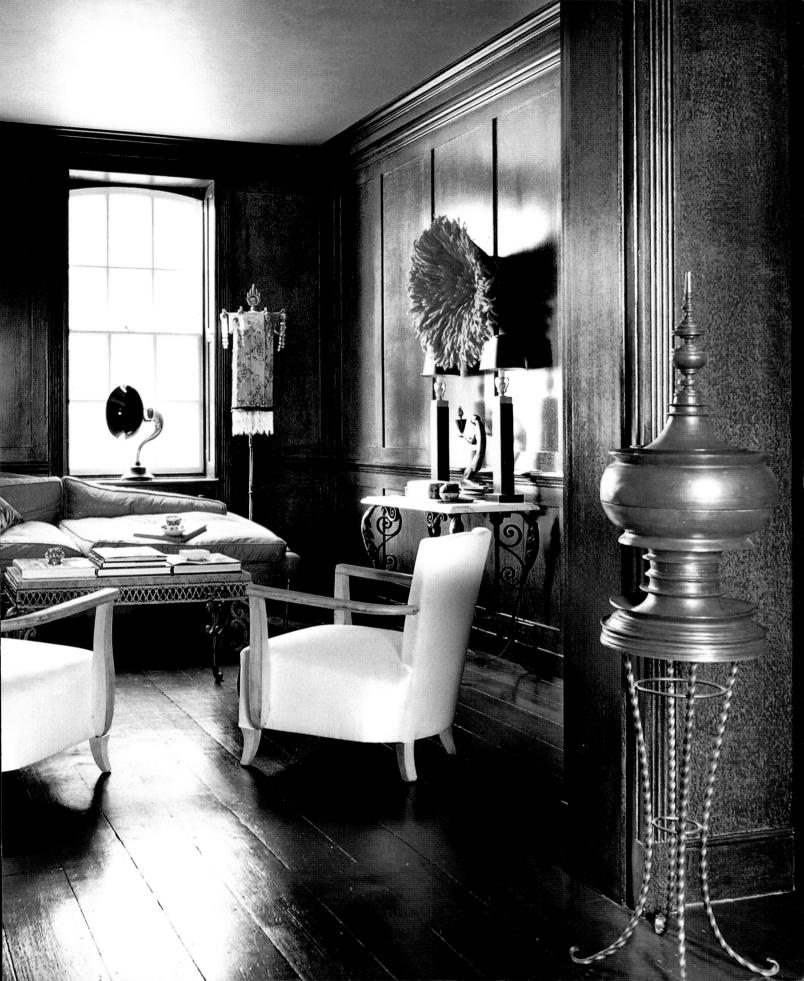

44 the red and green story, part ii: English chintz

f all the examples of red and green palettes that history has thrown up, none is more agreeable than this one: magenta red and sage green. This is the palette of delicate nineteenth-century French printed linen and of chintz wallpaper. These colours date from the 1950s, the 1920s and the eighteenth and nineteenth centuries. They are even medieval, for the simple reason that they represent common dyed fabric colours, those produced by woad and indigo for blue, by weld for yellow, and by roots from the madder plant, which yielded a range of intense pinks and reds.

But the earliest, most coherent use of red and green together occurs in seventeenth-century India, from where the fashion for this palette spread throughout Europe. These swatches were all matched against Murghal wallhangings and floor coverings, delicately embroidered with tracing floral patterns, in fine, beautifully dyed silk, which printing inks cannot hope to emulate.

If you are looking for any kind of balance or lightness of touch when using all these colours, it's essential that the magenta is used sparingly. The ground colour should dominate or balance the green in quantity. The red and pink are secondary. Experiment by using the grey viewer and blocking out portions of the red and pink swatches.

Alternatively, use the green and the pink together freely.

- 1 A sage-like green but with more yellow in it. Similar to many 'historic' green paint colours. The foliage colour of Murghal hangings. Use in quantity against the red.
- 2 Neutral off-white ground colour, very useful when juxtaposed against the red to control it and as a support for the green.
- **3** Magenta-red pink, but fairly deep. Can be used in abundant quantity with the green. These two colours together form a very flexible palette.
- **4** Deep magenta-red used with the pink as the floral colour in Murghal hangings. Use with care.
- 5 Historically, green fabrics were produced by overdyeing a blue dye with a yellow dye, such as weld. As the yellow dye fades over time it reveals the soft blue of the woad or indigo used beneath. This colour is a good foil to the pinks and greens of this palette.
- **6** This colour is equivalent in tonality and intensity to the colour, left, and can be used with it or with any combination of colours in this palette.

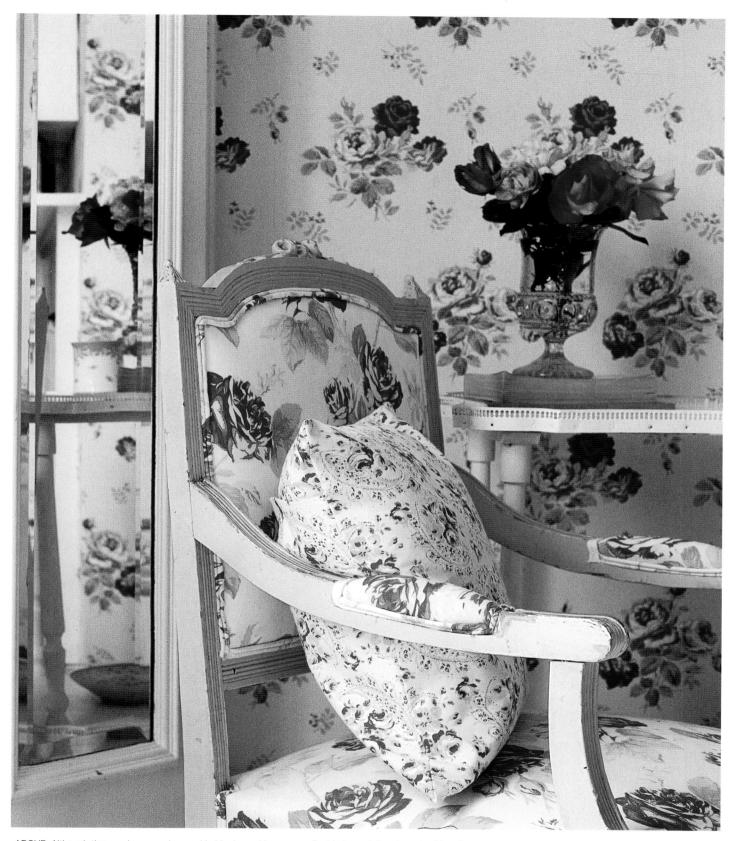

ABOVE: Although these colours can be used in blocks and large areas for big impact, they have traditionally been mixed in small patterns, following the early inspirations for the palette: roses and other wild flowers. Cath Kidston is the latest designer to rework this vocabulary.

45 the red and green story, part iii: Italian punch

- 1 and 2 This first pair of colours appeared together in 1350. Here the deep and blackened green has some blue in it. The red, equivalent to a slightly dull vermillion, is relatively pure. To avoid the green looking completely black, it should not be used as a detail colour against the red but in large areas (see the photograph for palette 43). The red will support being used in small areas, but will appear to 'hover' in front of the green.
- 3 and 4 The historical equivalent of orange is red lead. Its light tonal value contrasts starkly with the very dark green. This tonal contrast makes up for the fact that the hues of these two colours are not complementary on any colour wheel, but occupy the same third of the wheel. The result is that orange detail on a green ground will be clear and readable. But, as above, the dark green will appear black if the relationship is the other way round.
- **5 and 6** Colour 5 is another intense red, brighter and moving towards orange. This time the green in colour 6 has given up, it's too weedy by comparison. The only way it can fight back is with volume, so a combination of these two colours must employ the red sparingly, otherwise the green will look grey.

he great dialogue between red and green is one of the major ideas running through the history of colour. But there is a secondary, related idea about pinks and purples and orange, and how, in the minds of artists, they have also been worthy adversaries of green.

The juxtaposition of a pure spectrum red with pure green to produce a shimmering complementary effect is not common before the twentieth century. The nearest thing occurs in medieval fashion, where different coloured robes were worn together (although the notion of the two colours as complementary did not emerge until much later). But what does occur a lot throughout history is the modification of one or both colours to a tint, or a darkened tone or a greyed or otherwise muted colour.

The references for the colours here come from Tuscan and Sienese Renaissance painted furniture, on which the interplay of red and green was experimented with for several hundred years.

46 the red and green story, part iv: French pinks

- 1 A cool bluish mauve pink, which sharply contrasts with the acid green to the right to make a very exciting combination.
- **2** An intense sharp green, striking against most colours, especially purples.
- **3** A typical Sèvres pink, supposedly invented by Mme du Pompadour and named after her, its name later changed to 'Rose DuBarry'. There is enough white here to make the colour versatile, enough blue to prevent it turning sugary.
- **4** A complementary green to the pink, left, representing 'Sèvres Vert'. Also tinted with white.
- **5** A generic intense pink that came to represent Sèvres 'Famille Rose'. Also the colour of some early Dutch ceramics painted in imitation of imported Orientalware.
- **6** A Sèvres blue, a version of 'Bleu Celeste', lightened with white to tonally balance the 'Famille Vert' and 'Famille Rose' colours.

his palette continues – and develops – the honourable red-green dialogue. The bottom four colours on this page consist of pinks and softened greens that in the main are all shifting towards blue, giving them a collective family trait. The top pair, however, contrast more sharply with each other. Here, the pink is moving markedly to blue, while the green is moving to yellow, blue and yellow also being complementary. This is a complicated game they're playing.

This is a interesting since the top pair of colours is taken from a primary reference source – Chinese porcelain – while the other four indicate French eighteenth-century taste, being colours formulated in the Sèvres factory, which in the 1760s began to imitate Oriental imported ceramics to satisfy domestic demand. In any case, these colours mutated slowly through time: by the late nineteenth century the pinks (of the Harewood bottle, made in imitation of Sèvres) had become warmer and a little sickly.

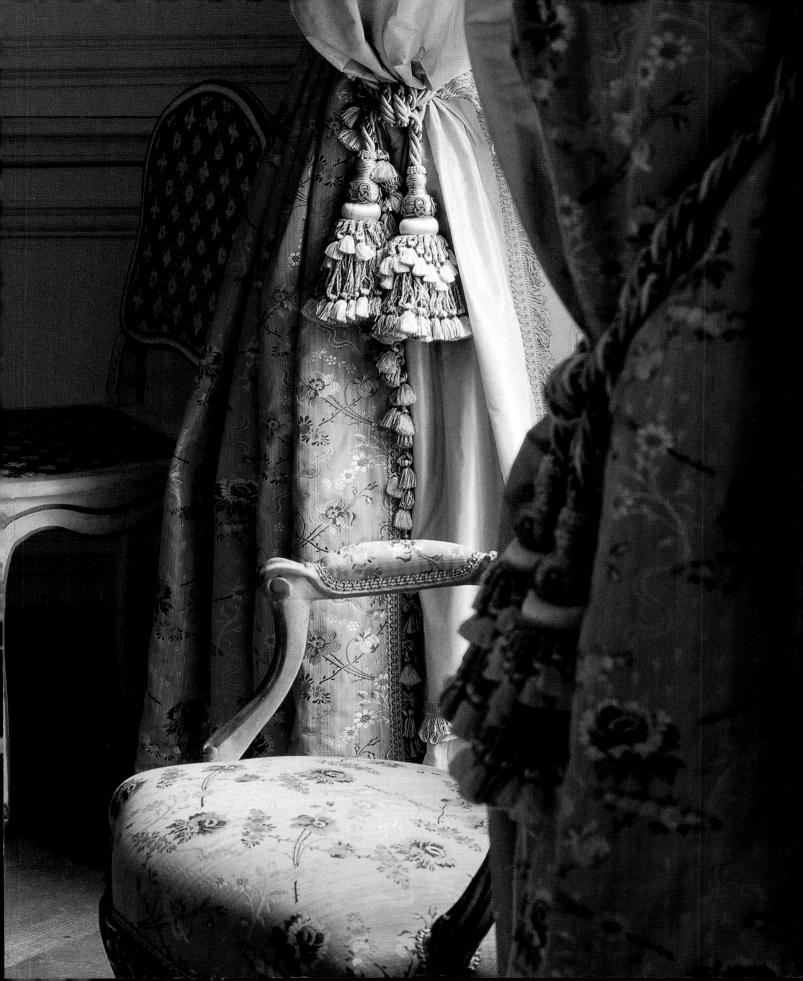

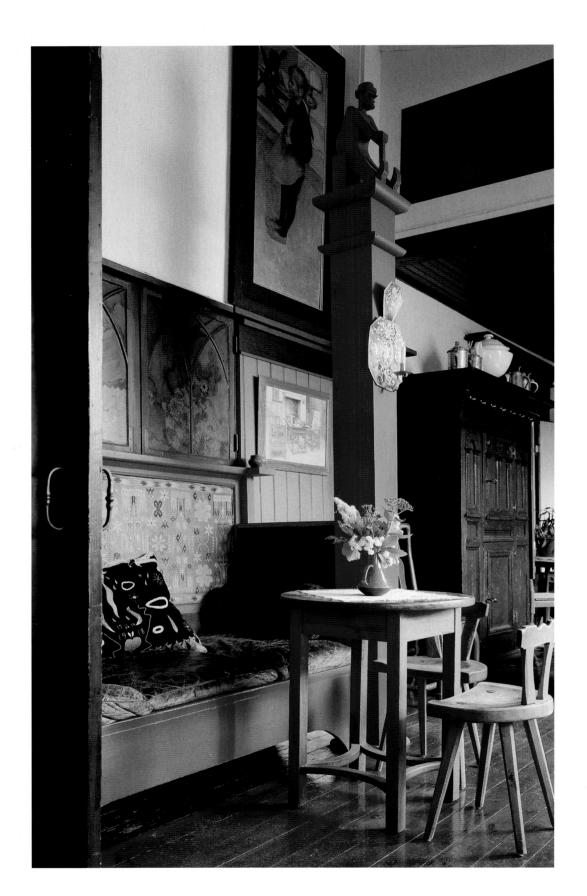

LEFT: The objects from which this palette came are weavings from loeland. This historic interior from the 1880s is also Scandinavian. It is the artists Carl and Karin Larsson's house, Lilla Hyttnäs, in Sweden.

47 natural dyes

- **1** This is the colour of yellow ochre mixed with white, an earthy yellow. Good for decoration.
- 2 A light Brunswick green, a colour much used for exterior house-painting in the nineteenth century and employed as a standard colour in many international colour systems since the 1900s.
- **3** This is a slight tint of the best grade of orange vermilion pigment, in use throughout history as a rare and expensive colour. The most important colour in this palette, even when used sparingly.
- 4 The ambiguity of this colour makes it fascinating to look at, especially when surrounded by other colours. Producible as a paint by mixing Prussian blue (available cheaply from the early 1700s) and yellow ochre and popular in many countries as a furniture colour from the eighteenth century onwards.

here is something very satisfying about this collection of four colours. They are certainly all 'off' in some way or another: the red is pale, burnt and slightly orange, the colour of baked bean sauce; the yellow is straw coloured; the green is yellowed and dark, and the blue is actually deep turquoise. On reflection, these are of course versions of the four colour primaries – red, yellow, blue and green – an obvious starting point for a palette. And yet, these colours are not discrete, they subtly interpenetrate each other: the red, it seems, has been weakened by the addition of the yellow; the blue has been polluted by the green, the green by the yellow, and the yellow by a mixture of them all. The key to a successful colour grouping is often a clever admixture of the colours between themselves, something that has happened here.

The sources for this palette are seventeenth-century weavings from the then relatively isolated culture of Iceland. The patterns are simple and the colours distinct: those of wool dyed with the most common dyes derived from lichens, or plants such as woad. The colours are also representative of four important historic pigments.

48 archaeological colours

ABOVE: Colours are never of themselves 'historical', they are just colours, but when used together they can nevertheless suggest a connection to ancient things. This apartment in Anvers, which belongs to the architect Jo Crepain, demonstrates that point. The palette's primitiveness imbues the place with a sense of timelessness and immutable permanence.

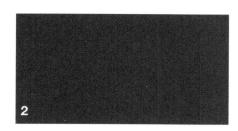

- **1** This dusty red has all the qualities of a good haematite red oxide. Try it paired with the blue.
- 2 A deep green-grey, almost black, the colour of linework in Minoan painting. En masse, this colour also works well with the blue, or with the yellow.
- **3** A chalky off-white with a pink cast, the colour of wet gypsum.
- **4** This delicate pale cobalt blue is sufficiently strong to contend with the other three major colours. Compare it and the two other colours in this column with palette 41. A beautiful and useable colour.
- **5** An intense golden yellow, almost too strong to be an ochre, but a useful detail colour against any of the other colours, particuarly the near-black and the blue

his is a well-balanced palette where the colours appear to have a dusty film over them. This reticence renders them ideal for decoration or use in large areas because the dusty finish 'knocks' the colours back into the wall. The colours are in fact very ancient. In the quest for the earliest known palette of colours the Egyptians run a close second, since they used a complex set of pigments from the earliest times. But the first artists were cavemen and the most primitive hand stencils found in French caves were achieved with red- and ochrecoloured earths and soot or charcoal from their fires. Their four colours: the off-white stone background, yellow, red and black are still being used by Aboriginal artists.

The palette here marks a step forwards and dominated Mediterranean wall painting for almost a thousand years. It originated in Crete and represents the colours of Minoan muralists of the fifteenth and sixteenth centuries BC. The colours were still being used together in third-century BC Etruscan frescoes. The red is good and pure, the yellow is bright and there is a soft blue. The Minoans traded vigorously around the Mediterranean and would have culled their materials and pigments from far and wide. Equally, they profoundly influenced other societies, from which it is possible to deduce that these are also the colours of pre-classical Greece. In fact, this palette does occur on the Greek mainland from the thirteenth century BC onwards.

49 earthy primaries

here is an earthy cheerfulness about this palette, perhaps because these are the colours of rock, sand and sky, perhaps because these are organic versions of childlike primaries – red, yellow, blue and black, only green is missing.

But since the complementary of cyan blue is yellow (warm yellow in the four-colour palette and pure yellow among the optical primaries and secondaries – see the colour models on pages 10–11) there ought to be more of a struggle going on here. One reason why there isn't may have something to do with this palette's origin. These are not only the colours of a hot country's landscape, they are also the colours of mineral pigments that have been in use for thousands of years, so we're subconsciously very familiar with them.

This is a palette of our cultural ancestors: the Minoans and Greeks used it as their essential basic palette (see palette 48), the Romans adopted it and it was among the colours of Native Americans. However, the plenteous use of the intense blues shown here is particularly indicative of early Mayan wall painting, the source for these colours.

- **1** A good orange-tinged earth red. The colour of good-quality iron oxide pigment.
- 2 The intense blue of 'Maya blue' a pigment made with indigo. Obliterate the red to see how this colour works well with the black and yellow (see also palette 41).
- 3 The colour of yellow ochre, sister to the red, above. Its strength and depth of tone (as against bright primary yellow) means it has an equable relationship with the black. For a different blue/black/yellow relationship, compare this with palette 41.
- **4** A useable clear tint of the blue, above. Try it with just the red or just the yellow and black.
- 5 Black is used as the line colour in much early wall painting and is a key contributor to many palettes based on mineral pigments.

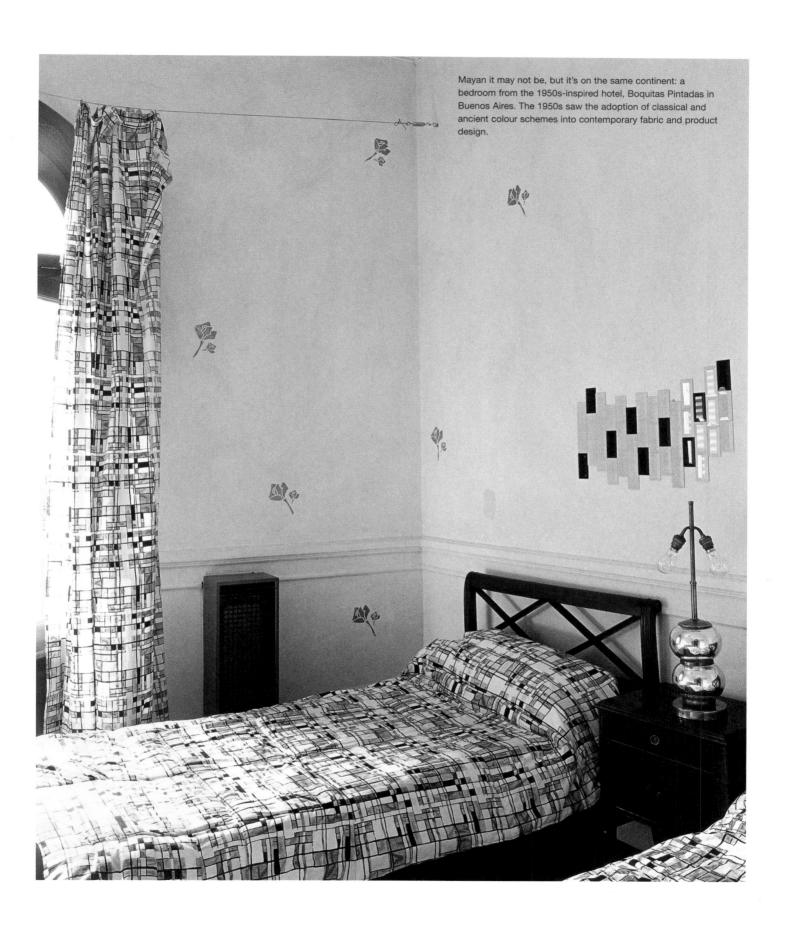

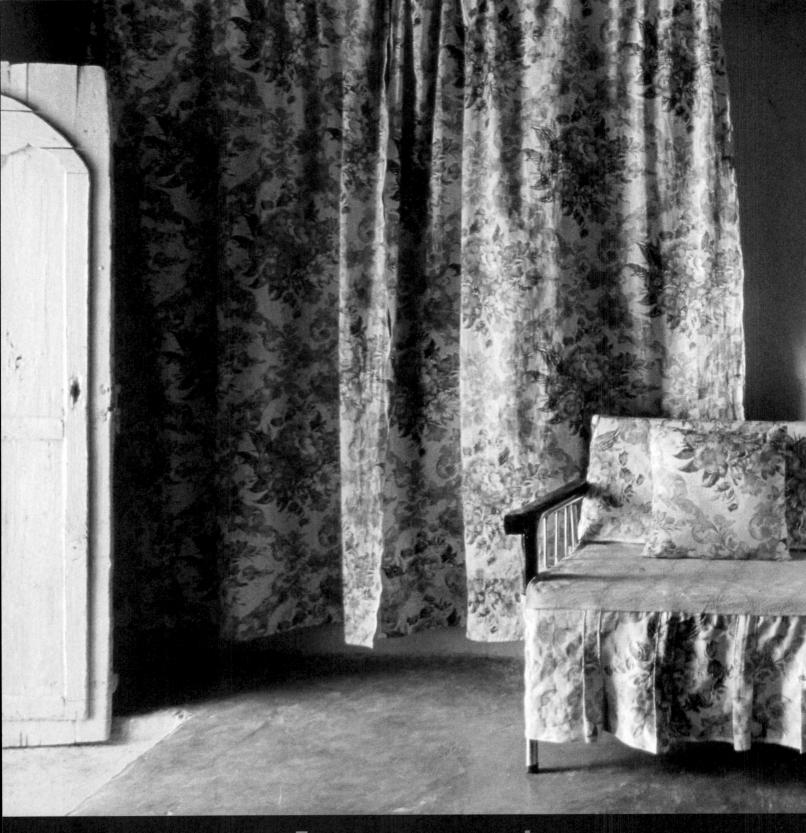

complex palettes

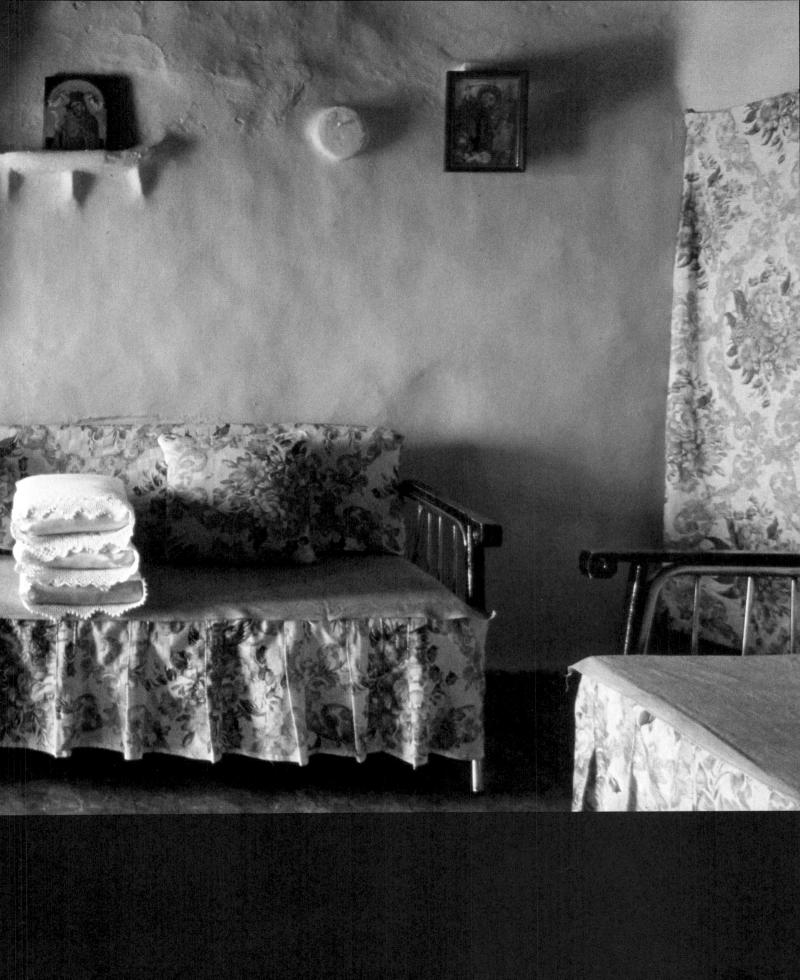

50 northern light

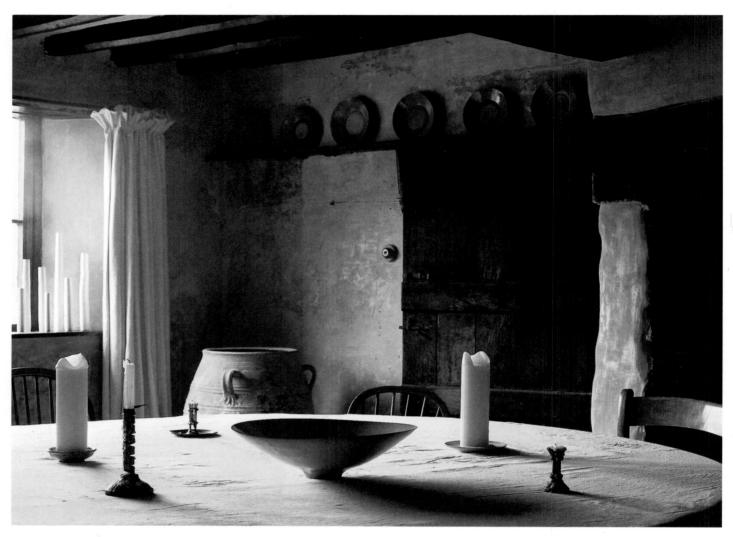

ABOVE: The English home of potter and artist Rupert Spira is a masterly exercise in the manipulation of light with colour. His decorating palette consists almost entirely of traditional pigments.

- 1 A warm chalky off-white that can look cream under intense lighting. Suitable as an exterior off-white. Formulated with white, raw umber and yellow ochre.
- 2 The colour of backlit plain porcelain and rice pudding. A difficult colour due to its orange warmth, but useful. A good foil to many of the greens and blues in this palette and a much-used exterior colour.
- **3** A pink that despite its apparent sugariness has an historic place in decoration. Works well with ceramic blues and will change colour according to lighting due to the blue undertone it has. The colour of my dining room.
- 4 Part of a fashionable group of colours that contain violet, grey and brown, this one is another cusp colour that will change markedly under different lighting conditions. Use with cream or white.

ABOVE: Just because colours work well in old houses, it doesn't mean they can't be used in a contemporary setting, or for that matter somewhere other than a northern climate. The architect Bert Pepler dipped into this palette for his house in Kalk Bay, South Africa.

righter, equatorial and tropical colours can look tired and inappropriate out of context. In climates where the sky is predominantly cloudy and particularly where that cloud is thick and low (such as the UK, Netherlands and parts of North America) full-spectrum daylight is filtered. Clouds allow the blue end of the spectrum to pass unhindered, while blocking substantial amounts of the red and orange end, resulting in what we call a 'grey day', lit by blue-tinted light. This Northern Light palette was formulated to combat that. The yellows, pinks and reds are all formulated as complex pigments (in paints these are earth pigments such as yellow and red ochres) which dodge the blue light. As a result, creams made with yellow ochre, for example, will not turn greenish, even in a north-facing room. There are additional blues and greens that take subtle and complex advantage of a predominantly blue-light spectrum.

50 northern light

- **5** An ideal cream, that in paint form is matched by a mixture of white and yellow ochre only. This is a cream which refuses to look cold or greenish under any natural lighting condition.
- **6** A yellow made up with yellow ochre only, a complex, muddy pigment which ensures that under poor and cool lighting conditions the colour will veer towards brown rather than green.
- ${f 7}$ A good cool neutral stone colour. Made with raw umber and white pigments.
- **8** This deeper warm grey is the colour of old oak when left outside.
- 9 One of the prettiest and most innocent colours

- I have ever used. Very approachable and quite guileless.
- 10 A muddier tone of colour 9 but still very useable.
- 11 A deeper cream, more tolerant in brighter lighting conditions, with more red in it. Suggestive of paints formulated with earth pigments.
- 12 A deeper yellow, tolerant of extreme lighting conditions and suggestive of place and historical uses, principally Italy.
- **13** An interesting and complex green with a slight oiliness. Good outdoors.
- 14 Another stone colour, a tint of colour 8. Together

- with colour 7 it forms a phalanx of neutral tints that will take on any other colour here.
- **15** A more complex and slightly toned version of colour 10. Good outdoors.
- **16** A deep outdoor blue. Use it as a detail colour as part of the six top colours on this page (obscure the lower half to see the full effect).
- 17 Sand colour, again matched to earth-pigmented paint, containing iron oxides that themselves are the true colouring material of sands and rocks.
- **18** A golden ochre tint. Use with other colours in the two left-hand columns or for greater effect with just colours 17, 23 and 24.

- 19 This is a delightful and slightly blued green, clean and clear. It works as part of the larger group of greens here and can be used with any or all of them.
- **20** A slightly more traditional decorating green, subtle and greyed. The most useable decorating green here.
- 21 A beautiful and purple-tinged blue made by adding ultramarine blue pigment to white. The colour of my bedroom and a tint which appears to alter character through the day as the light changes.
- 22 A deeper tint of colour 21, better suited to outdoors.

- 23 An earthy sand colour, again formulated with earth (clay) pigments.
- 24 Terracotta comes in a wide range of colours. This one is intended to match lighter-coloured pottery and is a warm pinky brown formulated from the same earth pigments that colour the ceramic clay.
- **25** The red of a traditionally decorated dining room or picture gallery, being a lighter and interior version of colour 26. Just the right tint for indoors.
- 26 From Morocco to Northern France, Norway to America, traditional (especially wooden) buildings have been painted in reds like this, made from haematite (iron oxide). This version is warm, uncompromising and cheerful.

- 27 A pretty but uncompromising sage green with enough blue in it to alter character under different lighting conditions (and therefore a cusp colour).
- **28** Another uncompromising bluish green but one with hairs on its chest. Assertive and good outdoors.

VIEW THIS PALETTE AGAINST WHITE OR WITH THE GREY VIEWER

51 chocolate ice-cream sundae

any of the palettes in this book are derived from particular objects or schemes that are representative of an era or place, but they can only tell a tiny part of a much bigger story. I'm aware of the danger in choosing them as ambassadors of a bigger and more complex idea. It's impossible, for example, to represent every colour of the eighteenth century, or to show one room which in some way is the acme of the period. For this reason, I've often resorted to showing groups of colours from several sources together – or even collating the work of other researchers to give a more comprehensive palette.

But here, I've been able to rely on one source with reasonable trust. These colours are taken from a watercolour of about 1802 of the bedchamber of Mme Récamier, the wife of a wealthy Parisian banker who had his house redecorated by the designer Berthault in 1798. The scheme represents what was then the very latest in fashionable taste: a combined Roman/Greek-style interior hung with silk and furnished with reproduction classical bronze artefacts. The house was visited by anyone interested in this new style and became an influential example of what was to become French Empire style. This palette stands out as an exemplary combination of delicately balanced colours.

- The violet colour of Mme Récamier's wall hangings, and no doubt an intoxicating colour when
- **2** This cream is just slightly orange-tinged. Use with the violet or just with the pink for a more rustic early twentieth-century scheme.

dyed onto silk. Very useable, especially with the

cream or with white.

- **3** A cool bluish pink, the colour of a tint of Indian red. A cusp colour, like the violet: used together they make a colour scheme that is very sensitive to changes in light.
- 4 This reddish brown is the colour of the furniture in the Récamier room and should be used with discretion in this palette. Alternatively, use it as the main colour. Compare these four colours to the first four of the Northern Light palette.

The apartment of Cape art dealer Michael Stevenson is a latter-day version of Mme Récamier's room: soft and curving but a carefully controlled statement.

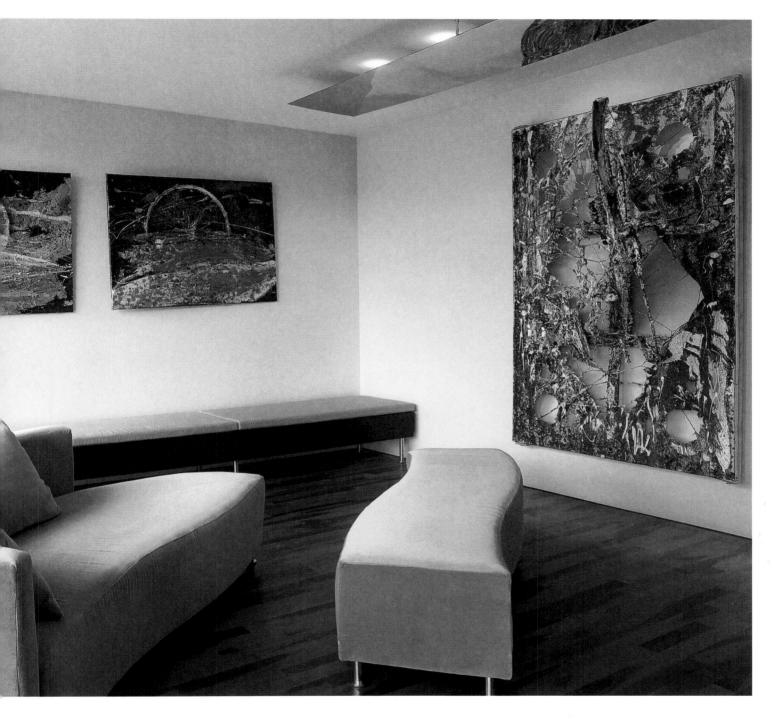

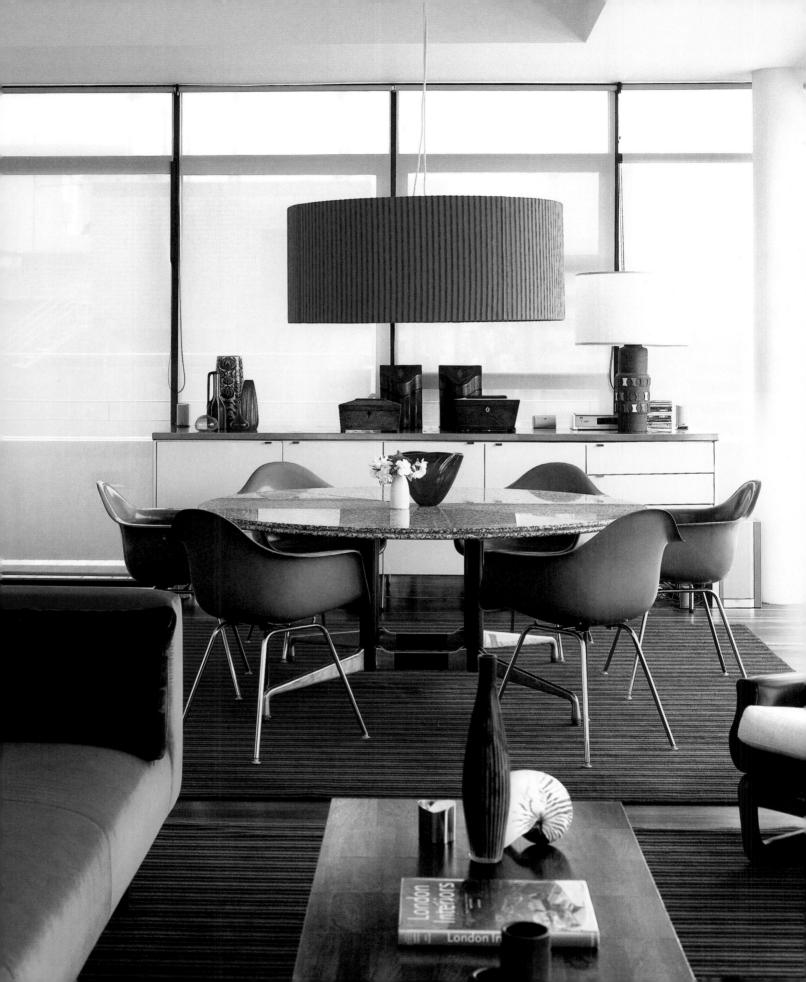

52 the innocence of powder blue

his palette grows out of the two preceding it. It plays around with reds and oranges, chooses a neutral and then crafts them into an exquisite blend with a delicate lilac and a totally clean blue. The key colours here are actually the brown and purple.

Both help anchor the entire palette and give it fibre. The purple is delicately phrased (as is so often the case).

But for spark, nothing comes close to the blue. Without it, the palette dies. Its cool presence makes for a very sophisticated combination that is very appealing to the modern eye, although in fact many of these colours were used together in early nineteenth-century fabrics and wallpapers.

- 1 A good picture room red, deep and bruised. It has a bluish bias and is an uncompromising colour. Note how the three reds have different characters but get on with each other.
- 2 Rusty orange that pairs well with the red because they are almost equally intense, from a similar part of the spectrum but of different perceived temperatures: the red is dark and cold, this is bright and warm.
- **3** The third player from the same part of the spectrum, but its dusty character renders it more useable and softer in character than colour 1. Use it with the blue and the two colours below.
- **4** A suspiciously cheerful blue but one with a slightly icy smile. A toothpaste colour that needs the other colours to bring it to life.
- **5** A very subtle violet that acts as a bridge between the blue and the other colours here. Try covering it up to see how this works.
- **6** Sludge: bluish green-grey. Not an obvious first choice for many people, but umber-based browns like this are invaluable 'rooting' colours in many schemes.

OPPOSITE: An eclectic palette like this suits an eclectic scheme. This apartment in Sydney, designed by Tim Janenko Panaeff, is a funky mix of twentieth-century chic: Eames chairs, a Danish '60s coffee table and modern rugs. The look plays with different earthy reds that are all pinned through with a dash of pale blue.

53 brown and blue in a hot climate

- 1 A clear yellow ochre cream free of any hint of dirtiness. Rich and warm, a colour that will work as a background/backbone to any other combination from this palette.
- 2 An earthy pink the colour of city walls in Jaipur, Essaouira and Taroudant. A cool pink with no trace of delicacy or the synthetic. So a macho colour then.
- 3 Deeper sandier ochre, from which the tint above comes. Use it as a key colour, using only the four colours in this column or the four in the central section of these eight.
- **4** A right-in-the-face iron haematite red. Bluish and dusty, a very common colour worldwide. Use with the other three colours at the top of this page.
- **5** A tint of ultramarine blue and hence tending to purple. Also a good indigo dye blue. A very persistent colour that maintains its 'colour constancy' regardless of which other colours it is placed against. Use with the three other colours in this central section or as part of a four-colour palette using the lower four colours (obscure the other colours with your hand to see how the intensity of this colour does not change).
- 6 Dust colour, from the Thar desert, Saharan city walls and parched Mediterranean coast. This colour appears in local sands and clays and consequently in building renders, mortars and plasters. A good warm neutral buff colour to use especially with the ochres, above, or the greens, below.
- 7 This malachite green is dusty and greyed, the colour of worn painted doors and decorative detail. Pair it with the blue above for a dynamic combination.
- **8** A slightly milky vivid tint that hovers between turquoise blue and green. It's the colour of verdigris on copper or bronze and also the colour of paint made with that mineral.

ravel leaves the colours of exotic destinations printed on our memory like a stain of the place itself. Some places have particularly strong palettes and originally I thought of assembling separate palettes for North Africa, the Mediterranean and the Indian subcontinent. But these seemed ridiculously large geographical areas to try to sum up with just half a dozen colours for each. Anyway, there are, without doubt, countless palettes with which tribes, villages and cities brand themselves individually. So I scrapped the idea. But in looking at the generalities of architectural colour across these vast landmasses, similarities and coincidences began to occur that were too interesting not to record. So here is a palette of much more general colours that belong to those three hot, dry climates. There are the blues of Sahrouis costume, Marrakesh and villages in Greece, the ochres and sand colours of the Sahara and Thar deserts, the copper-based bluish green paints that pop up regularly in Morocco, India and Greece, and the earth pinks of the walls of Jaipur and Essaouira. These building colours are representatives of these places: the palette, if anything, is a shortcut to the character of a swathe of culture that runs from the Atlantic to the Indian oceans.

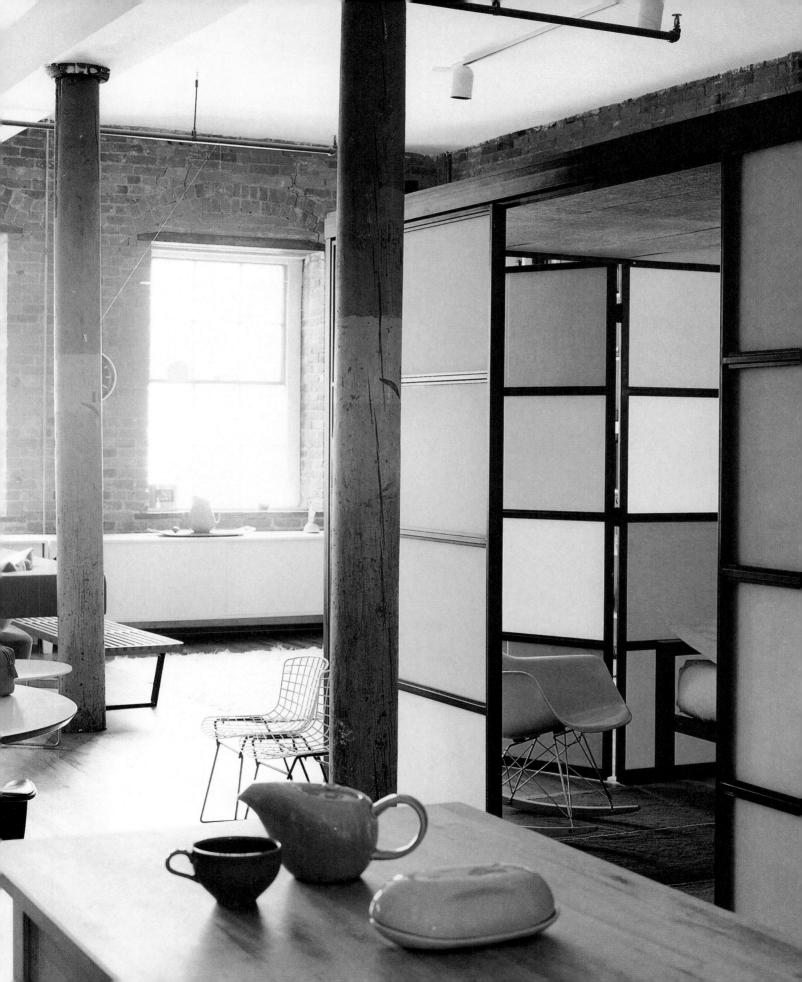

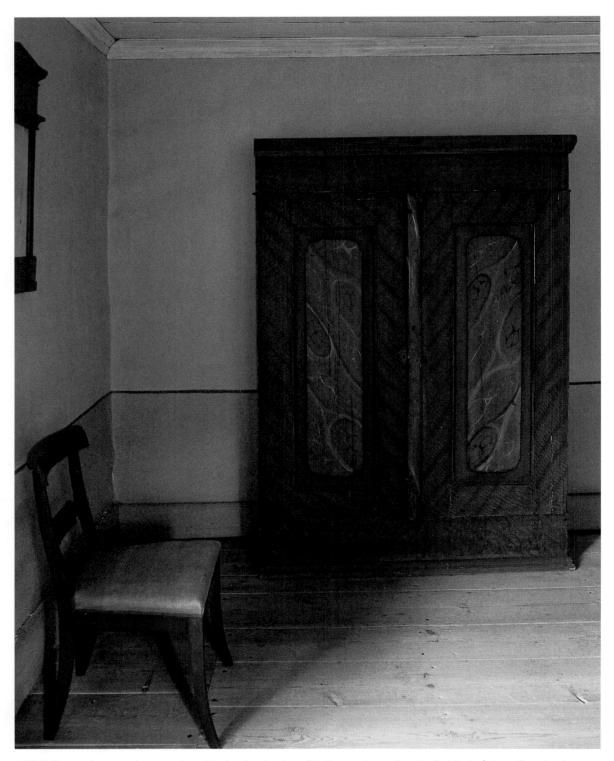

ABOVE: These colours are of course not restricted to desert regions. This is a guest room from the Ekshäradsgården, a Scandinavian manor house.

OPPOSITE: The places where you will find deep ultramarine blue or indigo used with abandon are in the streets of Greece, on Indian walls and in the houses of Morocco. This is the home of Françoise Dorget (creator of the shop Caravane) and the architect Charles Chauliaguet near Tangiers.

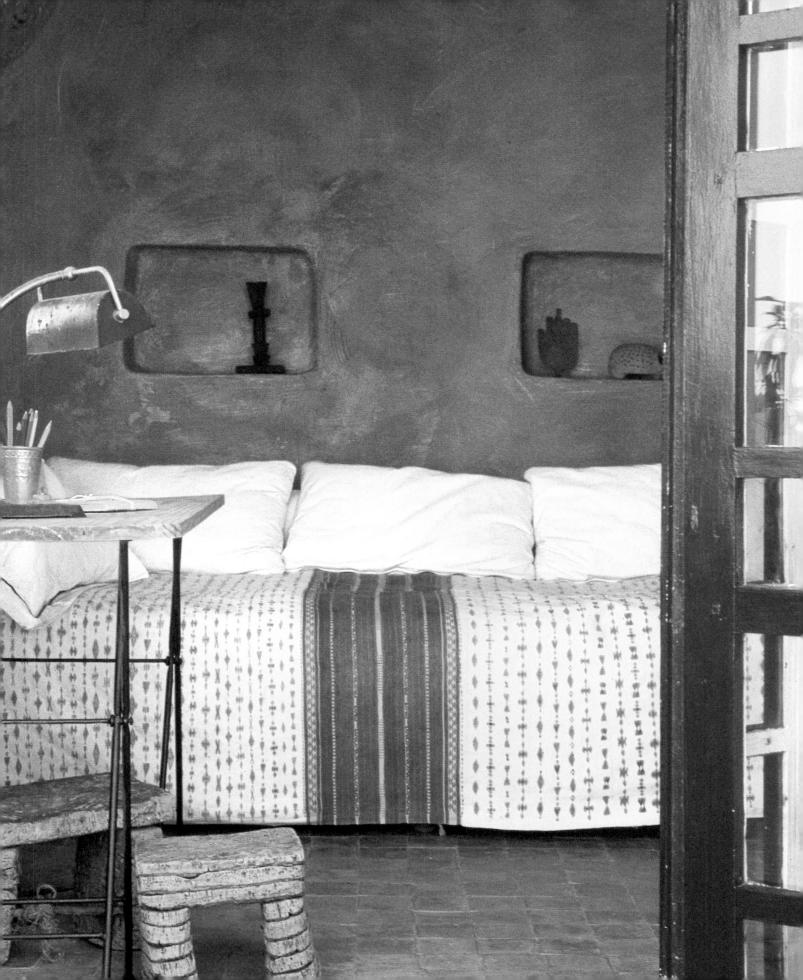

53 brown and blue in a hot climate

lue is a colour that, like a rare spice, follows a trail from exotic countries to the Mediterranean.

These particular blues can now be

produced by universal colorants but they began their journeys in Africa and India.

Indigo, as the name suggests, was being exported from the Indes in Pliny's time during the Roman Empire and remained the primary source of blue dye in the Middle East until synthetic indigo was isolated in the late nineteenth century (natural indigo's equivalent in Europe was woad). It was also added to paint as a pigment (as at Jodhpur). Ultramarine blue pigment, sourced originally by the River Oxus in Afghanistan, was being refined from lapis lazuli as an intense deep blue sometime during the eleventh to twelfth centuries. From there it found popular appeal all over the known world, to be then synthesised in the 1800s in France. Its antecedents, azurite blue and Egyptian blue, were in use in Egypt millennia before, as were cobalt blue and copper blue glass (from which Egyptian blue was made). Latterly, the artist Yves Klein developed a number of synthetic ultramarine variants, including a blue bearing his name, 'International Klein Blue'. The architect and artist Louis Majorelle famously used a similar ultramarine, now known as 'Bleu Majorelle', in his garden in Marrakesh in 1924, which was recently restored by the fashion designer Yves Saint Laurent.

India and North Africa are the source of blue and still the home of blue.

OPPOSITE: Rupert Spira decorated his English home with many of the colours that occur in the Northern Light palette 50, but this room seems to take its inspiration from hotter countries. The shared natural sources of the colorants in both palettes means that they are entirely compatible.

VIEW THIS PALETTE AGAINST WHITE OR WITH THE GREY VIEWER

- **9** A deep and impure woad or indigo blue, slightly greyed and purplish. Although deep, this is a delightful colour that comes alive when used with the burnt orange colour next to it.
- 10 Burnt orange, an earthy colour. An unusual combination with the blue and the grey-violet below.
- 11 Another ultramarine or indigo tint, warm and aerial, as if looking into a blue sky. Use with just the colour above and below it for a wild blue palette like the one on the previous page.
- **12** Cooler and more cobalt (pigment) based than the other blues in this palette. Especially good with the burnt orange above it. Perhaps a more appropriate colour for azurite pigment.
- **13** Dusty ultramarine, lacking the overpowering intensity of colour 16 and so more useable,

particularly when heightened with small quantities of the turquoise green below.

- 14 A very useable and complex violet with plenty of warm grey in it. Use as a major element with the other three colours in the central part of this palette or as a means of subjugating colour 16, below it.
- 15 The colour of turquoise Middle Eastern pottery glazes and the only colour on this page with a green bias, this slightly dusty tint is a relation of the copper greens on the previous pages. Avoid using it with colour 10, or there again, exploit their difficult relationship! At source, in Indian and Morocco, this is a detail colour used against expanses of colour 16.
- **16** The colour of cobalt glass (not pigment), indigodyed silk or ultramarine blue pigment.

54 colours for a new white box

- 1 A dull purple, typical of the rarer iron oxide violets. Interesting because it is less depressive or threatening than the equivalent blue or red. It has a good relationship with the yellow below.
- 2 This warm brown is a clean, reddish colour. It's a colour that can be used to tone all the other colours in this palette, turning them towards itself and reducing the overall contrast of the palette.
- **3** A light ochre yellow. It has a powerful relationship with the purple and is related closely to the red and brown. By removing the yellow or the purple the character of this palette is destroyed.
- 4 Iron oxides produce a wide range of reds (see the bluish pink overleaf) but perhaps the most prized are those that sit at the meeting point of orange-red and brown. A colour in use from antiquity to the modern day.

here are several palettes in this book in which brown is a pivotal colour, where it assumes an anchoring role. There are also several palettes where, strangely, purple has a similar role. The interesting thing about this palette is that it contains both, and as a result, this combination of colours is rock solid.

All four are muted and are uncontentious, since they all come from the same side of the colour circle. They are also connected, at least in the natural world, by a common provenance: iron. These are the colours that iron oxides, present in geology worldwide, produce in rocks, stone, marbles, clays and sands. You will find them again in palette 31.

So it is not surprising that iron oxides colour many of the buildings of the world, not least in out-of-the-way places: this very appealing combination comes from homes in Guatemala.

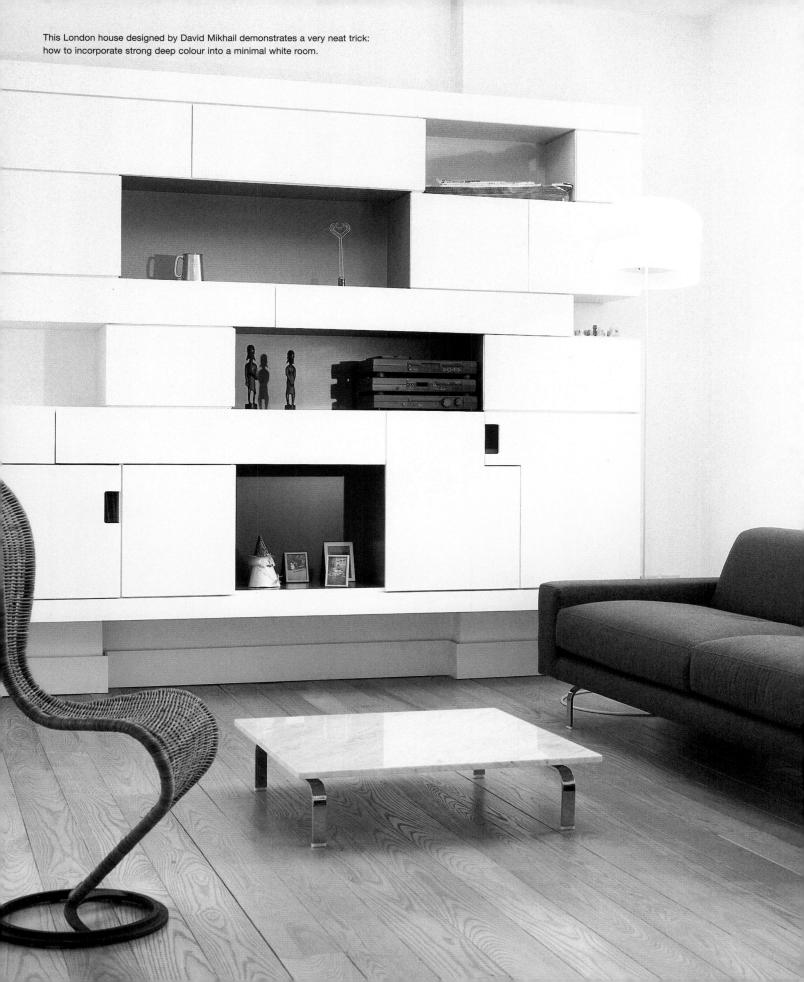

55 vegetarian primaries

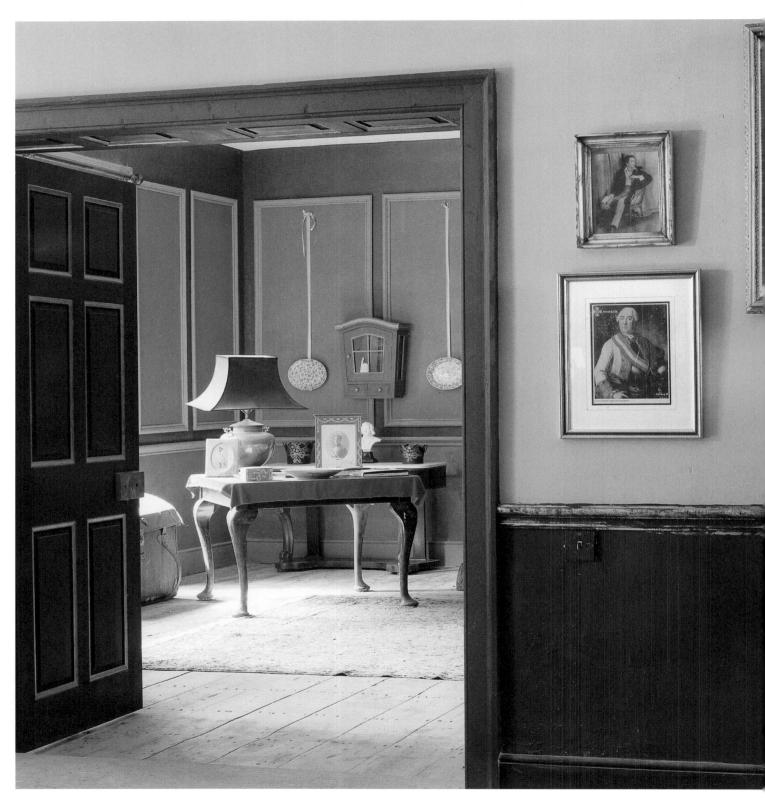

ABOVE: Not that you'd have thought it possible to find a room painted in these colours, but here is an interior, not from Japan, but from a cottage in Ireland. And, surprisingly, the colour scheme, in all its madness, works.

or centuries, colour in Japan has been developed and codified – through the applied arts, costume, theatre and religion – to a level of ritualised sophistication that is beyond our comprehension in the West. Only in Japan can grass be green but a 'go' traffic light be blue, such is the conceptual refinement of colour language there.

The development of such distinctions was also due in part to dyeing technology: early Japanese dyers experimented with a wide range of plant extracts and the technique of 'overdyeing' to achieve intermediary colours – a process viewed with immense suspicion in the West until the Renaissance (the Greco-Roman and later the Christian view was that mixing colour represented interference with the divine order). The three-colour palette on this page represents a very ritualised element of Japanese life: the Kabuki theatre in the Edo period (seventeenth to nineteenth centuries). They are postulated colours, formulated from recipes for dyeing the theatre curtain hung at the opening of every performance.

- 1 Green based on the colour *moegi*, that of 'green tinged with the yellow of onion tops, then greyed like strongly brewed green tea'. An intense and almost lime green.
- 2 The Kabuki theatre brown was also very specific: tannin from the persimmon would produce an orange that was then subdued with red mixed with black. Clearly, mixing and overdyeing were acceptable techniques. The resulting colour is unremarkable by itself, but it has a subtle relationship with the other two colours, particularly the green.
- 3 The Edo Kabuki black was apparently tinged with purple and blue, something easier to see on dyed cloth that has a sheen, than on the printed page.

56 the importance of brown and cream

- **1** A yellowish moss green, difficult to use without the brown or cream.
- **2** Less yellow and more blue in this colour. Very good with the cream.
- **3** This cream is pale and cool. It can afford to be: the brown here is very assertive.
- **4** A rich reddish brown, the colour of burnt umber. An oft-used pivotal colour.

ere is a very refined palette made up of four colours and therefore very useable in its entirety. It uses one key colour, brown, to 'anchor' the scheme: if you obscure it, it's easy to see how the overall character of the palette is changed, whereas any other colour can be dropped with little effect. It's interesting to note that brown often occurs as a pivotal colour in a palette: its effect is profound and its presence often more important than black.

The colours have been taken from a 1920s Art Deco interior design scheme by the French practice Süe et Mare, and they are not controversial. There is, for example, no clash of similarly strident hues, although the reddish brown and dirty greens are vaguely complementary. But there is a structural relationship at work here, which can often be found repeated in other schemes of the period: the use of two muted colours (here green) that are related (one lighter, one darker) set against a cream and a brown of some kind. It would be interesting to pursue this structure using different pairs of colours, with cream and brown, to see if the results all look equally Art Deco in spirit.

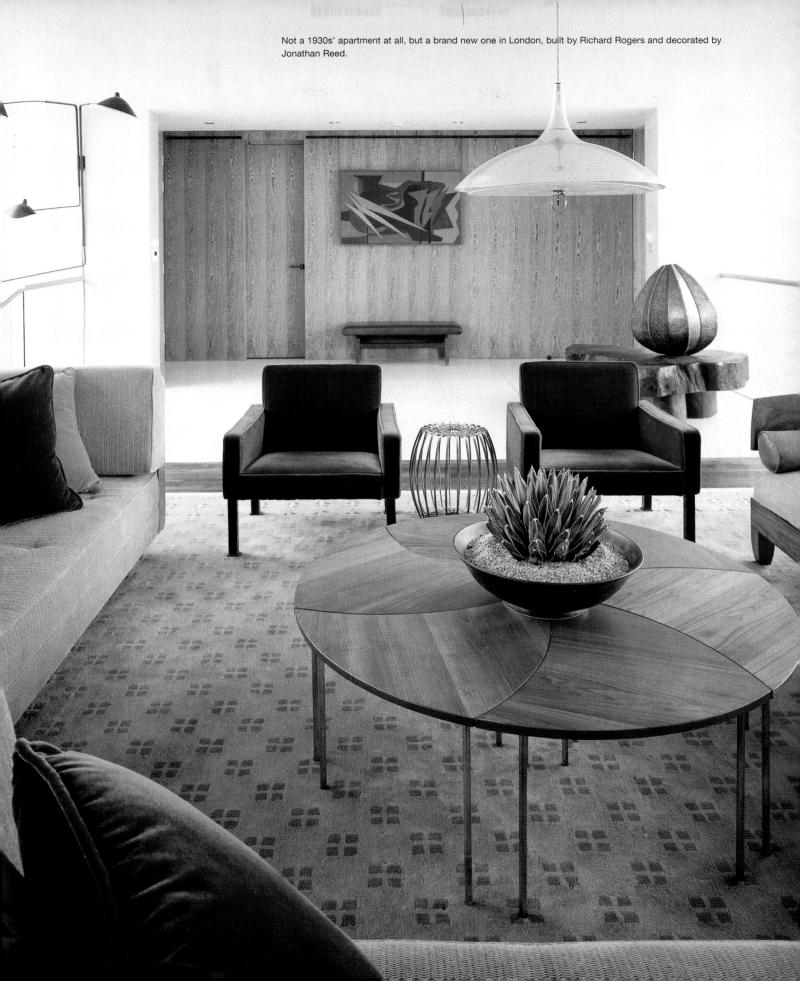

57 a dash of brown to tie it all together

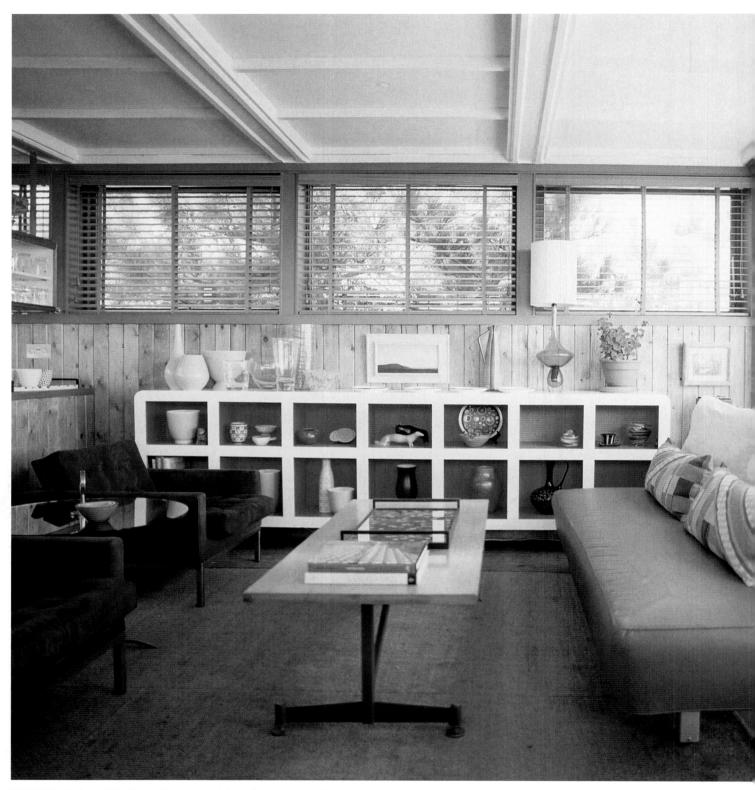

ABOVE: The designer Philip Hooper is a master of the understated colour blend. At his own seaside retreat he has woven colour stories through the space, taking a sophisticated colour palette like this one and breaking it down into many small elements. It's a 1958 house, by the sea, on stilts. It's just waiting for a VW Camper with surfboard attached....

- 1 A glossy cherry red/red oxide mix called 'Chianti Red' that looks its best when matched with white. All these four colours appeared on early Volkswagen Camper vans and 'Microbuses', as the manufacturer called them.
- 2 A deep sienna/ochre, 'Sierra Yellow' that, because of its depth, looks particularly rich in gloss.
- **3** An iconic 1970s colour for an iconic vehicle, burnt orange. Note how all these colours are 'browned' to make them more interesting.
- **4** 'Niagara Blue', the most restrained colour in this collection of four, but interesting and still, like the others, very useable.

he colours of the millennium were bright and breezy. They came from palette 62. Those of the first decade of the twenty-first century are far more subdued and retrospective. The bright chromatic optimism of the late 1990s seems to be giving way to a more complex and restrained taste for muted colours, browns, burnt oranges and the colours of the 1940s, '50s and '60s (see palettes 20, 21, 22, 23 and 24). These colours slot right into that taste, mainly because they are associated with a particular kind of mid-twentieth-century icon, the Volkswagen Camper Van.

58 a little journey across the colour globe

- **1** Muddy turquoise. A complex and useful tone. Try hiding this colour to radically alter the character of this palette.
- **2** A mix of the colours above and below. Hide this colour to alter the balance of the palette.
- **3** A mix of the colours above and below. Cover this colour to alter the balance of the palette.
- **4** Muddy orange, like a deep, rich ochre. Try hiding this colour to radically alter the character of this palette.

his palette is representative of the kind of colour play that some graphic artists and designers are now using. It might be hard to spot the formula at work behind these colours, but it is very simple: this palette a journey between the colour at the top and that at the bottom. Were there more swatches, the journey would be more obvious, the colours would appear to blend more easily into each other. But the palette becomes a much more subtle thing when just a few colours are picked out from that journey.

This is how it works: the blue at the top and the yellow at the bottom are of approximate equal luminous intensity and equally milky. They are impure tints of two hues, turquoise and orange, which appear directly opposite each other on modern colour wheels that take four, rather than three, colours as their primaries and which, as a result, alter the relationships of those colours (see colour models on pages 10–11).

If you travel across the colour wheel from one hue to another, bang in the middle, you hit grey. But if those colours are not pure hues but muddied tints, like these, the middle ground between them will also be muddied and impure – as here.

OPPOSITE: This scheme, in Courtney Sloane's house, follows this palette's idea. Even the picture contributes (the reflections in the water, providing the intermediary colour steps).

59 seen through a fine gauze

ABOVE: As is so often the case, purple is the key anchoring colour in this palette. The owners of this small hotel on the island of Rhodes obviously knew that.

- **1** A good neutral off-white-to-stone colour approximating one colour found in the background glaze.
- 2 A tint of the same colour. A pure white against the colours opposite will sharpen and crisp them. Use of these off-whites will quieten their effect and homogenise them into the kind of balanced arrangement that the Della Robbias achieved so well.

his combination of vibrant milky colours is taken from glazed terracotta ware of late sixteenthand early seventeenth-century Florence, made by the Della Robbia family. The colours are striking for their family resemblance: optically, they each contain about the same amount of hue colour and the same amount of black and white: there's not one that jumps out as being too intense. Consequently, they can all be used successfully together in virtually any combination. Their light tonality (the milky quality) occurs because of the quantity of white used. In a shiny coating, such as gloss, the milkiness would be retained. In a matt coating, such as emulsion, it would translate as a chalky dustiness.

- **3** All these greens have a large quantity of blue in them that contrasts vividly against the very warm yellow used. The yellow and green are as far away as possible from each other on the colour wheel.
- **4** The nearest colour to red that the Della Robbias achieved.
- **5** A delicate grass green that seems like a mix of several colours. Interesting and useable although intense.
- **6** This blue is cooled somewhat by its grey content, but it sits chromatically around pure spectrum blue. Similar to Oriental ceramics blues.
- **7** An emerald green saved from uselessness by the thin veil of white or cream that appears to

hover in front of it. A rich appley green that could work well outdoors.

- **8** A more useable tint of colour 6, although it has a steely edge. A good balance for colour 7 and particularly fine when used with colours 3 and 5.
- **9** The typical golden yellow of the Della Robbias and often contrasted against pale blue or green. Open and guileless, the colour of sunshine or butter, but be warned: it can appear overpowering when used in large quantities. Moderate it with colours 3, 4, 5 or 10.
- 10 Probably the most approachable colour here, but despite its dustiness, still assertive. Similar to a woad or indigo colour.

VIEW THIS PALETTE AGAINST WHITE

60 blue adventure

he inclusion of colours in this palette that are in turn intense, bright, deep, dull, pale and mid-toned makes for a subtle and complex whole: it is possible to choose virtually any combination of colours here. But the key colours are the turquoise and magenta. They are optical secondary colours that, like yellow, excite many more cones in the retina than reds, greens or blues. Their role here is to point up the blues, but in this they are aided and abetted by the warm brown and the dull greens below.

The source for this palette is a variety of early Chinese and Japanese ceramics. The colours of willow pattern are here (colours 11, 12, 13 and 14), together with a variety of blues produced from cobalt glaze. The most interesting group is colours 3, 4, 5 and 6, which come from a Chinese alcohol jar on which they were arranged in a simple, abstract – and very modern – way.

1 A key colour in this palette, strident against the deep blues, interesting in small quantities, especially against the pale blues and more neutral colours here.

- **5** A very deep purplish blue. Use as a line or accent colour with the three colours around it.
- **6** The partner of colour 3, above left. Subtle and greyish. A cusp colour.

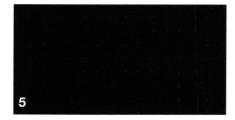

- **7** An icy pale blue that provides a background for colour 8, right.
- 8 An intense bright and warm blue that resembles the pigment ultramarine. Use a neutral colour to quieten it.
- **9** A slightly dirty and deep magenta. It can be used as the dominant colour in a scheme with the neutral colours, left, and/or the pale blues. Or use it as a detail colour to 'spike' the deeper blues.
- **10** One of the deeper colours of Oriental ceramics, useful as a quiet line colour with the four blues below.
- 11, 12, 13 and 14 These last four colours all derive from one type of Japanese pottery. Because they are all muted, slightly greyed versions of the other blues on this page (due to the impurity and firing temperature of the cobalt glaze on the original objects) they are very useable and work well together. For a very interesting and subtle palette, block out the top of the page and view these four with only the four lower ones opposite.

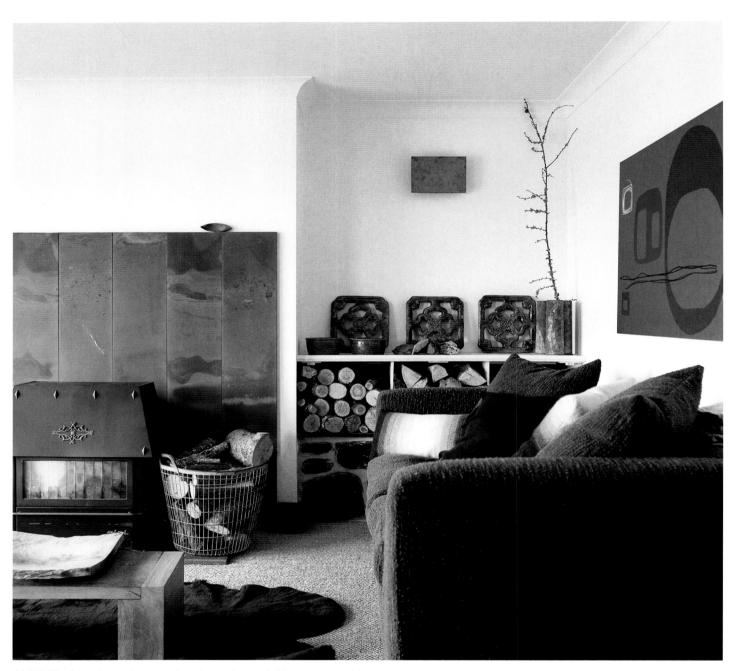

ABOVE: The Oriental ceramic palette plays through the purple-blue-green part of the spectrum, but both the purple and green veer towards blue. This Welsh home does the same thing. The pinky-brown painting works like colour 4 on the previous page.

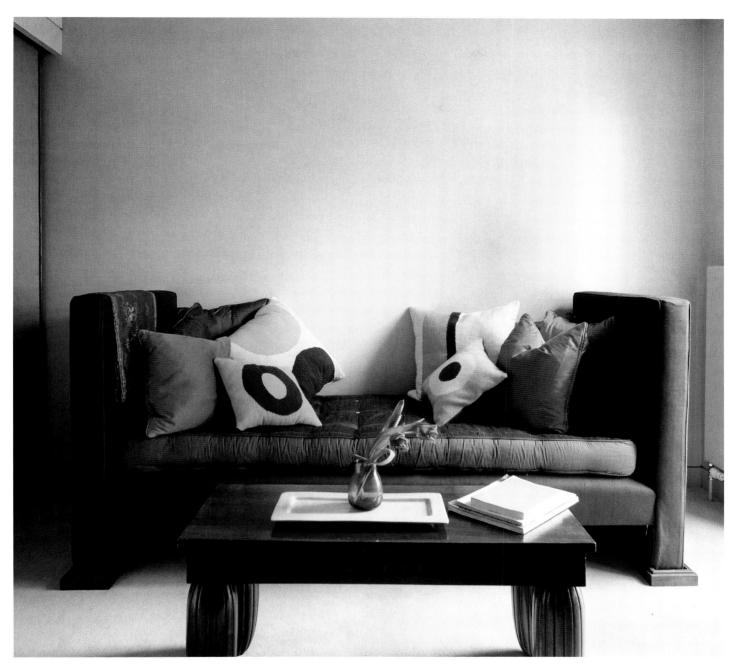

ABOVE: Another, purer example of mixing blue, brown and a little pink (note the magenta-coloured tulip and the bronze-pink of the sofa mattress). The work of the designer David Collins.

vibrant palettes

61 an aniline trip on class A colours

- 1 This is mauve. Not the washed-out colour we now think of, but the dye first synthesised by scientist William Henry Perkins in 1856 and which launched the famous 'Mauve Decade' in fashion. A fabulous colour on silk or wool and a satisfying cross between purple and magenta.
- 2 Fuchsin, or magenta, so-named after the battle of Magenta (the Italian city where the Austrians were defeated by the French and Sardinians in 1859). An extraordinarily powerful colour with great optical properties. This example is closer to the nineteenth-century synthetic dye than the modern printing ink.
- **3** A beautiful crimson a slightly bluish red with depth and character. An approximation of alizarin crimson first synthesised in 1868. Try looking at it with just colour 4.
- **4** Methyl violet, another early dye colour that is purple without seeming cloying or opaque. Instead it seems positive and engaging. The dye still sometimes used to colour methylated spirits.

hese four colours make an intense, almost psychedelic palette that is on the one hand very typical of dyed sari silk and on the other typically groovy 1970s – the sort of colours that Danish designer Verner Panton used. They all have a slightly bluish tinge which connects them. They also belong in one part of the colour wheel, that area between purple and red where magenta dominates. Because magenta is an optical secondary colour – stimulating many more colour receptors in the eye than a primary colour – all these hues have an exciting luminous quality. They can all be used together.

In fact, the colours all derive from early synthetic dye technology of the 1850s and '60s, a revolutionary time in the history of colour that kick-started modern colourant production.

Without it, modern Indian saris and Verner Panton interiors wouldn't be the same.

OPPOSITE: Here are some vibrant silks from Gujarat hanging in Jaouad Kadiri's Marrakesh home built by architect Stuart Church. Nowadays, fabrics all over the world are dyed using lightfast and colourfast descendants of Perkins' early synthetic dyes.

62 and now, in glorious full colour...

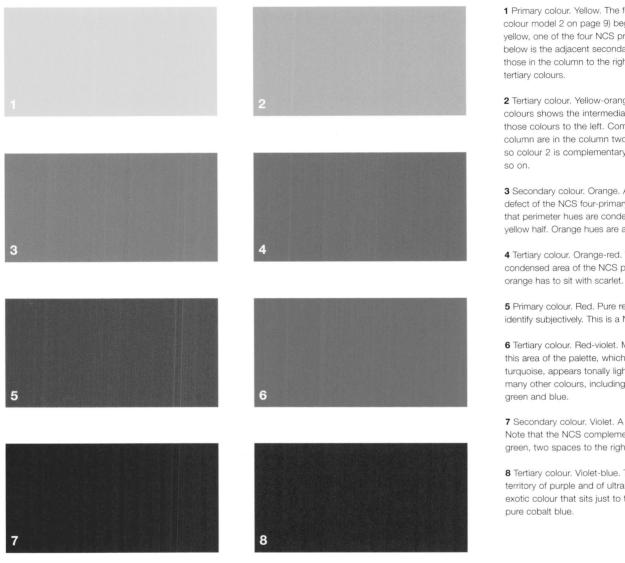

1 Primary colour. Yellow. The four-colour model (see colour model 2 on page 9) begins at the top, with vellow, one of the four NCS primaries. The colour below is the adjacent secondary colour, while all those in the column to the right are intermediate, or

2 Tertiary colour. Yellow-orange. This column of colours shows the intermediate tertiaries between those colours to the left. Complementaries to this column are in the column two spaces to the right, so colour 2 is complementary to colour 10 and

3 Secondary colour. Orange. A NCS secondary. A defect of the NCS four-primary model is the way that perimeter hues are condensed in the blue to vellow half. Orange hues are a little compromised.

4 Tertiary colour. Orange-red. This is a rather condensed area of the NCS palette where blood

5 Primary colour. Red. Pure reds are difficult to identify subjectively. This is a NCS primary colour.

6 Tertiary colour. Red-violet. Magenta occupies this area of the palette, which, like yellow and turquoise, appears tonally lighter and brighter than many other colours, including the primaries, red,

7 Secondary colour. Violet. A NCS secondary. Note that the NCS complementary of this is lime green, two spaces to the right of this swatch.

8 Tertiary colour. Violet-blue. This is the familiar territory of purple and of ultramarine blue, the exotic colour that sits just to the warm side of

his is a technical palette: all the colours here represent principal hues from around the modern four-colour wheel that was first theorised by Hering in 1878 and is now the basis of the model of the Natural Color System (NCS). It's a system that has been adopted as several national standards and is particularly used by colour professionals and paint and coatings manufacturers worldwide (see colour model 2 on page 9).

But that's not the reason this palette is here. It's here because the colours are so in-your-face. Here are sixteen hues of vivid brilliance, as saturated as ink on paper can permit. There is no subtlety here, no ambiguity. Consequently, they all work with each other equally well and equally badly. It's only recently that technical developments in litho printing have made the reproduction of these colours possible in normal print. Modern lightfast pigments also now offer these colours for all kinds of industries, so our lives are finally being surrounded by colour of an intensity only dreamed of by our forebears of only fifty years ago.

The NCS system, and particularly the combination of the four secondary colours, has had a fundamental influence over fabric, product and furnishing design in the last five years. Lime green, turquoise, purple and orange have recently been dominant contemporary colours.

- **9** Primary colour. Blue. An approximation of cobalt blue, i.e. as pure a spectrum blue as possible that moves neither to green nor to red.
- **10** Tertiary colour. Blue-turquoise (cyan). A cool blue equivalent to Prussian blue or phthalo blue.
- 11 Secondary colour. Cyan (turquoise blue). The mid-point between green and blue on the NCS model and an important 'new' secondary colour.
- 12 Tertiary colour. Cyan-green. A 'new' tertiary colour that results from the expansion of the blue-green side of the four-colour palette, thanks to the introduction of green as a fourth primary. Note that the great majority of seventeenth- and eighteenth-century historical greens were blue-biased (see palette 17).
- **13** Primary colour. Green. The fourth colour primary, introduced by Hering. Note the emerald hue of this colour.
- 14 Tertiary colour. Yellowish green. It is interesting that many historic, especially eighteenth- and nineteenth-century, colours are muted tertiary colours like this one. Most of the tertiary colours on these pages (i.e. colours 2, 4, 6, 8, 10, 12, 14 and 16) have an equivalent muddy or dusty 'period' equivalent. This is less true for primaries and secondaries, mainly due to the imperfection of traditional pigments.
- 15 Secondary colour. Lime green. Lime, turquoise, orange and purple make up the NCS secondary colours that have been used together so much in the last few years. They constitute a palette of their own.
- **16** Tertiary colour. Lime yellow. This colour brings us full circle back to yellow.

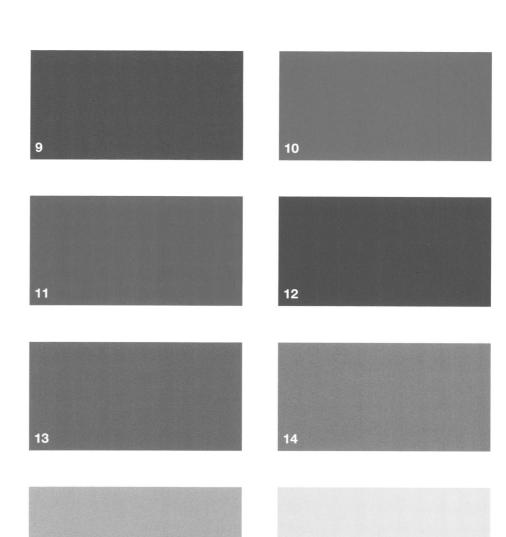

LEFT: The London home of fashion designer Matthew Williamson, clearly a colour junky. The bedspread (from Designers Guild) was re-dyed for Matthew and he's even painted the ceiling.

RIGHT: This English house designed by Richard Rogers is dotted with bright secondary and tertiary colours like jewels in a minimalist box.

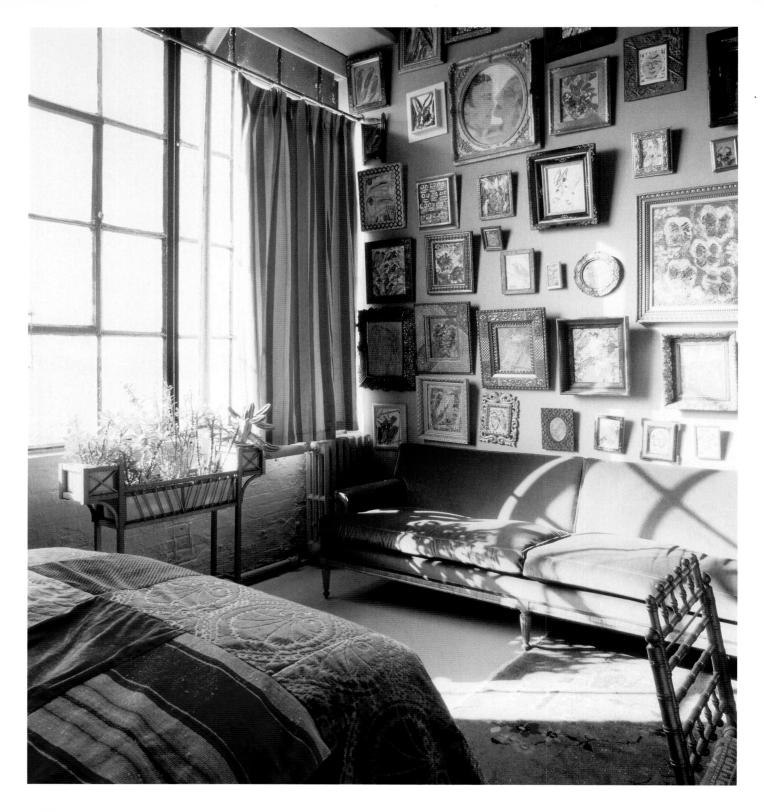

f all the cultures that celebrate and revere colour, perhaps none is as sophisticated as those of the Andes. There are very few palettes based on historical textiles in this book, partly because the fugitive nature of dyes means they can be historically inaccurate documents of a society's view about colour. But the coloured fabrics of the Andean Amarus Indians are dyed in an unbroken tradition of techniques and colours that is centuries old, mainly because they believe that the rainbow and its colours have healing and regenerative powers (for example, magenta and fuchsia are connected to courage and innovation). So their society regenerates itself through the recreation of colour.

These colours demonstrate just how possible it is to work with intense colour – in unusual hues – and still create sophisticated combinations.

63 weaving the rainbow

1 and 2 This is a palette of complementary relationships that are modified by reducing the intensity of some of the colours with white, and by the inclusion of one pivotal, controlling colour – which is not the green. The complementary of green is, well, magenta in one system (additive) and red in others (optical channels and the four-colour system). Either way both are present here, together with several variants: the pinks and orange. Use these greens with the more intense complementaries or with the pinks.

3, 4, 5 and 6 This group of reds and pinks is a sophisticated set of near colours with variable amounts of blue, red and white in them. There is a marked struggle for assertion between them, but this internecine battle is merely a squabble when the group is seen against the greens, blues or oranges. The overall success of this palette depends on this layered structure of relationships; so the best use of this palette will always involve all the colours.

7 and 8 Even the relationship between these two colours is sharp: one is dark and reddish, the other light and moving towards yellow. The first could be seen as red, but also as orange, just in the way that colour 4 could be seen as red or as pink. This occasional ambiguity is a necessary component in the success of this palette. Use these colours with the greens or the pinks. Obscure these other colours to see a rather successful combination of the red-oranges with the blues.

9 and 10 Like the greens, the rich blue has a complementary effect on both the pinks and, particularly, the oranges. The resulting optical effects are shimmering. However, it is the quietest colour in the palette, the soft bluish grey-purple colour, which is the pivotal element here. In many Andean fabrics it is colours like this which predominate and form a background against which the brighter hues are displayed. At the very least, a combination of any of these colours can be made to operate together provided this colour is included.

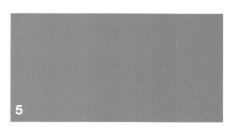

OPPOSITE: The lesson of this palette is a simple one repeated throughout the book: purple is as important a colour as brown in anchoring a scheme. Never underestimate its importance.

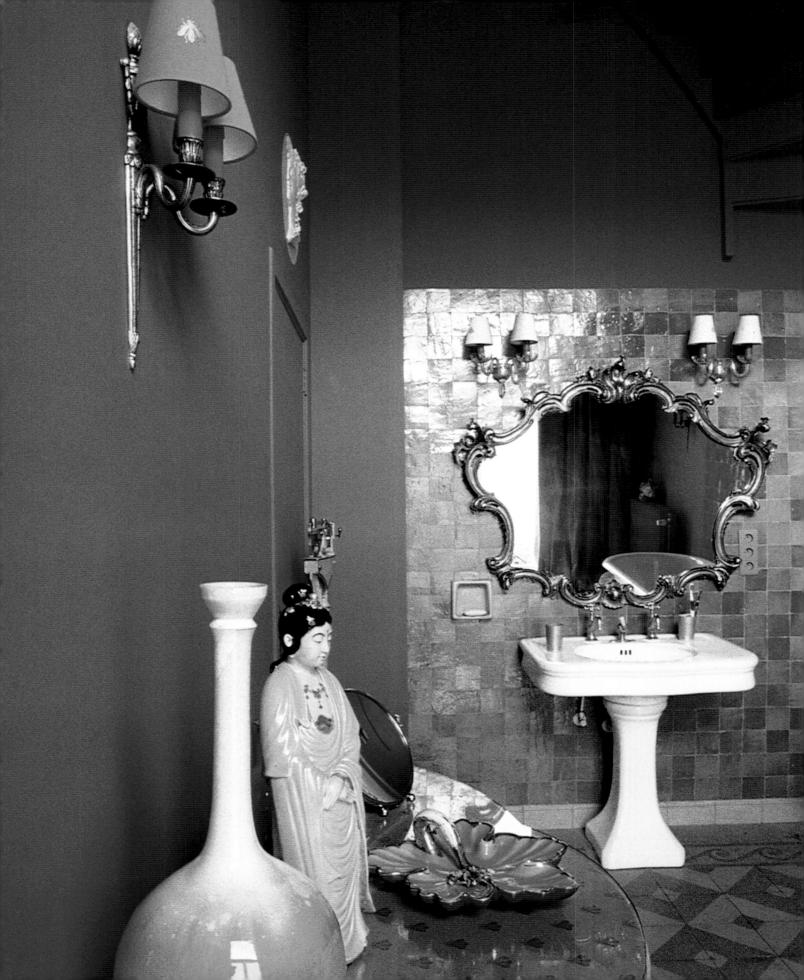

64 full-on seaside dazzle

hese are seaside colours. You'll find them around the world painted onto the walls of houses, shacks and bathing huts in coastal towns. Portofino in Italy has some of these colours; the English South Coast resorts of Weymouth and Dartmouth (for example) have some too. Any seaside resort, especially those that face south, enjoys the luxury of reflected light and, as a result, an increase in overall ambient light levels – in which high levels of contrast and variance of hues can be accommodated.

These vivid colours are, however, historically much more important. They are the colours of applied paint, not on buildings but on Roman pottery from Canosa (Canusium) a seaside resort near Bari in Italy: on figurines, busts and vessels. They demonstrate the brilliance of the pigments available to the classical artist and decorator and are a reminder of how intensely coloured the buildings and sculptures of the ancient world probably were.

OPPOSITE: Agnés Emery chose these suitably resort colours for her client's house in Brussels. This is a very demanding palette that requires a lot of manipulation to get right – as she has.

- 1 and 7 Two clean blues that are derived from a very mid-blue hue. Consequently, there is very little bias towards either green or purple, which means these colours are straight and uncomplicated. Ideal in a bright, well-lit environment and with sufficient difference in character to make an interesting combination. Try them with just the pinks or just the flesh tones in this palette.
- 2, 5 and 8 The most intense pink here is more than a match for the dark blue and can be used in isolation in a scheme with all the blues together. But these pink colours also work well together as a group of three: note how, as for the browns, the paler more flesh-coloured swatch adds interest and stability to the group. For a fresh and harmless combination of seaside colours, look at just the two pale pink swatches with the pale blue swatch.
- **3, 6 and 9** This family of browns is warm and biased to orange and red. The deep reddish brown is the unmistakable colour of iron oxide pigments and the deep orange is that of fine orange-biased cinnabar or even red lead pigment. These three swatches are a palette on their own, in which the palest colour underscores all the others.
- **4** An intense and unbelievably bright yellow from the ancient world, sharp and full in Mediterranean sun but one that turns acid under a cloudy sky.

notes to the palettes

Below is a list of provenances for many of the colours in this book. The numbers refer first to the palette and then to the individual colours within that palette.

All historical wall references are specified as matt and are therefore printed on uncoated paper. Many of the references for painted walls are to extant, conserved examples in museums or in situ. There are obvious problems associated with identifying the colours used by artists hundreds of years ago: principally to do with the way that certain pigments age or discolour in reaction to chemicals present in walls or the atmosphere. All painted surfaces will become dirty in time, but in an attempt to reduce inaccuracy, the following safeguards have been met in colour matching references:

- 1 In order to avoid the misrepresentation of colours that have altered through the effects of age, all source references for wallpainting and decoration in the ancient world are extant examples of buon fresco or fresco secco or encaustic painting. processes where the pigments employed are relatively stable and resistant to the effects of alkali, atmospherically-borne chemicals, such as sulphur, and ultra violet radiation. The technique of buon fresco (used for example at Pompeii) also requires no medium other than the lime of the wall on which it is applied. The technique of fresco secco (used for example in Egyptian wallpainting) requires a medium such as gum, casein or lime, which themselves discolour minimally or not at all. The encaustic technique (used by the Romans, again at Pompeii) involves the suspension of pigment in a purified wax medium that discolours minimally over time and which has been demonstrated to protect the pigment from abrasion and atmospheric pollution much more effectively than either fresco technique.
- **2** Wherever possible, medieval painted references are derived from furniture and panels painted in egg tempera, a technique wherein the vibrancy of pigments are not in the main altered in the egg medium over time.
- **3** Furniture, objects and walls painted in oil colours have not, in the main, been referred to, due to the fact that some oil media darken and deteriorate over time and some pigments react and discolour in reaction to some oil media over time.

Wall colours from the seventeenth century onwards have been matched not to commercial 'historic' paint ranges, but to references, samples and studies of several renowned architectural paint historians (see page 192), directly by comparison with Hexachrome[®] colour swatches and indirectly with a spectrophotometer and translation from Lab or RGB colour spaces to Hexachrome[®].

Wherever possible, historical paint matches for ancient world wallpainting, medieval tempera panel painting and painted objects have been conducted by comparison of Hexachrome® colour swatches with the actual painted object. Further colour matching has been possible using a portable spectrophotometer.

The colours of enamels, ceramics and textiles have been matched by the comparison of Hexachrome® colour swatches with the actual object. These colours may have been specified on either coated or uncoated paper depending on the reflectivity of the original source.

Use has been made of source texts (Pliny, Vitruvius, Cennini, Theophrastus) and archaeological and conservation publications in identifying many of the pigments and colours of the ancient and medieval worlds. Descriptions and recipes have been crossreferred to extant examples of painting and decoration from the period.

Wherever possible, historic paint colours on a particular wall or object have also been cross-matched against pigment/ media samples. These samples were prepared with reference to historic texts using the appropriate historical medium for the palette source (gum, lime, egg tempera) and painted as massed tone swatches tints or washes as appropriate. In nearly every case, the pigment used was derived from the same source or via the same process as the pigment on the original wall or object (where it was identified). Two examples neatly illustrate this pursuit of authenticity: ultramarine blue pigment was derived from ground lapis lazuli from mines adjacent to the Oxus river in Afghanistan and processed in an identical way to that described by Cennini; 'Refiners' Verditer' was also procured according to the eighteenth-century method (as a by-product of silver refining). Here, I am indebted to the artists' colourman Ole Cornelissen and especially to the colourman and hound of pigment authenticity, Keith Edwards, for their forensic passion. Additionally, historical pigments have been matched, wherever possible, to examples of the minerals from which they would have been ground, deriving from a region known to have supplied that pigment. Examples are limonite, haematite, malachite, azurite, orpiment and cinnabar.

Palettes 1-16

I have not quite followed the progression of colours in the NCS four-colour colour wheel (see palette 62), so there are no turquoise/ green, green/lime-green or lime-green/yellow palettes. This is partly a reflection of taste and interest in those parts of the spectrum, but mainly because I have followed the colour balance of the Hexachrome® system used to print this book, whereby precise nuances between shades in the green-yellow part of the spectrum can sometimes be lost on the printed page.

If anything, this section follows the traditional system of the subtractive primaries: there are three palettes dedicated to red, yellow and blue and a further three to the secondary subtractive colours orange, purple and green. There are a further six tertiary palettes: yellow/orange, etc. There is one change to this structure. I have inserted two tertiary palettes between green and blue: turquoise and cyan, partly as a gesture towards the expansion of the colour spectrum in this part of the NCS wheel and partly because of the perceived variance of shades/tints in this part of the six-colour process spectrum.

Palette 1

No notes.

Palette 2

- 1 The term ochre applies to yellow iron oxide earth colours and is a term really reserved for colour washed out of sand.
- 2 Indian yellow is mercifully no longer made, since it was extracted from the urine of cows fed on mango leaves, a diet which did the cows no good.
- 3 The colour of cadmium yellow (since the 1850s and Ridgway 'Cadmium Yellow') and of saffron yellow (made from the stigma of crocus sativus; British Colour Council (BCC) 'Saffron Yellow'). The latter sounds much more romantic.
- 7 The colour of the pigment Barium yellow.

Palette 3

- 1 A popular colour in the early twentieth century.
- 2 The right orange for climates with a lot of cloud: its luminance stops it looking too brown. Equivalent to a tint of Ridgway 'Cadmium Orange'.
- 3 Produced here by printing Hexachrome® orange ink at 100 percent intensity with nothing else added. Ridgway 'Cadmium Orange', and the colour of orpiment orange/ realgar, native arsenic trisulphide.
- 4 BCC 'Spectrum Orange'.
- 12 Very 1920s and 1970s. Popular as an institutional colour.

Palette 4

3 Vermilion is also known as mercuric sulphide. Made according to a method perfected in Holland. Consequently known as 'Dutch

Vermilion', or since the fourteenth century as 'Fire Red'. Also called 'Poppy Red' in the paint trade and allocated the names 'Scarlet' (Ridgway) and 'Rouge Grenadier' (Repertoire).

Palette 5

- 1 This is a near match for the colour card named 'Vermillion' in the British Royal Horticultural Society's Colour Charts of 1939 and 1941.
- 2 The colour of woollen cloth dyed to a pure red with madder root, a colour known in the nineteenth century as 'Turkey Red' or 'Adrianople Red' and labelled by the RHS as 'Orient Red'. Another vermilion colour and British Post Office red.
- 3 Oriental laguer was coloured with vermilion.
- 7 Similar to the colour chosen by Nicolette Pot of OMA architects, which she calls 'NAP'.
- 9 The palest colour of Famille Rose porcelain, which was then popularised by Mme de Pompadour in France during the late 1750s.
- **11** Like colour 9, this was first adopted to imitate Oriental ceramics in the seventeenth century, becoming later popular as a decorating colour during the first and second French Empires.
- 12 A Famille Rose colour and a tint of the supposed 'Rose Pompadour' introduced by Mme de Pompadour.

Palette 6

- **1** The word 'Carmine' comes from the Greek *kermes* and the insect from which reddish dyes could be produced.
- 2 'Tyrian Purple' is a name that dates from the 1600s.
- 3 This colour is unforgiving and uncompromising because, like the other optical secondary colours, yellow and turquoise, it excites two sets of receptor cone cells in the retina, in this case those for red and blue, communicating literally double the colour to the brain as produced when only one set are stimulated.

Palette 7

1 This colour has also been known as 'Imperial Purple' and amethyst.

Palette 8

- 1 A tint of one of the first aniline dyes, methyl violet.
- 2 A colour full of historical resonance. The colour of ultramarine blue pigment – both the modern synthetic version and its valuable medieval antecedent made from lapis lazuli. Also the colour typical of Moorish cobalt-glazed ceramics.
- 5 These qualities result partly from simple colour association (we think of sky as being blue) and partly from an optical phenomenon that creates the impression that blue (and particularly pale or bright blue) appears to recede (whereas reds appear to advance).
- **9** An illustration of how a tint of an interesting colour does not automatically produce an equally useable decorating colour.

- **1** The colour chosen by Norman Foster for the HQ of EDF, the French national power company, in Bordeaux.
- 2 Corresponds to Ridgway 'Spectrum Blue' and modern glass frit Egyptian blue pigment bound with gum.
- 3 Late nineteenth/early twentieth century in feel (together with colour 4 to its right).
- 4 Purple often occurs in this book as a pivotal colour in a palette, especially when muted with either grey or brown or both. When shaded or toned in this way, purple can take on a brooding, bruised look but also an interesting, complex quality. This colour and colour 12 illustrate just how pleasingly ambiguous purple can be.
- **5** Similar in character to some of the blue synthetic ultramarine pigments developed by the artist Yves Klein.
- 7 The colour of the bright blue glaze of Persian pottery.
- 11 This colour and colour 6 above it are versions of 'Korsmo Blue', a colour much favoured by the eponymous Scandinavian architect for the outside of his buildings. Also a tint of Cerulein blue, a pigment invented in 1859.
- **14** This is a favourite colour of the architect Alessandro Mendini, 'Azzurro Nontiscordardime' (forget-me-not blue).

Palette 10

- 1 The sequence of palettes steps a little out of line on this page, because there are two, not one, palettes between blue and green: this one, and cyan and turquoise over the page.
- 14 The colour often historically used for aircraft undersides and similar to the British Colour Council's 'Sky Grey' of 1934.

Palette 11

- 1 The kind of blue that appears on Middle and Far Eastern ceramics. An optical secondary colour and thus bright to look at.
- 2 Another ceramic and very marine colour.
- 3 The colour of deep viridian pigment and a tint of modern phthalocyanine green.
- 5 Similar to coal-tar dye colour 'Capri Blue' produced by Bender in 1890.
- 7 An intense Georgian and 1920s Georgian revival shade, a tint of chrysocolla pigment (a naturally occurring copper compound used by the ancients).

Palette 12

- 1 It's the colour of nickel arsenate (the mineral cabrerite) and is known as 'Nickel Green'.
- 4 This colour appears on exterior woodwork and gates in modern Paris.
- **5** A relatively intense tint of malachite or 'Mountain Green', an ancient pigment.
- 10 Also used in the eighteenth century and known as 'Mineral Green' (see palette 17 for more common colours of the eighteenth century).

- 13 A tint of malachite.
- **16** This is Sung green, the colour of porcelain from the eponymous Chinese period.

Palette 13

- 7 It's also the colour of uranium salts and is known as 'Uranium Green'.
- 9 This standard method of dyeing green persisted until the late nineteenth century.
- 14 Also a tint of the green much used by the painter Veronese.
- 16 Greys are difficult to get right, since black produces hard, bluish tints.
 Umber greys are flexible but greenish greys are fresher.

Palette 14

No notes.

Palette 15

- 1 A good colour for leather, ceramic cookware and 1970s car interiors. Not so good for painting the bedroom ceiling.
- 2 A colour that historically was often used indoors and out (in Roman wallpainting, for example). Consequently a classical revival colour.
- 3 Traditionally a useful pigment for glazing (oil painting, wood-graining, etc.) because of its transparency.
- 6 A mid-toned iron oxide that is like brown shoe polish. Another colour much used in history.
- 8 Almost beige or manila, more like a tint of raw umber, since it has a slight greenish cast.
- 9 This colour is redolent of varnished pine. Use it if you ever want to see that colour again.
- 10 The most prized brown pigments in history were those with a clean orange bias. This is similar in colour to the best of them, an earth from Pozzuoli in Italy.

Palette 16

No notes.

Palette 17

This palette is derived entirely from Patrick Baty's work in the field of historical colour research. A full palette of 64 colours has been published and hand-painted swatch cards and paint in a variety of media in these colours can be bought from Papers and Paints Ltd, 4 Park Walk, London SW10 0AD, www.papers-paints.co.uk. Some colours, notably some of the 'common colours' such as 'Lead Colour', 'Dark Stone' and 'Cream Colour' have not been reproduced here because of the technical limitations of printing this volume: in particular, dark bluish green-greys do not reproduce well.

Patrick Baty's published range has been selected from three sources: some are colour matches to early paint recipes; some depend on his

own study and analysis of paint colours from historic buildings, together with the research work of Dr Ian Bristow; some are colour matches to painters' cards from 1807. The range is a selective representation of some of the more popular colours of the period that are mentioned in contemporary texts.

Additionally, colours cross-match to samples of pigment known to be available in the period, notably the earth colours and green and blue verditer, which conform in hue to pigment being produced by the colourman Keith Edwards, according to historical recipes.

Further references are given in the text to some similar colours that have been found on buildings in America. These are published in the 1994 volume *Paint in America* and represent the research of the colour analyst Frank S. Welsh, who has done much to dispel fictional ideas about America's historical colours. He has published a list of 35 colours from various important historic sites in America, which are strikingly similar to many colours in this palette. His published list contains Lab measurements for each colour, which have been referred to in cross-matching his references to Baty's paints with a spectrometer (set at illuminant C, 2 degree angle). Only the Welsh colours that most closely approximate Baty's colours have been referred to. Full paint samples of the American colours can be bought from Frank S. Welsh at PO Box 767, Bryn Mawr, PA 19010, USA. See the bibliography for fuller details of the volume mentioned, together with other research work.

Palette 18

British Standard Colours for Ready-Mixed Paints, No. 381C (this reference still applies to a British colour range, chiefly paints for technical use, and most of the original colours, the battleship greys excepting, are still included in it), taken from a 1931 colour card issued by the British Engineering Standards Association (BESA). Also BESA Proposed Standard Shades, plate XV in A. Seymour Jennings' Paint and Colour Mixing, seventh edition, 1926.

BESA colours were being experimented with earlier in the century, but were only standardised by a large committee of interested parties in 1925–26 that was appointed by the BESA to deal not only with colours but coating materials and raw ingredients. One sub-panel was appointed to allocate names to paint colours and, having collected all the available manufacturers' shade cards, found that under accepted common terms, such as 'Sky Blue' a wide range of colours was available on the market. This is a problem they rectified with the first 381C range and the standard names given in this palette are those chosen by that panel.

Other national standards had been introduced in the first two decades of the century, but none had been created for the paint trade. Robert Ridgway, a Bird Curator in Washington, USA, had published Color Standards and Color Nomenclature, a reference system of 53 plates of coloured swatches based on the colour wheel, intended for natural history colour identification. Also in the USA, the Textile Colour

Card Association of the United States of America had published the Standard Color Card of America, a swatch card of 106 coloured silk ribbons for identifying dye colours. In France, M.H. Dauthenay had edited the Repertoire des Couleurs, par la Societé Française des Chrysanthesmistes, a collection of 365 plates in two portfolios of colour tints and shades to be used for identifying the colours of fruit, flowers and foliage. All proved useful contributions to understanding colour and codifying it. All were used in disciplines well beyond the spheres for which they were created. All acknowledged the difficulty of how to name colours.

Palette 19

- 1–12 From the 'Alabastine' range of water-based interior wall paints from the Alabastine Company (British) Ltd. From the full colour card published in A. Seymour Jennings' Paint and Colour Mixing, seventh edition, 1926.
- **13–22** From the 'Nayrodec' range of water-based interior wall paints from Naylor Brothers (London) Ltd. From Jennings *op. cit*.

Palette 20

- 1-6 From a proposed colour scheme for a dining room; the main colour in this proposal was the grey-brown and the secondary colour lime green.
- 7–10 From a proposed colour scheme for a library; the main colour in this proposal was the violet-grey and the secondary colour dark battleship grey. Note that two minor colours in the original proposal, a deep empire green and a blue-grey have been omitted from this book. All from Elizabeth Burris-Meyer's Contemporary Colour Guide, New York, 1947.

Palette 21

1–5 From a design for a proposed apartment living room by Raymond Rust, mid-1950s; V&A Museum, London.

Palette 22

- 1-4 From a wallpaper designed by Lucienne Day, 'Limited Editions 1951' series, manufactured by John Line & Sons Ltd., 1951; V&A Museum, London.
- 5–8 From 'Triad' furnishing fabric designed by Lucienne Day, screenprinted rayon satin, Heals Wholesale and Export Ltd., 1955; V&A Museum, London.

Palette 23

1-5 From a textile design by Eddie Squires; V&A Museum, London.

Palette 24

1–5 From a wallpaper designed by Eddie Squires, 'Colourtron', Warner and Sons Ltd., 1967; V&A Museum, London.

- 1 From a Fiorenza chair, designed by Motomi Kawakami, manufactured by Alberto Bazzani, ABS plastic; V&A Museum, London.
- 2 From a Pastilli Chair, designed by Eero Aarnio, fibreglass and polvester resin, 1968; Asko, Lahti, Finland.
- **3** From a chair designed by Joe Colombo, plywood with polyester varnish, 1963; Kartell, Milan, Italy.
- 4 From a stacking chair designed by Verner Panton, fibreglass and polyester resin, 1960; Herman Miller Furniture Co., Michigan, USA.
- 5 From an armchair designed by Ernest Race, 1946; Ernest Race Ltd, London, UK.
- **6** From a 'Toga' stacking chair, designed by Sergio Mazza, hot press mould fibreglass, 1968; Artemide, Italy.
- 7 From a chair designed by Pierre Paulin, 1966; Artifort, Netherlands.
- 8 From a 'Oberon' garden seat, designed by H.W. Wood MBE, 1964; Lurashell.

Palette 26

1–4 The Book of Historical Colours, Thos. Parsons & Sons Ltd, 1937 (reprint). By kind permission of Patrick Baty.

Palette 27

- 1 From interior wall colour, ballroom, Lidingsberg, Sweden.
- 4 and 7 From interior woodwork and walls, manor, Olivehult, Sweden.
- **5–8** From painted dados, woodwork and furniture, traditional farmsteads, Skåne, Denmark.

Palette 28

All the swatches in palettes 28 and 29 were matched against camouflage scheme colours of various air forces and navies. However, as with all the palettes in this book, no guarantee can be given that colours have been reproduced utterly faithfully. Nor is this palette in any way comprehensive. With thanks to Humbrol paints.

- 1, 4, 7 and 10 Russian Air Force.
- 2 'Duck Egg Blue'; RAF, European.
- 3 Blue FS35414; USAF Navy and Marine, contemporary.
- 5 'Gris Bleu Clair' (light blue-grey); French Air Force.
- 6 'Hellblau' (light blue); Luftwaffe, World War II.
- 8 Light grey; generic naval vessels.
- 9 'Himmelblau' (sky blue); Luftwaffe, World War II.
- 11 'PRU Blue'; RAF post-war.
- 12 'Azure Blue'; RAF overseas.

Palette 29

- 1-4 All from USAF, Vietnam.
- 1 Upper-surface green olive drab.
- 2 Upper-surface dark green. Also base colour, disruptive pattern, UK forces, Burma 1942.

- 3 Under-surface grey.
- 4 Upper-surface tan.
- Matt pale stone; base colour, British military two-colour disruptive pattern, North Africa 1937,1939, 1940, 1942, Syria, Persia and Iraq 1943.
- 6 German overall sand: tanks. World War II.
- 7 Afrika Korps desert yellow; military vehicles, World War II.
- 8 Eighth Army desert yellow.
- 9 'Pink Panther' pink; modified lightweight landrover colour as used by SAS commandos in the 1991 Gulf War. Matched to a vehicle currently at Blandford Forum.
- **10** British military two-colour disruptive pattern, North Africa 1939 and 1942, Syria, Persia and Iraq 1943.
- **11** Base colour; British military three-colour disruptive pattern, Europe 1939 and North Africa 1943.
- 12 Japanese airforce mauve.

Palette 30

- 1-7 Construction sites.
- 8 'Red Oxide of Iron Paint' (formulated with linseed oil and very pure iron oxide pigment) manufactured to paint the Forth Rail Bridge. Courtesy of Craig and Rose paint manufacturers, Edinburgh.

Palette 31

- 1 This is usually a refined clay containing silica, coloured by the presence of iron oxides and can be extracted from ochreous sand, clay deposits and goethite (a form of limonite FeO(OH).nH₂O).
- 2 Because of their muddy complexity, yellows and creams made with ochre and white tend not to turn greenish under natural daylight from an overcast or North sky. As a result, ochre is an invaluable colour for decoration and is now chemically synthesised for mass production of paints and coatings.
- 3 Naturally occurring mineral pigments vary in colour and intensity around the world according to their purity. An ochre with high levels of hydrated ferrous oxide will look stronger.
- 5 If Goethite or yellow ochre are heated, they give off water molecules and turn, irreversibly, red (becoming anhydrous ferric oxide). This is something you can try with yellow ochre pigment and a gas ring. The naturally occurring equivalent red mineral is haematite (Fe₂O₃), which is found in several colours, the most common of which is cool and slightly purplish. Spanish red is the name for the impure pigment and Indian red that for the purer, more intense versions.
- 6 If the intense purplish hue of some haematite reds is too strong and uncompromising for many uses, then the tints it produces with white are equally accessible, useable and pretty.
- 9 The deepest haematites have a brownish shade due to the presence of manganese oxides in the pigment. This is a similar colour to a warm red ochre but deeper. In fact the finest shades are the most

intense of all the earth colours and are made by calcining (roasting) raw sienna pigment to drive off water molecules and produce a deep red pigment with intense fiery undertones that become visible when the colour is diluted.

- 10 This pigment is again a clay coloured with iron oxides and manganese, and is mined as the mineral glauconite.
- 13 Although the classification of earth pigments breaks down into yellows and reds with the addition of manganese in some cases, in practice there are six basic terms of which yellow ochre and red ochre are the brightest pair and raw sienna and burnt sienna are their slightly duller equivalents. They take their name from the Italian city of Siena, from around which the finest grades of raw sienna could once be found.
- **15** The colour is a feature of the particle size of haematite (which is black before being pulverised): 0.5 microns produces violet-red, while 0.1 microns produces red.
- 17 The more manganese there is in an earth pigment, the blacker it will appear.
- **19** Haematite will also produce an orange pigment if the particles are ground even finer (to 0.05 microns).
- 21 The manganese in raw umber turns the brilliance of the iron oxide present in yellow ochre into a deep greenish brown.
- 22 When black is mixed with white the resulting greys are almost always blue-tinged and slightly unnatural.
- 23 When raw umber is calcined (roasted) it loses its yellowish greenness and becomes the deepest brown of all the earth colours. It also becomes more transparent.

Palette 32

1-8 From faded Verdure tapestry colours from several sources. See also Thos. Parsons & Sons Ltd, Historical Colours, London 1937 (and earlier editions), for alternative conjectural tapestry colours.

Palette 33

From a variety of paint manufacturers' shade cards.

- 1 Also appears on much Shaker painted furniture, especially chairs and stands.
- 4 Matches several early Pennsylvanian Dutch pieces in the collection of the American Museum, Bath.
- 5 From a counter painted dark blue at The Shaker Museum, Old Chatham, New York, c.1815.
- 7 From a painted chest painted in blue-green by Z. Winchester at the Hancock Shaker Village, Pittsfield, Massachusetts. Dated 1821.

Palette 34

1–6 All from pottery: amphorae, cups and other vases from Athens and Rhodes, 600–400 BC; British Museum, London.

Palette 35

- 1-6 From Turkish tiles and Mosque lamps, some from the Piyale Pasha Mosque, Istanbul, and the Yeni Valide Cami Mosque, Iznik, 1550–70.
- 7 From a Syrian panel from Damascus, supposedly from the Sinaniye Mosque; V&A Museum, London. All the colours are present in the numerous architectural tile schemes of Samarkand, notably on the mosque of Bibi Khanom (1398), the dome of the Gur-e Amir (1398) and the madrasah of Shir Doh (1619).

Palette 36

1–8 All from Roman stone tesserae mosaics from Halicarnassus and Ephesus in Turkey, Carthage and Utica in Tunisia. British Museum, London.

Palette 37

1-12 All from Roman stone tesserae mosaics from Halicarnassus and Ephesus in Turkey, Carthage and Utica in Tunisia. British Museum, London.

Palette 38

- 1 From a bowl, single colour, Song dynasty, 960–1279; V&A Museum, London.
- 2 Export colour, from various ceramic items, seventeenth century onwards.
- 3 From a bowl, single colour, Song dynasty, 960–1279; V&A Museum, London.
- 4 From a teapot, single colour, Dehua ware, Ming-Qing dynasty, 1620–1700; V&A Museum, London.
- 5 From a bowl, single colour, Song dynasty, 960–1279; V&A Museum, London.
- 6 From a jar, single colour, Yuan dynasty, 1350–1400; V&A Museum, London.

Palette 39

- 1-4 Listed in *The Colours of Japan* by Sadao Hibi (see introductory essay by Kunio Fukuda for a description of traditional terms). Mayer (1981) gives a list of Japanese pigments, principal among which are vermilion (cinnabar red), azurite (blue), malachite (greenish blue) and a variety of whites with different surface qualities, ground from shells, mica, quartz or calcite.
- Matched to a sample of Chinese cinnabar (mercuric sulphide) from Yuanshanchiang; Natural History Museum, London. This pigment is recognised as one of the oldest in widespread use in Japanese culture.
- 4 Matches a sample of azurite pigment from Thuringia; Natural History Museum, London. Japan still imports azurite from America (Mayer, 1981) and samples from Morenci and the Copper Queen mine in Arizona (held in the NHM London) show a deep blue capable of producing a pigment of this intensity.

Note that some sources consider the original meaning of the four colour terms to represent light and dark, clear and vague, a construct similar in form to Aristotle's colour scale on which all colours (but principally red and green) stood in relation to darkness and light. His model persisted in Western culture until the Renaissance and, it would appear, therefore ran parallel with the suggested Japanese meanings.

Palette 40

- 1 From a red silk hat, Qing dynasty, nineteenth century; V&A Museum, London.
- 2 From various lacquer objects, from the seventeenth to twentieth centuries, and matched to modern sourced manufactured Chinese vermilion
- **3** From a porcelain vase, Kangxi period, Qing Dynasty, 1662–1722, China; V&A Museum, London.
- 4 From eighteenth-century Chinese robes, also Repertoire 'Jaune Indien' 27/2 and RHS 'Chinese Yellow' 60/6.

Palette 41

1–3 All taken from designs executed in watercolour for lead-glazed creamware; The English Archive. Also from ceramic 'zellij' tilework, columns. Sahriz Mandrasah, Fez (1321–26).

Palette 42

Percentage figures in printing denote the dot density for each colour and therefore what amount of each colour is being used. It does not denote the percentage quantity of each ink as part of the finished colour. Thus it is possible to have, say, a dark brown comprising 100 percent magenta, 100 percent yellow and 40 percent black.

1–3 From 1960s and 1970s magazines, including Vogue, House & Garden and Connaissance, in the collection of the author. Also see Lesley Jackson's Contemporary, which illustrates many period objects and interiors with original photography and printed imagery, especially pages 106, 109, 118–19 and 132.

Also these colours appear together in Middle Egyptian wall paintings: see Gustave Jequier's *Décoration Egyptienne*, Paris, 1911, Pls XXVI and XXVIII; painted ceiling in the tomb of Hepuseneb, Thebes, 1495–75 BC and Tombs of Amemheb and Nebamon at Thebes, 1400s BC.

Palette 43

- **1–2** Matched to a variety of vehicles in the Beaulieu Motor Museum and the Haynes Collection, UK.
- 3 This colour is matched to the Gordon Bennett Napier of 1903 at the National Motor Museum, UK. It is a British Standard (BS381C) colour, 'Deep Brunswick Green', the colour that Bentleys raced in

at Le Mans during the 1920s and which outsold all other colours on British MG sports cars throughout the twentieth century by a factor of four to one.

The origin of the colour is apocryphal, but the first allocation of colours to different countries' racing teams came about for the first world international series of motor races organised by James Gordon Bennett in 1899. The rules, laid out by the Automobile Club de France, allocated red to the Americans, blue to the French, yellow for Belgium, and white for Germany. In fact, very few teams stuck to these requirements for the first few years, and the association of Britain with green occurred through happenstance. In 1901 the British driver Charles Jarrott made a visit to the French workshops that were preparing his 40hp Panhard for that year's Paris-Berlin race. The workshop owner had ordered the car to be painted a 'beautiful, rich dark' green because the car had been allocated the number 13 for the race, and green being a lucky colour in France, he thought the new colour would ward off the ill effects of the number. A year later Britain won the Gordon Bennett race with SF Edge, it is reported, driving a green Napier (the previous year it had been a red Napier). This meant that in 1903 the British had to host the event but could not, due to parliamentary restrictions concerning road races. Ireland proved to be a compromise location and apparently, to honour their hosts, the British team painted all their cars green - the Irish national colour.

In 1905 national racing colours were reintroduced and black allocated to the Italians. They quickly objected, insisting on green, a stripe of their tricolor. Since by this time the Americans had lost interest in European races, a compromise appears to have been reached and by the following year, all Italian sports cars were being painted the old American colour, red (another colour in the Italian national flag). More arguments followed, more countries joined the races and more teams defied the regulations until after World War I when, finally, national teams got on with the business of competitive driving rather than competitive grooming. The final positions were: red for Italy, blue for France, white (and later silver) for Germany, green for Britain. The national prejudices survive today. Ferraris are still red, Porsches, Audis and Mercedes still silver, and what's left of British car manufacturing occasionally dips its brush in a pot of green paint.

Extracted from archive material at the National Motor Museum, in particular publicity for the Coys International Historic Festival, notes of the BRDC and the April 1990 edition of *British Racing Green* with an article by Bill Boddy.

Palette 44

1-6 Cotton fragment made in Burhampur, eighteenth-century; Murghal floorspread, cotton and silk, Gujarati, late seventeenth- or early eighteenth-century; Murghal loose tent hangings, late seventeenth century. All V&A Museum, London.

Note these colours also appear in Qanat panels of the period.

- 1-3 From a Forziere (marriagechest) painted with foliage; Tuscan, 1350; V&A Museum, London.
- 3–4 From a chest painted with foliage; Romanian, nineteenth century; collection of the author.
- 4 From a Cassone (large box) with a depiction of Susannah and the Elders by Francesco di Giorgio; Pinacoteca Nazionale, Siena.
- 5-6 From a Cassone panel: Sienese, 1475. V&A Museum, London.

Palette 46

- **1** From a porcelain wine cup, Qing dynasty, Kangxi mark and period (1662–1722); British Museum, London.
- **2** From a porcelain wine cup, Qing dynasty, Yongzheng mark and period (1723–35).
- **3–4** From a Sèvres teapot, Bowes Museum, Barnard Castle. A very similar pink appears on a decorated Qing dynasty porcelain teapot (1740–80) in the V&A Museum, London.
- 5 From 21/1 RHS colour charts. Parsons' Historical Colours.
- ${\bf 6}$ From Parsons' $\it Historical\ Colours$ by kind permission of Patrick Baty. ${\bf Palette\ 47}$
- 1-4 'Riddarateppid' (Coverlet of Knights), seventeenth century; Thjødminjasafn Islands, Reykjavik. Eight Point Star cushion, seventeenth century; Nordiska Museet, Stockholm.

Palette 48

1–5 From a wall painting panel, Palace of Cnossos, Crete; British Museum, London. Colourwork principally in red and blue with yellow. Linework in near-black. The red is undoubtedly haematite; the yellow of the period was ochre, although here it may have been overglazed (the colour is more indicative of orpiment, a naturally occurring arsenic trisulphide). The blue is probaby Egyptian blue, a finely powdered glass frit coloured with copper compounds that was known to the Minoans. It could also be a simple tint of azurite (this colour corresponds to a tint of a modern sample of calcareous Moroccan azurite, known as 'Blue Bice' in the collection of Keith Edwards). The blue-black corresponds to their use of powdered slate as a pigment. Further colours such as green were made possible by intermixing pigments (Mayer, 1981).

This palette also appears in the following locations: textile patterns from the Procession Fresco at Cnossos, about 1550–1400 BC; textile patterns from a fresco at Hagia Triada, about 1700–1600 BC; fresco fragment showing columns from Cnossos, about 1700–1550 BC; fresco ornament from Cnossos, about 1550 BC; also in Greece, floor paintings in the palace at Tiryns, about 1400–1200 BC (H. Bossert's An Encyclopaedia of Colour Decoration, Wasmuth, 1928 and H. Bossert's Alltkreta, second edition, 1923); also in Etruscan Italy at Tarquinia, fresco in the 'Tomba delle Leonesse', first half of the six century BC; frescoes in the 'Tomba dei Leopardi' and 'Tomba del

Triclinio', about 500 BC; fresco in the 'Tomba del Tifone', third and second centuries BC (F. Weege, *Etruskische Malerei*, Halle, 1921 and H. Bossert, *An Encyclopaedia of Colour Decoration*, Wasmuth, 1928.

Palette 49

1–5 From wall paintings at Cacaxtla, near Mexico City; early Mayan (although outside Mayan territory), 650–900 AD. The red and yellow have been identified by Diana Magaloni as containing haematite and limonite respectively (*National Geographic*, Vol. 182, No. 3, September 1992). The blues are almost certainly Maya blue, a pigment developed for wall painting and ceramics in pre-conquest Meso-America and made by precipitating indigo onto the white clay mineral, attapulgite (Gettens, 1962, and Kleber et.al., 1967).

Palette 50

No notes.

Palette 51

1–4 Watercolour by Robert Smirke, c. 1802; Drawings Collection, Royal Institute of British Architects, London. Also illustrated in J.C. Krafft and N. Ransonette, *Plans, Coups, Élevations des plus belles Maisons et Hôtels construits à Paris et dans les Environs*, Paris, 1802. See also P. Thornton, *Authentic Décor*, Weidenfeld & Nicolson, London, 1984, pl. 241.

Palette 52

- 1 From wallpaper border, 1820–30; A.L. Courtan gift, V&A Museum, London.
- 1 and 3 Also appear together in Nathaniel Whittock's *The Decorative Painters' and Glaziers' Guide* (London, 1827) as a family of rather brilliant colours for simulating a variety of 'fancy woods' for 'shop fronts, halls, &to', including rosewood, red satinwood and coralwood.
- 4 From a silk panel manufactured by Joseph Dory, Lyon, 1813; V&A Museum, London.
- 5 From wall and fabric colours from a watercolour proposal for a bedchamber design in the Empire style, based on classical models; Théodore Pasquier, Dessins d'ameublement, Paris, c. 1830, Bibliothèque Forney, Paris. See also Peter Thornton, Authentic Décor, London, 1984, pl. 324.

Palette 53

This palette was assembled from commonly recurrent architectural colours. Notable examples only are given.

- 1 From walls in buildings, Thar desert, India, and house colours in villages of Olympos, Menetes, Arkassa and Volada, Karpathos islands, Greece, recorded in *Les couleurs de L'europe* by Jean-Philippe Lenclos, Moniteur, France, 1995.
- 2 From city walls of Taroudant and Kasbahs in rammed earth, Ksour (fortified villages), Morocco.

- 3 From Greek islands as colour 1 and mud houses, Thar desert, India. Also nomadic huts in coastal Guiarat.
- 4 From mud houses, Thar desert, India and walls of Taroudant, Essaouira and Kasbahs in the Dades valley, South Sahara.
- 5 From Greek islands as colour 1 and houses at Burano, Naples, Italy.
- **6** From mud walls and houses in the villages of Mzonda, Rissani and Tinerhir, Morocco.
- 7 From applied colour, houses in the Thar desert, India.
- 8 As colour 6 and also shutters/garages/details of houses in Essaouira and Taroudant plain, Morocco, and applied colour to houses in Burano, Naples.
- 9 From ceiling of Bahia Palace, Marrakesh and walls in the Brahmpari (city of Brahmins), Jodhpur. Also clothes worn by Sahraouis nomads, Sahara desert, the 'blue men of the Sahara'.
- **10** From walls at a coastal farmhouse, near Essaouira and walls of Old Palace, Taroudant, Morocco.
- **11** From wall colour at Chaouen (between Tangiers and Fes, Morocco), and Brahmpari, Jodhpur (see above).
- 12 From woodwork, farmhouses near Essaouira; indigo-dyed clothing of the Sahraouis; doors at Chaouen; a shade of the colour of the Merinid dynasty (1269–1465). All Morocco.
- 13 From Brahmpari, Jodhpur (see above).
- 14 From nomadic huts in coastal Gujarat.
- 15 From detail colour on buildings in the Thar desert and also near Tadpatri, Andhra Pradesh (with colour 16). Detail colour at Nimaj Haveli (former townhouse), Jodhpur; all India. Also town walls of El Jorf and at Chaouen, Morocco. Note this tone of turquoise nearly always accompanies colour 16, as a detail colour.
- 16 Also the colour of Portuguese window frames, Greek villages and the darkest walls in the holy city of Jodhpur. Also, in western culture, the blue of the Madonna's robes, French medieval royalty and washing blue. Similar to the blue of Villa Majorelle, Marrakesh. Also house colours in villages of Karpathos islands, Greece (see above). Also Brahmpari, Jodhpur, India. It is commonly associated with colour 15.

1-4 All from Lagoan house, Flores, El Petén, Guatemala; exterior wall colours, Calle Noche Triste, Oxaca, Mexico; exterior wall colours, Rio Lagartos, Yucatan, Mexico.

Palette 55

- 1–3 Postulated and formulated to historical descriptions given in Japanese Detail by Hibi Sadao with an introductory essay by Kunio Fukuda.
- 1 The green moegi was produced by overdyeing yellow plant dyes with indigo (Japan had a thriving domestic trade in indigo-dyed cloth from early times). Fukuda notes that silk dyed in this way generally turned out an attractive yellow, while cotton turned drab olive green.

2 Note that in Japan brown became classified as a colour in its own right only in the Edo period and was referred to as *chairo* ('tea colour'). By the late eighteenth century, shades of brown were being named after famous Kabuki actors.

Palette 56

1-4 From an illustration by Éric Bagge of a bedroom designed by Louis Süe and André Mare (partners from 1919–28 and the founders of the Compagnie des Arts Français). See L. Moussinac, Intérieurs, 1924; Bibliothèque Nationale, Paris. In partnership with the artist Mare, Süe designed interiors for among others, Helena Rubinstein, Jean Patou and the ocean liners Normandie and Ille de France.

Palette 57

- 1-3 From a 1972 copy of the Volkswagen Microbus sales catalogue.
- 4 Matched to a vehicle.

Palette 58

1-4 NCS colour palette.

Palette 59

- 1 Virgin and Child; V&A Museum, London.
- 2 Virgin and Child; V&A Museum, London.
- 3 Foliage and clothing colour, roundel and shrine panel; V&A Museum, London.
- 4 Clothing and 'shadow' colour, frieze; Ospedale del Ceppo, Pistoia.
- 5 Foliage colour, coats of arms, The Annunciation and other panels; Ospedale del Ceppo, Pistoia; large round panel, V&A Museum, London.
- 6 Various panels, V&A Museum, London.
- 7 Foliage colour, coats of arms, The Annunciation and other panels; Ospedale del Ceppo, Pistoia; large round panel, V&A Museum, London.
- 8 Various panels, V&A Museum, London.
- 9 Coat of Arms of the Medici, Ospedale del Ceppo, Pistoia. Various panels, V&A Museum, London.
- 10 Various panels, V&A Museum, London.

Palette 60

- 1-2 From a food box, Jaijing reign, 1522–66, China, V&A Museum, London.
- 3-6 From an alcohol jar, China; V&A Museum, London.
- 7-8 From a Ming porcelain food box, Jaijing reign, China.
- **9–10** From a porcelain flask, Yuan dynasty, c. 1350, China, V&A Museum, London.
- 11–14 From cobalt glazed Arita pottery, 1600 onwards, Japan; various tems, V&A Museum, London.

1—4 Until the 1850s, all dyestuffs were natural. Dyers had to rely on plant-based products such as indigo and madder, the separate supply industries for which were vast. Essentially, very little was known about the chemical properties of dyes until the advent of modern organic chemistry, which more or less started at this time. One man in particular, William Henry Perkins, deserves mentioning, since it was while searching for a cure for malaria in 1856 that he accidentally produced an intense synthetic dye which he called mauve. It was not stable in UV light and faded, so our modern understanding of the name mauve does not convey the excitement this discovery created, nor the influence the colour was to have in fashion of the period.

Perkins' colour was the first in a range of simple aniline, or coal-tar, dyes. Many others quickly followed, including the first synthetic alizarin dye in 1868, which posed the first serious threat to the traditional plant-based dye trade. Later azo-type and sulphur-based dyes were more permanent and formed the basic building blocks of modern colorant chemistry that has allowed every one of us to enjoy colour as a freely available property of the modern world.

- 1 Mauve; simple aniline (coal-tar) dye, Perkins, 1856. Silk dress dyed with Perkins' original dye, c. 1862, Science Museum, London. Origin of the term mauve is from malva, the latin for mallow, mauve being the French term for the plant.
- 2 Magenta, simple aniline (coal-tar) dye, Verguin, 1858–9. The second basic dye, and more widely used than mauve. Also known as 'Fuchsin'. BCC 'Magenta' 198.
- 3 Alizarin crimson, synthetic madder, the first example of a synthesised vegetable dye, Graebe and Liebermann, Germany, 1868, and Perkins, independently in England. Ridgway 'Rose Red' 71, modern Alizarin crimson, artists' pigment, RHS 'Crimson'.
- 4 Methyl violet, basic dye, Lauth, 1861. Similar to Ridgway 'Bluish Violet' 57 and RHS 'Methyl Violet'.

Palette 62

1-16 NCS colour palette.

Palette 63

Admittedly, the Andeans have had generations to get it right, but this palette is masterful. And, like many of the most interesting palettes in history, it relies on purple as a pivotal colour.

1-10 From clothes, shawls and fabrics from the Urubamba valley, Pisac and Cuzco markets, Peru.

Palette 64

Some colours appear on more than one object.

- 1, 3, 4 and 9 Askos (spouting jar), made in Canosa, Italy, 270-200 BC.
- 2, 3, 5 and 8 From terracotta figures, made in Canosa, Italy, 270-200 BC.

- 2 and 7 Statuette of a woman with a duck and a conch shell, made in Canosa, Italy, 270–200 BC.
- 6 Rhyton (drinking horn), red-figured, from Capra.

All decorated in paint over a white slip ground on terracotta. From the Steuart and Durand collections, British Museum, London,

No analyses of pigments have been conducted on the artifacts in these collections, but x-ray diffraction, chemical and UV analyses have been conducted on other polychrome objects of the period, notably by RA Higgins in 1970. They identified a wide variety of paint pigments in use, including ochres and haematites, soot or bituminous blacks, chalk, gypsum, malachite and Egyptian blue.

Colour 3 is the colour of a pigment from a mine at Pozzuoli in Italy, known to the Romans at this time, producing a strong, warm red ochre which famously became known as Pozzuoli red. Matched to a modern sample of pigment produced at Pozzuoli and to a sample of the pozzolanic rock from the mine at Pozzuoli, courtesy Keith Edwards.

Colour 6 is extremely close to a sample of medieval formula vermilion formerly sold by the pigment company Kremer, and a good tonal match for a sample of cinnabar mined at Mount Amiata in Tuscany. Both in the collection of Keith Edwards.

Colour 4 is the colour of very pure orpiment, rarely found as free of orange as this. However, it is more likely to be a lead yellow glaze, used in conjunction with polychrome painting on pottery of this period.

The blues in this palette suggest the use of a very pure azurite with little green content. Colour 1 matches a modern paint, in both gum and egg tempera, of azurite pigment from the Tsumeb mine in Namibia. However, the use of Egyptian blue pigment (cobalt or copper glass frit) was widespread at this time as a decorative ceramic paint colour in Greece (see above). Riederer (Artists' Pigments, Vol. 3, 1976) identified it on Greek painted vases at Centuripe in Sicily from the second century BC. Egyptian blue was also known as Pozzuoli blue.

The pinks in this palette could be derived from one of several sources: the same murex shellfish that produced the extremely expensive dyes used for colouring fine cloths of the period; a madder lake (more likely) formed by precipitating an intense dye made from the roots of madder plants onto an inert base such as chalk; or a pigment manufactured from the kermes insect. Colour 2 is the colour of a modern genuine rose madder lake massed in gum, but this colour is also closely related to a pigment sample in Keith Edwards' collection of modern Indian lake (lac), formulated from insects that are similar to the kermes insect. Higgins identified madder as the colorant in one analysis but failed to identify the pink colorant of one thespian statue of 450 BC (1970). However, W.T. Russell (1892) and Farnsworth (1951) separately identified madder lake as the colorant in samples of processed pigments from Egypt and Corinth dating from the Greco-Roman period, making it the most likely source for these colours.

For a full discussion of these pigments see Riederer, Schweppe and Winter in *Artists' Pigments*, Vol. 3, (1997).

bibliography

In addition to the works mentioned in the Notes to the Palettes on pages 176–185, here is a core bibliography.

history of colour, pigments and colour in decoration

Philip Ball, Bright Earth: The Invention of Colour, Viking, 2001.
Jenny Balfour-Paul, Indigo, British Museum Press, London, 1998.
Patrick Baty, 'Palette of Historic Paints', Country Life Magazine, 20 February 1992, UK.

Patrick Baty, 'Palette of the Past', Country Life Magazine, 3 September 1992, UK.

Paul Binski, *Medieval Craftsmen: Painters*, British Museum Press, 1991. Viola and Rosamund Borradaile, *Practical Tempera Painting:*A Student's Cennini, Dolphin, Brighton, 1949.

Helmuth Bossert, An Encyclopaedia of Colour Decoration, Ernst Wasmuth, Berlin, 1928.

lan C. Bristow, *Architectural Colour in British Interiors*, 1615–1840, Yale University Press, London, 1996.

lan C. Bristow, *Interior House-Painting Colours and Technology*, 1615–1840, Yale University Press, London, 1996.

Ian C. Bristow, 'Ready-Mixed Paint in the Eighteenth Century', Architectural Review, No. 963, April 1977.

lan C. Bristow, 'Repainting Eighteenth-century Interiors', ASCHB transactions 1981 (vol. vi, 1982).

M. Brusatin, *A History of Colours*, Shambala, Boston, USA, 1991. E.R. Caley, 'Ancient Greek Pigments', *Journal of Chemical*

Robert Chenciner, Madder Red, Curzon Press, 2000.

Education, 23 (1946).

François Delamare and Bernard Guineau, *Colour, Making and Using Dyes and Pigments*, trans. from the French edition, Thames and Hudson, 2000.

Alan Dronsfield and John Edmonds, *The Transition from Natural to Synthetic Dyeing*, Edmonds, 2001.

John Edmonds, *The History of Woad and the Medieval Woad Vat*, Edmonds, 1998.

John Edmonds, *The History and Practice of Eighteenth-century Dyeing*, Edmonds, 1999.

John Edmonds, Tyrian or Imperial Purple Dye, Edmonds, 2000.

English Heritage, Layers of Understanding, Proceedings of Architectural Paint Seminar, Donhead, 2002.

R.L. Feller (ed.), *Artists' Pigments*, Vol. 1, National Gallery of Art, Washington, USA/OUP, Oxford, 1986.

M. Farnsworth, 'Ancient Pigments', *Journal of Chemical Education*, 28 (1951).

Simon Garfield, Mauve, Faber & Faber, London, 2000.

Oliver Garnett, Colour: A Social History, The National Trust, 2000.
 R.J. Gettens & G.L. Stout, Painting Materials: A Short Encyclopaedia, reprint of 1942 edition, New York, 1966.

F. Hamilton Jackson, Mural Painting, Sands & Co., London, 1904.

R.A. Higgins, 'The Polychrome Decoration of Greek Terracottas', Studies in Conservation, 15 (1970).

Historic Paints Ltd, A Treatise and General Primer on the Properties of Early American Paints, Historic Paints Ltd, USA, 1994.

Arthur Seymour Jennings, *Paint and Colour Mixing*, 7th ed., Trade Papers Publishing, London, 1926.

Catherine Lynn, 'Colors and other Materials of Historic Wallpapers', Journal of the American Institute for Conservation, Vol. 20, No. 2.

Maclehose and Brown, *Vasari on Technique*, Dent 1907, Dover 1960. Ralph Mayer, *The Artist's Handbook of Materials and Techniques*, 4th ed., Faber & Faber, London, 1981.

Thos. Parsons and Sons Ltd, *Historical Colours*, reprint, Thos Parsons and Sons Ltd, London, 1937.

Michel Pastoureau, *Bleu, Histoire d'une Couleur*, Editions du Seuil, 2000.

Traditional Paint News, Journal of the Traditional Paint Forum, 1994.

A. Roy (ed.), *Artists' Pigments*, Vol. 2, National Gallery of Art, Washington, USA/OUP, Oxford, 1992.

Frank S. Walsh, 'The Early American Palette: Colonial Paint Colours Revealed', *Paint in America: The Colors of Historic Buildings*, (R.W. Moss ed.), John Wiley & Sons Inc, USA, 1994.

E. West Fitzhugh (ed.), *Artists' Pigments*, Vol. 3, National Gallery of Art, Washington, USA/OUP, Oxford, 1997.

Georgian Group Guide No. 4, Paint Colour, 2nd ed., UK, 1991.

classical and early texts on colour and pigment

Leon Battista Alberti, *On Painting*, trans. C. Grayson, Penguin, London, 1972 and 1991.

Aristotle, On the Soul, book II, vi-viii, book III, i-iii, v, trans. W.S. Hett, Harvard University Press, 2000.

Aristotle, 'On Colours' in *Minor Works*, trans. W.S. Hett, Harvard University Press, 2000.

Aristotle, *Parva Naturalia, On Sense and Sensible Objects*, trans. W.S. Hett, Harvard University Press, 2000.

Cennino Cennini, Il Libro dell'Arte, ed. F. Brunello, 1971.

Plato, Timaeus, 36: Colours, trans. D. Lee, Penguin Classics, 1977.

Pliny the Elder, *Natural History*, (book II 151–3, book IX 125–127, book XXXIII 111, books XXXIV–XXXVII, trans. J.F. Healy, Penguin Classics, London, 1991.

Theophilus, *On Divers Arts*, (1122), trans. Hawthorne and Smith, Dover, New York, 1979.

Translations of the major medieval works such as the manuscripts of Jehan Le Begue and Alcherius can be found in the republished 1849 work by Mary P. Merrifield, *Medieval and Renaissance Treatises on the Art of Painting*, Dover, 1967. (Two volumes bound as one).

colour theory, mapping and systems

- Roy S. Berns, *Billmeyer and Saltzman's Principles of Colour Technology*, 3rd ed., John Wiley and Sons Inc., 2000.
- Färgrapport F28, Colour Order Systems and Environmental Colour Designs, ed. Anders Hård and Lars Sivik, Scandinavian Colour Institute, 1983.
- Färgrapport F22, On Studying Colour Combinations, ed. Anders Hård and Lars Sivik, Scandinavian Colour Institute, 1989.
- Johann Wolfgang von Goethe, *Theory of Colours*, trans. Eastlake 1840, reprinted M.I.T., 1970.
- Wilhelm Ostwald, *The Color Primer*, ed. Faber Birren, English edition, Van Nostrand Reinhold. New York. 1969.
- Charles A. Riley, *Colour Codes*, University Press of New England, Hanover, USA, 1995.
- Paul Zelanski and Mary Pat Fisher, Colour, 3rd ed., Herbert Press, 1999.

colour vision and perception

Edith Anderson Feisner, Colour, Laurence King, 2000.

Dennis Baylor, 'Colour Mechanisms of the Eye', *Colour Art and Science*, ed. Lamb and Bourriau, Cambridge, 1995.

John Berger, Ways of Seeing, Penguin, London, 1972.

B. Berlin and P. Kay, *Basic Color Terms*, University of California Press, 1969.

The Colour Group, *Newsletter*, Colour Group (Great Britain, www.colour.org.uk)

John Mollon, 'Seeing Colour', *Colour Art and Science*, ed. Lamb and Bourriau, Cambridge, 1995.

Malcolm Longair, 'Light and Colour', *Colour Art and Science*, ed. Lamb and Bourriau, Cambridge, 1995.

H. Varley (ed.), Colour, Marshall, London, 1980.

M.D. Vernon, The Psychology of Perception, Penguin 1962.

Michael Wilcox, Blue and Yellow Don't Make Green, Artways, Australia, 1998.

Ludwig Wittgenstein, *Remarks on Colour*, ed. G.E.M. Anscombe, Blackwell, 1977.

H. Zollinger, Colour, A Multidisciplinary Approach, VCH, Zurich, 1999.

colour and art

- D. Bomford and A. Roy, *Colour*, National Gallery Co. Ltd., London, 2000.
- N. Charlet, Yves Klein, Vilo, Paris, 2000.
- Johannes Itten, *The Art of Colour*, John Wiley and Sons Inc., 1961 and 1973
- Johannes Itten, *The Elements of Colour*, Van Nostrand Reinhold, New York, 1970.

John Gage, Colour and Culture, Thames and Hudson, 1993.

John Gage, Colour and Meaning, Thames and Hudson, 1999.

Paul Hills, Venetian Colour, Yale, 1999.

Trevor Lamb and Janine Bourriau (ed.), Colour Art and Science, Cambridge, 1995.

colour and place

Michael Lancaster, Colourscape, Academy, 1996.

Michael Lancaster, Britain in View, Quiller, 1984.

Jean-Philippe Lenclos, Les couleurs de l'europe, Moniteur, 1995.

Hibi Sadao, *The Colours of Japan*, with an introductory essay by Kunio Fukuda, trans. John Bester, Kodansha, Tokyo, 2000.

Hibi Sadao, *Japanese Detail*, with an introductory essay by Kunio Fukuda, Thames and Hudson, London, 1989.

Raghubir Singh, *River of Colour: the India of Raghubir Singh*, Phaidon, London, 1998.

Ed Taverne and Cor Wagenaar (ed.), *The Colour of the City*, V+K Publishing, 1992.

Bonnie Young and Donna Karan, Colours of the Vanishing Tribes, Booth Clibborn, London, 1998.

contemporary culture and colour

David Batchelor, Chromophobia, Reaktion, 2000.

Norman Foster, 30 Colours, V+K Publishing, Blaricum, 1998.

Derek Jarman, Chroma, Vintage, London, 1995.

Rem Koolhaas/OMA, Norman Foster, Alessandro Mendini, *Colours*, V+K Publishing/Birkhauser, 2001.

NCS, Top 300 Colours in Design, Architecture and Manufacturing, 2002–2003, Scandinavian Colour Institute, 2002.

Maggie Toy (ed.), Colour in Architecture, Architectural Design publication, 1996.

paint suppliers

quality paints matched to colours in this book available at choosingpaint.com

choosingpaint.com

tel +44 (0)121 381 4800 fax +44 (0)121 381 4848 text +44 (0)121 381 5050 www.choosingpaint.com

Cole & Son

Chelsea Harbour Design Centre, London SW10 0XE tel +44 (0)20 7376 4628 / +44 (0)20 8442 8844 fax +44 (0)20 8802 0033 email customerservices@cole-and-son.com www.cole-and-son.com

Craig & Rose

Unit 8, Halbeath Industrial Estate, Crossgates Road, Halbeath, Dunfermline, Fife KY11 7EG tel +44 (0)1383 740011 fax +44 (0)1383 740010 email enquiries@craigandrose.com

Designer's Guild

275–277 Kings Road, London SW3 5EN tel +44 (0)20 7351 5775 fax +44 (0)20 7243 7710 email info@designersguild.com www.designersguild.com

Fired Earth

Twyford Mill, Oxford Road, Adderbury, Oxon OX17 3HP tel +44 (0)1295 812088 fax +44 (0)1295 810832 email enquiries@firedearth.com www.firedearth.com

The Little Greene Paint Company

Riverside Works, Collyhurst Road, Manchester M40 7RR tel +44 (0)161 203 2400 fax +44 (0)161 203 5234 email mail@thelittlegreene.co.uk www.thelittlegreene.com

Paint & Paper Library

5 Elystan Street, London SW3 3NT

tel +44 (0)20 7823 7755 fax +44 (0)20 7823 7766 email davidoliver@paintlibrary.co.uk www.paintlibrary.co.uk

Sanderson

100 Acres, Sanderson Road, Uxbridge, Middlesex UB8 1DH tel +44 (0)1895 830044 fax +44 (0)1895 830055 email cvc@a-sanderson.co.uk www.sanderson-online.co.uk

Zoffany

63 South Audley Street, London W1
tel +44 (0)20 7495 2505 / +44 (0)8708 300350
email enquiries@zoffany.uk.com
www.zoffany.com

other paint manufacturers offering a colour matching service

Beckers

Lövholmsgränd 12, 117 83 Stockholm, Sweden tel +46 8 775 60 00 fax +46 8 775 62 40 email info@alcro-beckers.com www.alcro-beckers.com

Dulux

Dulux Customer Care Centre, ICI Paints, Wexham Road, Slough, Berkshire SL2 5DS tel +44 (0)1753 550555 email info@dulux.co.uk www.dulux.co.uk Call the Dulux Colour Design Studio on +44 (0)9068 515222 to speak to a colour consultant for advice on colour schemes

Leyland Paints

Huddersfield Road, Birstall, Batley, West Yorkshire WF15 7LS tel +44 (0)1924 354500 fax +44 (0)1924 354001 email technicalenquiries@kalon.co.uk www.leyland-paints.co.uk Call the Colour Matching Service on +44 (0)1924 354321 to match a paint to any wallpaper, fabric or other colour swatch

Papers and Paints

4 Park Walk, London SW10 0AD tel +44 (0)20 7352 8626

fax +44 (0)20 7352 1017

email enquiries@papers-paints.co.uk

www.colourman.com

Call the Colour Matching Service on +44 (0)20 7352 8626 to match a paint to any wallpaper, fabric or other colour swatch either in-store on on-site

other paint manufacturers offering quality paints

Auro Organic Paints

Unit 2, Pamphillions Farm, Purton End, Debden, Saffron Walden,

Essex CB11 3JT

tel +44 (0)1799 543077

fax +44 (0)1799 542187

email sales@auroorganic.co.uk

www.auroorganic.co.uk

Crown Paints

supplied by Akzo Nobel Decorative Coatings Limited PO Box 37, Crown House, Hollins Road, Darwen, Lancashire BB3 0BG

tel +44 (0)1254 704951

fax +44 (0)1254 774414

www.akzo.nobel.com

Ecos Paints

Unit 34, Heysham Business Park, Middleton Road, Heysham,

Lancashire LA3 3PP

tel +44 (0)1524 852371

fax +44 (0)1524 859978

email mail@ecospaints.com

www.ecospaints.com

Farrow & Ball

Uddens Trading Estate, Wimbourne, Dorset BH21 7NL

tel +44 (0)1202 876141

fax +44 (0)1202 873793

email farrow-ball@farrow-ball.com

www.farrow-ball.com

Call the Farrow & Ball Showroom on +44 (0)20 7351 0273 to

hire a colour consultant for on-site advice

Holkham Linseed Paints

The Clock Tower, Longlands, Holkham, Wells-Next-The-Sea,

Norfolk NR23 1RU

tel +44 (0)1328 711348

fax +44 (0)1328 710368

www.holkham.co.uk/linseedpaints

John Oliver Ltd

33 Pembridge Road, London W11 3HG

tel +44 (0)20 7221 6466 / +44 (0)20 7727 3735

fax +44 (0)20 7727 5555

Keim Mineral Paints

Muckley Cross, Morville, Nr Bridgnorth, Shropshire WV16 4RR

tel +44 (0)1746 714543

fax +44 (0)1746 714526

email sales@keimpaints.co.uk

www.keimpaints.co.uk

Marston & Langinger

192 Ebury Street, London SW1W 8UP

tel +44 (0)20 7824 8818

fax +44 (0)20 7824 8757

email sales@marston-and-langinger.com

www.marston-and-langinger.com

Natural Colour System

supplied by J.W. Bollom

PO Box 78, Croydon Road, Beckenham, Kent BR3 4BL

tel +44 (0)20 8658 2299

fax +44 (0)20 8658 8672

www.bollom.com

Paintworks

211-212 Avro House, 7 Havelock Terrace, London SW8 4AS

tel +44 (0)20 7720 8018

fax +44 (0)20 7720 8418

email info@paintworks.co.uk

www.paintworks.co.uk

Rose of Jericho

Horchester Farm, Holywell, Evershot, Dorchester, Dorset DT2 OLL

tel +44 (0)1935 83676

fax +44 (0)1935 83903

email info@rose-of-jericho.demon.co.uk

www.rose-of-jericho.demon.co.uk

- 1 Albany, Red Torch
- 2 Little Greene, 15V04
- 3 BS 381C Technical Colour, Albany, Deep Brunswick Green
- 4 Fired Earth, Bone

Palette 44

- 1 Cole & Son, Hamilton
- 2 Sanderson, Silver Dust
- 3 NCS, Albany, NCS 1040-R20B
- 4 Little Greene, 18V04
- 5 Zoffany, La Seine
- 6 Paint Library, Blue Charm

Palette 45

- 1 Albany, Red Torch
- 2 Albany, Emerald Pagoda
- 3 Albany, Gold Flame
- 4 BS 381C Technical Colour, Albany, Middle Brunswick Green
- 5 BS 381C Technical Colour, Albany, Rail Red
- 6 Little Greene, 32B03

Palette 46

- 1 Fired Earth, Flapper Pink
- 2 Sanderson, Pomona Green Light
- 3 NCS, Albany, NCS 1070-R10B
- 4 Sanderson, Brussels Sprouts
- 5 Little Greene, 17V03
- 6 Fired Earth, Ridge Blue

Palette 47

- 1 Fired Earth, Dune
- 2 Albany, Bracken
- 3 NCS, Albany, NCS 1870-Y50R
- 4 Albany, Cote d'Azur

Palette 48

- 1 Little Greene, 15C04
- 2 Zoffany, Ink
- 3 Fired Earth, Cotton
- 4 Little Greene, 25B03
- 5 Little Greene, 10V03

Palette 49

- 1 Cole & Son, Etruscan
- 2 NCS, Albany, NCS 1050-B10G
- 3 Fired Earth, Malmesbury Yellow
- 4 NCS, Albany, NCS 1030-B
- 5 Zoffany, Ebony

Palette 50

- 1 Zoffany, Olympia
- 2 Paint Library, Tea Tree
- 3 Zoffany, Degas
- 4 Fired Earth, Mells Violet
- 5 Little Greene, Hollyhock
- 6 Fired Earth, Farmhouse Cream
- 7 Little Greene, Mirage

- 8 Zoffany, Harbour Grey
- 9 Paint Library, Lullaby
- 10 Cole & Son. Howard
- 11 Fired Farth, Dunstable White
- 12 Little Greene, 10B02
- 13 Fired Earth, Northern Green
- 14 Sanderson, Chateau Grey
- 15 Zoffany, La Seine
- 16 Sanderson, Independence
- 17 Little Greene, Button
- 18 Zoffany, Fresco
- 19 Zoffany, Ice Floes
- 20 Little Greene, 51N01
- 21 Fired Earth, Cool Blue
- 22 Fired Earth, Solent Blue
- 23 Fired Earth, Earth Pink
- 24 Paint Library, Jaipur Pink
- 25 Fired Earth, Pompeian Red
- 26 Fired Earth, Shed Red
- 27 Cole & Son, Ruban
- 28 Fired Earth, Landscape

Palette 51

- 1 Sanderson, Sweet Lady
- 2 Zoffany, Olympia
- 3 Little Greene, 18B02
- 4 Paint Library, Bruno

Palette 52

- 1 Little Greene, 18V05
- 2 Little Greene, 14V06
- 3 Little Greene, 17D03
- 4 Sanderson, Window Blue
- 5 Designers Guild, Heather
- 6 Paint Library, Tarlatan

Palette 53

- 1 Fired Earth, Sienna Earth
- 2 Fired Earth, Red Ochre
- 3 Paint Library, Stellenbosch Oak
- 4 Zoffany, Russet
- 5 Fired Earth, Clear Blue
- 6 Albany, Teepee
- 7 Fired Earth, Ultramarine Ashes
- 8 Designers Guild, Ocean
- 9 Zoffany, Van Gogh
- 10 Fired Earth, Brussels Orange
- 11 Fired Earth, Skyscraper
- 12 Little Greene, 22A03
- 13 Sanderson, Vivid Violet
- 14 Fired Earth, Chalk Rose
- 15 Albany, Morning Room
- 16 Designers Guild, Amethyst

Palette 54

- 1 NCS, Albany, NCS 5010-R50B
- 2 Albany, Raisin
- 3 NCS, Albany, NCS 2340-Y30R
- 4 Sanderson (Morris & Co.), Brick

Palette 55

- 1 Albany, Tea Tree
- 2 Fired Earth, Warm Sepia
- 3 Sanderson, Dewberry

Palette 56

- 1 Albany, Reedgrass
- 2 Sanderson, Gardenia Green
- 3 Fired Earth. Dune
- 4 Sanderson, Old Burgundy

Palette 57

- 1 Fired Earth, Better Class Red
- 2 Little Greene, 10V06
- 3 BS 381C Technical Colour, Albany, Bright Red Orange
- 4 Sanderson, Danbury

Palette 58

- 1 Fired Earth, Ridge Blue
- 2 Sanderson (Morris & Co.), Sage
- 3 Fired Earth, Stone Ochre
- 4 Little Greene, 11D01

Palette 59

- Albany, Dovecote
- 2 Little Greene, Hollyhock
- 3 Designers Guild, Celadon
- 4 Fired Earth, Charleston
- 5 Cole & Son, Light Sage
- 6 Designers Guild, Bright Blue
- 7 NCS, Albany, NCS 2040-G20Y
- 8 Albany, French Blue
- 9 Fired Earth, Aconite Yellow10 Albany, Blue Horizon

- Palette 60
- NCS, Albany, NCS 2050-B30G
 Albany, Pansev
- 3 NCS, Albany, NCS 5010-B50G
- 4 Sanderson, Twig
- 5 NCS, Albany, NCS 6030-R60B
- 6 Cole & Son, Ruban
- 7 Designers Guild, Cloud
- Designers dulla, cloud
- 8 Sanderson, Princess Blue
- 9 Little Greene, Mischief
- 10 Paint Library, Lavenham Blue
- 11 Fired Earth, Skye Blue
- 12 Albany, Colonial
- 13 NCS, Albany, NCS 1010-R90B14 Albany, Blue Horizon

Palette 61

- 1 NCS, Albany, NCS 2060-R40B
- 2 NCS, Albany, NCS 1070-R20B
- 3 Fired Earth, Bengal Rose

4 No near match

- Palette 62
- 1 Sanderson Dandelion
- 2 Albany, French Marigold
- 3 Sanderson, Brilliant Tangerine
- 4 Sanderson, Ole Orange
- 5 Paint Library, Galway Blazer
- 6 No near match
- 7 NCS, Albany, NCS 3060-R50B
- 8 NCS, Albany, NCS 3060-R60B
- 9 NCS, Albany, NCS 2070-R90B
- 10 NCS, Albany, NCS 1070-B
- 11 NCS, Albany, NCS 2060-B20G
- 12 NCS, Albany, NCS 3060-B80G
- 13 NCS, Albany, NCS 1570-G
- 14 NCS, Albany, NCS 1080-G30Y
- 15 NCS, Albany, NCS 0070-G50Y16 NCS, Albany, NCS 0070-G80Y

- Palette 63
- 1 NCS, Albany, NCS 2040-G10Y
- NCS, Albany, NCS 3043-G20YNCS, Albany, NCS 1560-R30B
- 4 Fired Earth, Bengal Rose
- 5 Paint Library, Sophie Rose
- 6 Paint Library, Sophie Rose
- 7 Paint Library, *Galway Blazer*8 NCS, Little Greene, *Bright Red Orange*
- 2008
- 9 Albany, *Blueberry*10 NCS, Albany, *NCS 2070-R80B*

- Palette 64
- 1 NCS, Albany, NCS 2570-R70B
- 2 NCS, Albany, NCS 1047-R30B
- 3 Little Greene, 14V054 Sanderson, Dandelion
- 5 NCS, Albany, NCS 0030-R10B
- 6 Paint Library, Hot Lips
 7 NCS, Albany, NCS 0030-R90B
 8 NCS, Albany, NCS 0015-R10B
- 9 Albany, Apricot Silk